An Introductio1

Japanese Kanji Calligraphy

Kunii Takezaki

竹﨑久仁衣

**Coauthor & Editor
Bob Godin**

TUTTLE PUBLISHING
Tokyo • Rutland, Vermont • Singapore

Table of Contents

師君公来耐元文人る斬于斎己丑二戦頬孫

ABOUT THE AUTHOR

Kunii Takezaki was born and raised in Koza City, Okinawa, Japan, and since opening a Japan Penmanship Education Foundation affiliated school in Ginowan City, she's been busy spreading the message that everyone can enjoy the beauty of calligraphy.

- 1998 Received the Japan Penmanship Education Foundation's Instructor Certification and granted the pen name *"Gyokushu"*.
- 1998 - 2001 Became a lifetime member as an instructor in the Ginowan City Calligraphy Circle.
- 2000 Received the 8th Level Instructor Certification, the highest level of achievement recognized for a Japanese shodo master.
- 2002 Participated in a calligraphy demonstration visit at a Japanese school in Melbourne, Australia.
- 2003 Conducted calligraphy demonstrations at the U.S. Air Force Academy in Colorado.
- 2004 Participated in street exhibitions and calligraphy demonstrations in New York City's Central Park.
- 2004 Carried out numerous calligraphy demonstrations in the Little Tokyo district of Los Angeles, and in Santa Monica, California.
- 2005 Joined the World Uchinanchu Business Association (WUB).

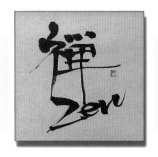

Zen beckons us to unleash the unlimited creative power within our heart, for it is not bound to any single language or culture.
4.7" x 4.7"
12 cm x 12 cm

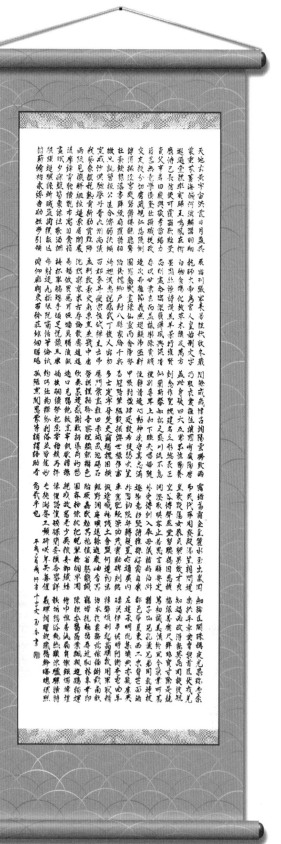

Ancient Chinese proverbs frequently take the form of the *"yonji ikku"*, an expression made with a unique series of four kanji characters.

During the Liang Dynasty (504 C.E.), Emperor Wu ordered the writing of a 1000 character scroll comprised of 250 consecutive *"yonji ikku"* proverbs with no repeated characters to be used for kanji study by his children.

Since that time, Japanese Calligraphy masters have made it a tradition to complete such works to hone their skills.

This scroll was rendered by the author in a single six hour sitting in 2005.

19.3" x 52.8"
(49 cm x 134 cm)

The Stone of Three Styles 三体石軽

This is a reproduction, created by the author, of a Chinese Gi Dynasty (240 C.E.) engraving that shows a variety of characters rendered in the three sacred scripts of Chinese calligraphy, Jakobun (古文), tensho (篆書), and reisho (隷書).
17.7" x 23.2"
(45 cm x 59 cm)

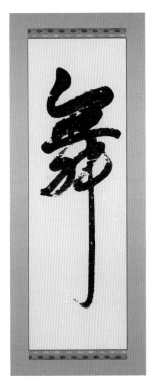

Dance 舞

Sprinkled with gold leaf on a violet background, "Dance" is reminiscent of the liveliness of many Okinawan festivals.
13.4" x 24.4"
(34 cm x 62 cm)

Samurai 侍

"In my effort to spread the joy of calligraphy around the world, people often request famous Japanese themes or historical figures. This is one that I think everyone will understand."
26" x 41.3"
(66 cm x 105 cm)

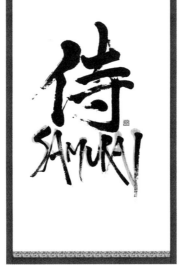

A Personal Invitation by the Author

Due to its limited natural resources and proximity to Japan, China, Korea, and other South East Asian nations, Okinawa has been involved in international trade and commerce for many centuries. As a result of this experience, thousand of Okinawans have emigrated to many nations all over the world.

It's a shame that many of the second, third, and fourth generation children born of these emigrants seldom have a chance to be exposed to the culture, writing, and language of their ancestral homeland.

As a practicing calligraphy instructor, I've noticed an increase in the number of non-Japanese students who have an interest in learning how to write kanji and speak Japanese. I tried to locate a book written in English from which they could both study calligraphy and learn the basics of the Japanese language, all to no avail.

To my students, the descendants of Okinawans living abroad, and all those interested in Japanese kanji calligraphy, I truly hope that this book will help you experience the enjoyment of calligraphy, as have so many others before us.

Kunii Takezaki, "Gyokushu"
September 21, 2005
Okinawa, Japan

Published by Tuttle Publishing an imprint of Periplus Editions (HK) Ltd. with
editorial offices at 364 Innovation Drive, North Clarendon, VT 05759 U.S.A.
and 61 Tai Seng Avenue #02-12 Singapore 534167.

Copyright © 2005 by Kunii Takezaki and Bob Godin except as otherwise noted.
Edited by Bob Godin
Translation: Kiyoko Fujita
Photography by Rob Oechsle

ISBN-10: 4-8053-0925-3
ISBN-13: 978-4-8053-0925-4

Distributed by:

Japan
Tuttle Publishing
Yaekari Bldg., 3rd Floor, 5-4-12 Osaki,
Shinagawa-ku, Tokyo 141-0032
Tel: (81) 03 5437-0171
Fax: (81) 03 5437-0755
tuttle-sales@gol.com

North America, Latin America, and Europe
Tuttle Publishing
364 Innovation Drive, North Clarendon,
VT 05759-9436 USA.
Tel: 1(802) 773-8930
Fax: 1(802) 773-6993
info@tuttlepublishing.com
www.tuttlepublishing.com

Asia Pacific
Berkeley Books Pte. Ltd.
61 Tai Seng Avenue #02-12 Singapore 534167
Tel: (65) 6280-1330
Fax: (65) 6280-6290
inquiries@periplus.com.sg
www.periplus.com

10 09 08 07
6 5 4 3 2 1

Printed in Malaysia

SKIP (System of Kanji Indexing by Patterns)
Copyright © 1993 by Jack Halpern

SKIP is used in several comprehensive kanji dictionaries, including Kodansha's
Kanji Learner's Dictionary, and the New Japanese-English Character Dictionary.
SKIP data has been included in the kanji library section of this publication
specifically to familiarize the reader with its ease of use. The SKIP system is
Copyright©1993 by Jack Halpern and has been used in this book with permission.

The utilization of SKIP and SKIP numbers, whether in printed material or software
form, is strictly forbidden without written permission from the copyright holder.

For complete information on SKIP and dictionaries that use the SKIP system,
please see The CJK Dictionary Institute's website at: http://www.cjk.org

INTRODUCTION TO KANJI CALLIGRAPHY

The word calligraphy literally means *"beautiful writing"* and is an art form that has been used by nearly every civilization whose language had a written script to stress the importance of its culture, religion, and philosophy.

As calligraphy became widespread, it began to be used more for purely artistic expression. In Asian art, calligraphic poety is often accompanied with illustrations of landscapes, decorative plants, or other natural beauty.

WHAT IS KANJI?

The word *"kanji"* is a Japanese word that refers to a group of thousands of symbols that are used in Chinese, Japanese, and other Asian languages.

Kanji characters are sometimes called pictograms, or a number of similar terms, because many of the oldest known kanji characters graphically depicted the object or idea that they represented.

Ancient Chinese Pictographs & Ideographs

As more characters were developed, it became increasingly difficult to 'draw a picture' that represented the complex ideas of each new character. So, even though the idea that kanji are pictograms may be true for many of them, it is, by far, not an accurate description of the majority of characters in use today.

Since the 2nd century, Chinese kanji scholars have used six categories to classify kanji characters according to their make-up:

- Pictographs, or *"shoukeimoji"* (象形文字), are rough sketches of the object they represent, such 'eye' in the graphic shown.
- Ideographs, or *"shijimoji"* (指事文字), represent abstract concepts like numbers or directions, such as up (上), down (下), two (二), and three (三).
- Compound ideographs, or *"kaiimoji"* (会意文字), are generally a combination of two or more pictographs that represent a complex idea or relationship, such as 'east' in the graphic on the right.
- The phonetic-ideographic, or *"keiseimoji"* (形声文字), account for about 85% of all kanji and are made of two main parts. Originally, one part indicated the meaning, and the other, the Chinese pronunciation. Though this type may or may not provide a hint about their pronunciation in Japanese, in most cases, you can't guess their meaning.
- Derivative characters, or *"tenchuumoji"* (転注文字), are characters whose meaning was derived from characters of a completely different meaning.
- And last, phonetic loan characters, or *"kashamoji"* (仮借文字), are kanji whose meaning is ignored, but borrowed for their sound alone. In kashamoji, America is sometimes written (亜米利加), "Amerika". This usage is like writing *"UR2"* in place of 'you are, too'.

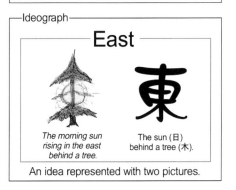

Pictograph

Eye

A simple representative picture.

Ideograph

East

The morning sun rising in the east behind a tree.

The sun (日) behind a tree (木).

An idea represented with two pictures.

THE ORIGIN AND HISTORY OF KANJI

The origin of kanji can be traced back to the earliest known civilizations of China. Though little information that all historians agree upon exists, many legends exist about its inception.

Though scholars disagree, the popular myth is that the first kanji were invented by a Chinese scribe by the name of Ts'ang Chie who began to develop them after studying the foot prints of various birds and animals in the royal gardens.

Bone and tortoise shell carvings that were used for fortune telling show the use of kanji in ancient China as far back as about 1,500 B.C.E. And by the turn of the millennium, kanji was a fully established writing medium.

Around the fifth century, Buddhism spread to Japan, bringing kanji with it. At that time, the Japanese had no writing system and the common class of people didn't have the education needed to read the thousand of characters.

At first, they adopted of a very small set of Chinese kanji whose sounds could be used to express the spoken Japanese language. A collection of popular Japanese poems was rendered in these characters which resulted in their widespread acceptance and use.

This set, eventually called manyogana, generally had their Chinese meaning ignored and were used to represent the sounds of Japanese only. Simplification of the characters resulted in two writing styles, hiragana and katakana.

Scholars, considering kana to be inferior, continued to work on devising methods to read *"kanbun"*, or Chinese literature, using rules to alter the word order and pronouncing the words using Japanese sounds. This resulted the adoption of many new Chinese words and concepts, and also, the sounds of onyomi pronunciation. But to adopt kanji in a way that would result in true Japanese kanji, the characters had to be paired with preexisting Japanese words based on their meaning. And this linked the kunyomi sounds to kanji pronunciation. Both of these methods will be discussed later in the book.

Meanwhile, kana had been on its way to becoming the mainstream writing system of the common people, and by the eighth century, it was in widespread use.

Eventually, all three of these scripts settled into the specific roles they play in the Japanese writing system of today.

SIMPLIFICATION OF KANJI INTO KATAKANA & HIRAGANA

KANJI	K	H
波	ハ	は
比	ヒ	ひ
太	タ	た
加	カ	か
安	ア	あ
仁	ニ	に
寸	ス	す
久	ク	く
礼	レ	れ
乃	ノ	の
毛	モ	も
己	コ	こ
遠	ト	と

STYLES OF KANJI

There are six main styles of written kanji and each has its own characteristic appearance and historic usage. Of these, only three pertain to modern Japanese calligraphy.

Kaisho

Kaisho is a plain style that is the easiest to read. It is also used by those first learning to write kanji. Its simplicity allows students to clearly see all of the brush strokes of each character. Kaisho is the style that is the closest to the modern printed fonts of today, and is the style taught in this book.

Gyousho

Gyousho is a semi-cursive style that is akin to the English cursive handwriting that people use after they become proficient at writing the characters. It sometimes blends strokes into a cluster and may slightly simplify some complex structures.

Sousho

Sousho, or *"grass script"*, is a fully cursive style of writing that uses flowing lines to merge many of the brush strokes together. Even though some of the characters are recognizable to the average reader, most people cannot accurately read sousho script because so many of the characters are modified to the extent that the resemblance is not always apparent.

Naturally, all of the major styles originated in China, and some are still used for purposes other than calligraphy in Japan today.

Such a style is the seal script, or *"reisho"*, which was originally used on the name stamps of calligraphers and craftsmen. Red or orange name stamps are still used today as an official signature for individuals and companies on legal documents, but only the biggest companies use the reisho style.

The character "Dream"

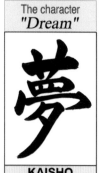

KAISHO
Plain Style

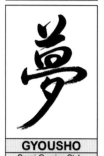

GYOUSHO
Semi-Cursive Style

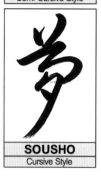

SOUSHO
Cursive Style

THE MODERN JAPANESE LANGUAGE

OVERVIEW OF THE JAPANESE WRITING SYSTEM

The modern Japanese language, especially, the writing system, is very complicated compared to English and most other western languages.

First of all, it uses a total of five different types of writing scripts: kanji, hiragana, katakana, Roman letters, and Arabic numerals.

Kanji Characters

Though the majority of kanji (漢字) characters are of Chinese origin, some were created in Japan, while others have been simplified for use in Japan. Generally speaking, we can treat all kanji alike regardless of their origin.

Though over 60,000 kanji characters are known to exist, most of these are obsolete Chinese characters. Modern Japanese uses between 2,000 and 3,000 kanji. Currently, the public schools teach the "Jouyou Kanji" (常用漢字) which is a list of 1,945 characters often encountered in daily life in Japan.

Kanji is typically used for Japanese words and words of Chinese origin.

The Roman Letter Alphabet (Romaji)

"Romaji" (ローマ字) refers to characters that originated in Rome, or what we call the Roman letter alphabet. The Roman letter alphabet was first introduced to Japanese during the sixteenth century and was used to preach sermons in Japanese by foreign missionaries who couldn't read kanji or kana. This is its main usage.

In Japan, even though many English and European words are written in their native Roman letter script, its main purpose is to provide a method for those who cannot read Japanese kanji or kana to read Japanese words with Roman letters.

Arabic Numerals (Sanyou suuji)

The Arabic numerals (算用数字) such as 1, 2, 3, etc. were adopted in Japan about the same time as Roman letters. The name "sanyou suuji" means 'numerals for calculation', so as you can guess, mathematics, financial documents, price lists, and the like, are normally written in Arabic numerals.

The Japanese numbering system using kanji is normally only used for smaller numbers, likes a person's age, or prices in a menu.

Hiragana

Hiragana (平仮名) is one of the two phonetic alphabets used to write purely Japanese words. It is also used to write what is called okurigana, when the root portion of a word is written in kanji and the second half, which includes the tense and mood, is written in kana.

More details about hiragana are in the section below, *SPECIFICS OF THE KANA SYSTEM*, and also on pages 14 and 15.

Katakana

Katakana (片仮名) is the other phonetic alphabet that is used to write all words of foreign origin, animal sounds, human sounds (like the English ah ha, oh, etc.) and sometimes used to emphasize regular Japanese words.

More details about katakana are in the section below, *SPECIFICS OF THE KANA SYSTEM*, and also on pages 16 and 17.

SPECIFICS OF THE KANA SYSTEM

I have decided to cover this topic in detail because I've found that many of my foreign students want to know how to pronounce the kanji characters they learn. To pronounce kanji correctly, you must know the basic sounds of the Japanese language. The kana system contains all of the sounds used in the Japanese language and has the rules pertaining to sound changes, as well.

Though hiragana and katakana have different shapes and are used for different types of words, nearly everything else about them identical. They both have the same number of characters, they share exactly the same sounds, and the rules

of the two writing systems about the same.

So, from this point on, I will say *"kana"* when talking about things that are common to both hiragana and katakana.

Despite the complexity of Japan's writing system, most of the sounds are easy to pronounce for English and Spanish speaking students, alike.

GOJYUU'ON

Refer to the chart on the right (Gojyuu'on: The Sounds and Characters of Kana) when reading the next few pages. Each individual sound block on the chart has three sections. The grey section shows hiragana, the colored section shows katakana, and white section shows the Romanization of each sound shown.

The sounds of the Japanese language are called *"gojyuu'on"* (五十音) which means *'the fifty sounds'*. Though only 46 of the 50 original basic sounds (section ❶) are used today, the name of the chart remains unchanged.

Unlike the English alphabet in which each letter's name is different than its sound, the name of each character in both of the kana alphabets is exactly the same as the sound they make. This makes learning them a fairly easy task for the dedicated student.

The character names and sounds can be learned by reciting them in the order of the kana alphabet, as follows:

> • a, i, u, e, o • ka, ki, ku, ke, ko • sa, **shi**, su, se, so
> • ta, **chi**, **tsu**, te, to • na, ni, nu, ne, no • ha, hi, **fu**, he, ho
> • ma, mi, mu, me, mo • ya, yu, yo • ra, ri, ru, re, ro • wa, wo • n

Most of the sounds are in sets of five with each of the five Japanese vowel sounds corresponding to a single consonant. Notice that there are four sounds (chi, tsu, shi, fu) in which the consonant does not match the other four in its group. Also notice that the "y-" and "w-" lines do not use all five vowels.

Each one of the 46 basic sounds, except for the first five (a single vowel) and the last (a single consonant), is a consonant-vowel combination. Also, each is represented by a single symbol and is considered to be an individual sound according to Japanese phonology. When pronounced, each symbol is given the same amount of time.

Using pronunciation marks and various character combinations, there are four main types of variations that can be made from the basic sounds.

Gojyuu'on: The Sounds & Characters of Kana

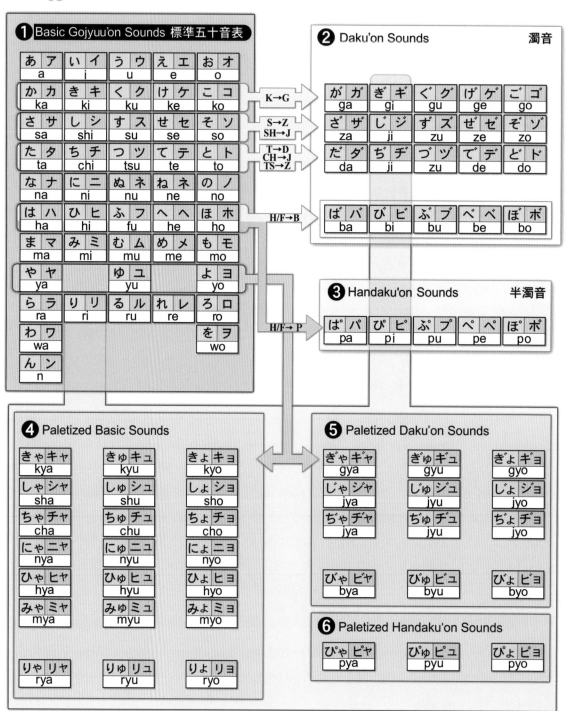

Voiced Sounds (Daku'on)

(See the section of the chart marked ❷.)

The *"daku'on"* (濁音) mark is a double tear drop that can be applied to the upper right corner of 20 of the kana coming from four rows of the basic sounds, when applied, these characters are changed into daku'on sounds. Characters from rows other that the "ka, sa, ta, ha" rows cannot use the daku'on mark.

In daku'on sounds, the consonant portion of each sound (the letter(s) in front of the vowel in the Romanized spelling) changes from a non-voiced sound into a voiced sound. The yellow arrows in the chart show the specific sound changes.

Half-Voiced Sounds (Handaku'on)

(See the section of the chart marked ❸.)

Notice that one row of five sounds from the basic 46 sounds can become *"handaku'on"* (半濁音) sounds by the addition of a small circle to the upper right side of the character.

In handaku'on sounds, all consonants change to the "p" sound as indicated by the green arrow.

Vowel Palatalization

(See the sections of the chart marked ❹, ❺, and ❻.)

Of the 46 basic sounds, the sounds that end in "i" can be palatalized, meaning they can have their "i" vowel sound replaced with one of the palatal sounds, the "ya", "yu", or "yo" sounds from the 8th row of the basic chart. This results in a mixed sound that is pronounced as one unit.

The "palate" refers to the roof of the mouth, the area where the sides of the tongue make contact when the "y" sound is pronounced.

The symbols that are mixed come from the second columns of chart areas ❶, ❷, and ❸ (under the blue bar), and are mixed with the "ya", "yu", or "yo" sounds (pink bar) resulting in the palatalized sounds of section ❹. Sections ❺ and ❻ are the palatalized daku'on and handaku'on sounds (purple).

Geminate Sounds

When written in Roman letters, some Japanese words have a double consonant, like the "-pp-" in the word "happyou" (発表). This doesn't seem possible considering there are no kana characters that end in the consonant "p", or any other consonant, nor are there any double consonant kana characters. And the only single letter consonant available to add to the end of another sound is the "n" (ん) sound.

Double consonants, or geminate sounds, are the result of certain natural sound combinations in some multiple-kanji words that are intentionally pronounced and written in a slightly different way. Look closely at the Romanization of the kanji characters in the following two examples:

DOUBLE STOP				DOUBLE FRICATIVE			
発 +	行 =	発行	発行	抜 +	歯 =	抜歯	抜歯
はつ	こう	はつこう	はっこう	ばつ	し	ばつし	ばっし
hatsu	kou	hatsukou	hakkou	batsu	shi	batsushi	basshi

When the つ symbol changes to a small つ, in lieu of its sound, the consonant sound of the next symbol is doubled. This creates either a double stop or a double fricative sound.

In both cases, the "tsu" sound at the end of the first syllable is changed to a small "tsu" (つ) causing the first sound of the next character to be doubled. This usually happens when the "tsu" sound is immediately prior to one of the fricative consonants ("ch-", "s-", "sh-") or a stop consonant sound ("k-", "t-", "b-", "p-"). These are called *"soku'on"* (促音) sounds.

Though the combinations mentioned generally result in the geminate sound being used, this is not always true.

OTHER SOUND CHANGES AND WRITING VARIATIONS

There are a number of other writing and sound changes that occur in Japanese. I will briefly explain the major ones so you can understand how various changes in the sound of a word can take place.

Long Vowels

A very common variation in the basic sounds is to turn short vowel sounds into long vowels, or *"choubo'in"* (長母音). The concept of short and long vowels in

Japanese is very different than in English.

Japanese is what is called a mora timed language. Basically, that means that the sounds represented by the individual characters and character combinations on the kana sound chart are pronounced for one beat. Short sounds that are pronounced for a single beat are one mora long.

So a long vowel sound is a vowel that consists of two characters and is merely pronounced for twice as long as a short vowel.

For example, the short "o" sound in the word *"okami"* is very similar to the "o" sound in the word *"over"*. In comparison, the long vowel "oo" in the word *"ookii"* is closer to the "-o o-" in the phrase *"n<u>o</u> <u>o</u>ver night parking"*, which is different than *"nover night parking"*.

Sometimes, as in the example above, the same vowel is repeated twice as a double vowel. This happens often in Japanese words. And word meanings are highly dependent upon the correct length vowel, so incorrectly pronouncing a long vowel as a short, or vice versa, may confuse the listener.

In other cases, long vowels are compound vowels that consist of two different sounds, like the "ei" at the end of *"sensei"*. See the chart on the right for a list of common long vowels and how to pronounce them.

To write a compound vowel in hiragana you simply write both characters, "ei" is えい, for example. Double (repeated) long vowels are written in the same way. The long "oo" is written おお, for example.

In katakana the rule is slightly different for repeating the same vowel. A double (repeated) long vowel is written followed by a long hyphen (ー). Long "oo" is written オー, long "ee" is written イー, and so on. If the vowels are different, both characters are simply written in succession.

The dash (ー) is not used to extend vowel sounds in hiragana.

Small Characters

Other than the soku'on "tsu" つ that was explained earlier, other characters may occasionally appear in small size, as well, usually, in katakana.

Katakana is used to write words of foreign origin, or *"gairaigo"* (外来語), which often contain sound sequences that are not found in native Japanese words. To make these non-Japanese sound combinations, it may use small characters mixed in with regular sized ones.

The classic example is the combination ティ or ティー which is often used to

Pronouncing the Sounds of Japanese

SIMPLE SHORT VOWELS			
Roman letters	pronounce like		
a	*a*	in	*father*
i	*i*	in	*tiki*
u	*ue*	in	*blue*
e	*e*	in	*egg*
o[1]	*o*	in	*corn*

COMMON LONG (DUAL) VOWELS			
Roman letters	pronounce like		
ai	*y*	in	*my*
ae	*a e*	in	*plaza exit*
au	*ow*	in	*now*
ao	*aw o*	in	*saw over*
ie	*ee e*	in	*three eggs*
ue	*o e*	in	*do everything*
ei	*ay*	in	*may*
oo	*ow o*	in	*throw over*
ou	*ow*	in	*know*

CONSONANTS			
Roman letters	pronounce like		
k	*c*	in	*cat*
g	*g*	in	*get*
s	*s*	in	*say*
z[2]	*ds*	in	*words*
t	*t*	in	*talk*
tsu[3]	*ts*	in	*its*
d	*d*	in	*dog*
n	*n*	in	*not*
h	*h*	in	*have*
f[4]	*f*	in	*for*
m	*m*	in	*many*
y	*y*	in	*yam*
r[5]	*r*	in	the Spanish *riviera*
w	*w*	in	*way*

See the text below for details on notes 1 - 5.

NOTES ON PRONUNCIATION

Note 1: The Japanese "o" sound is similar to the first part of the English long "o" sound, but without the rounded off "u" sound on the end of the American pronunciation. Long "o" words like *"rope, boat"*, and *"hope"* sound like a combination of the Japanese "o" sound followed by the "u" sound. For example, say the English word *"tow"*. Then say it again, but this time stop before you get to the sound change attributed to the "w" at the end. This "to-" is very similar to the Japanese "o".

Note 2: The "z" is very short and not slowly blended to other sounds like the English "z". The Romanized "ze" is pronounced similar to the *"-ds e-"* in *"wor<u>ds e</u>verywhere"*.

Note 3: The Japanese "tsu" is the only kana sound with the "ts" sound combination. This may seem difficult, but is very close to the "ts" on the end of "that's".

Note 4: The "f" sound only occurs in Japanese words using the "fu" combination. This "f" sound is unlike in English where the teeth touch the lips. The Japanese "f" is very gentle with the lips pursed as if one were blowing into a flute.

Note 5: The Japanese "r" is a flapped "r" as in Spanish with the tongue making contact with the roof of the mouth. In this respect, the Japanese "r" may sound more like an English "d". The Japanese word for "next month" is Romanized as *"raigetsu"*, though many beginners pronounce it more accurately when spelled *"daigetsu"*.

produce the *"tea"* sound of the word *"teacher"*. If you refer back to the chart of basic sounds, you'll notice that the Japanese language does not have this sound. It's not that no one can pronounce it, it just means that there is no character to write it. So the ティ combination serves the purpose.

Most of the sounds of gojyuu'on are consistent with the convention of matching a single consonant with all five vowels per group but there are exceptions and missing sounds.

Page 17 shows some other unusual combinations found in katakana.

Sequential Voicing (Rendaku)

The term *"rendaku"* (連濁) refers to sound changes that sometimes take place when two kanji characters (or other words) are pronounced in a sequence as a single word. Generally speaking, in words comprised of two kanji characters, rendaku sometimes causes the second character to be pronounced as a voiced (daku'on) sound.

For example:
no rendaku	kata + kana = katakana	(no change)
rendaku	hira + kana = hiragana	(k changed to 'voiced' g)

Linguists have been unable to establish a definitive rule as to why some sounds change and some don't. It seems to be a matter of phonological weight.

You don't have to understand it how it works unless you are creating new kanji combinations and new words. But you should understand that sometime the second character takes on the daku'on pronunciation because of rendaku.

PRONOUNCING JAPANESE SOUNDS

When learning a foreign language, using the correct sounds is very important. So for foreign students learning Japanese, correctly pronouncing the sounds of gojyuu'on is necessary to make oneself understood.

Naturally, learning all of the sounds takes a little time and practice. If possible, you should listen to the pronunciation of native speakers. There are many CDs and internet resources available to the students who want to work on pronunciation. Or even better, you could make some Japanese friends.

As a simplified guide to get started with, the chart on the left will give you a general idea of what Japanese sounds like.

THE REPEAT SYMBOL

There are many Japanese words that repeat a kanji character twice in a row, such as (人人), which is normally written with the repeat symbol in place of the second character (人々). This often results in a rendaku pronunciation for the repeated half of the word.

For example:
人々	ひとびと	hitobito	people
時々	ときどき	tokidoki	sometimes, occasionally
日々	ひび	hibi	days

ROMANIZATION METHODS

Romanization is the process of converting Japanese language sounds into a Roman letter alphabet spelling. There are about five or six main Romanization methods that have been developed over the years. The method most commonly used in Japanese-English dictionaries is the Hepburn method, however, readers with a limited understanding of it frequently mispronounce the Japanese vowels.

Japanese methods, such as *"Nihon-Shiki"* and *"Kunrei-Shiki"*, more accurately show the kana vowel content, but their use of the English consonants is poor and tends to cause English speakers to mispronounce them, as well.

For the sake of simplicity, I have decided to use a direct kana-Romaji transcription method. The kana chart on page 10 shows each kana character and the Romaji used in this book.

PRACTICING KANA

The next four pages have charts showing the correct way to write the basic hiragana and katakana characters. Be sure to following the correct stroke order according to the numbers.

While practicing, you should write each character about five to ten times while reciting it's sound. This will help you associate the written character with its name (sound) more quickly.

HIRAGANA

HIRAGANA DESCRIPTION

The chart on these two pages shows the 46 basic characters of gojyuu'on shown in hiragana characters. Hiragana is one of the two phonetic scripts comprising the kana writing system that is used to write the Japanese language. Some of these characters can be modified using either daku'on or handaku'on marks, and some can be grouped into various combinations. All of the main variations and combinations are shown on the chart on page 10.

CHARACTERISTICS

Hiragana are characterized by graceful strokes written with a continuous flowing style.

HOW TO USE THESE CHARTS

Study these charts closely when practicing the hiragana characters. Memorize the shape and spacial balance of each character and be sure to follow the stroke order numbers in sequence.

<u>FOLLOWING THE KANA ALPHABET ORDER</u>: You should practice writing these characters in the same order that they are recited in the kana alphabet. To do so, start at the top left (あ) and go down to (お). Continue at the top of the next column (か) and go down to (こ). Continue this pattern across the page to write them in the proper order.

<u>STROKE ORDER</u>: Be sure to follow the numbers shown in each block when writing individual characters in order to write them correctly. This is called *"stroke order"*, and is very important when writing kana, as well as kanji. The dotted lines show the brush's path when it's not touching the paper.

HISTORY

The hiragana script was developed around the 8th century, alongside the katakana script. At the time, it was called *"onnade"* (女手), or women's writing, and was considered to be the feminine version of katakana, the masculine script. See page 8 for more information about the history of kana.

MODERN USAGE

Any word of Japanese origin <u>can</u> be written in hiragana, but many are written in kanji according to historical use. Words that are normally written in hiragana include: Japanese words with no kanji assigned to them; the grammatical markers in a sentence, called particles (は after the subject and が or を after the object); and the kunyomi pronunciation of kanji characters in kanji dictionaries.

Nouns may be written in hiragana, but normally they're not if a kanji character is available. Most verbs, adjectives, and adverbs take the *"okurigana"* form, as explained below.

<u>OKURIGANA ENDINGS</u>

Many Japanese verbs are formed with a kanji character as the word's root, followed by one or more hiragana characters which provide either the tense, form, or level of politeness. Hiragana used in this way is called *"okurigana"* (送り仮名). An example is the word "go" (行く *iku*). (Okurigana in red.) Some okurigana variations include: (going 行っている *itteiru*), (want to go 行きたい *ikitai*), (went [informal] 行った *itta*), (went [polite] 行きました *ikimashita*). A example for adjectives and adverbs is the word "proper", (正しい *tadashii*), which becomes the adverb "properly", (正しく *tadashiku*).

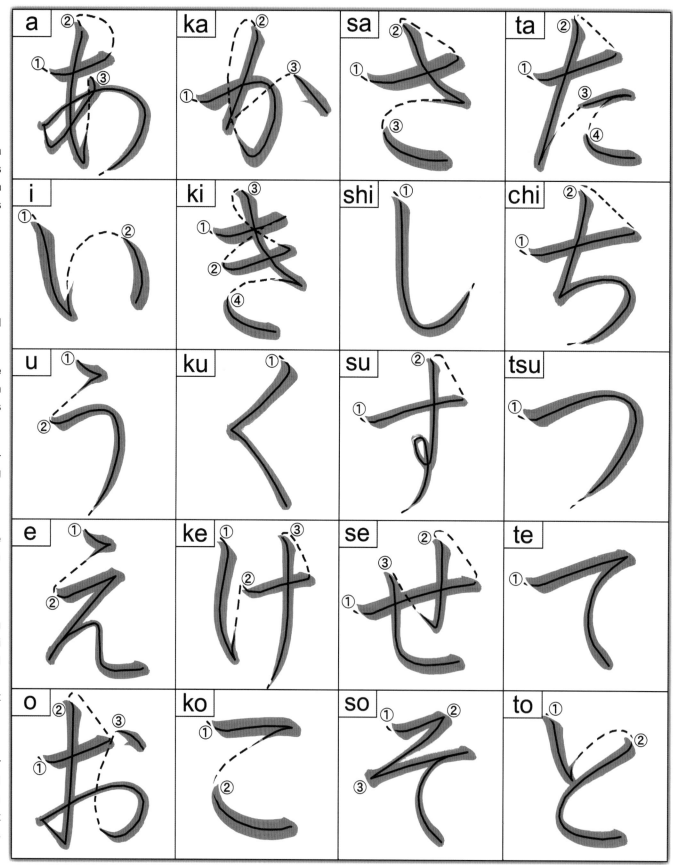

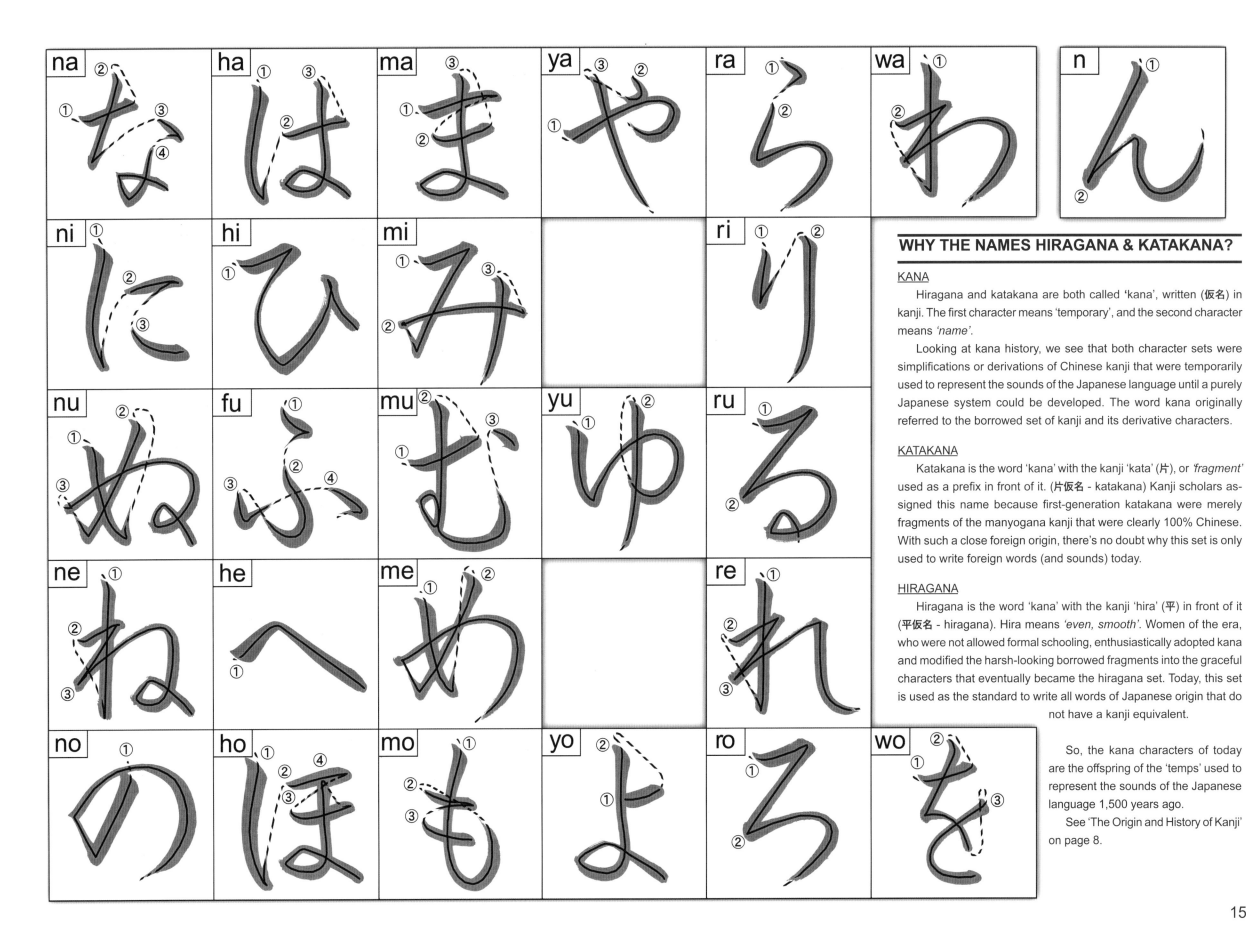

WHY THE NAMES HIRAGANA & KATAKANA?

KANA

Hiragana and katakana are both called 'kana', written (仮名) in kanji. The first character means 'temporary', and the second character means *'name'*.

Looking at kana history, we see that both character sets were simplifications or derivations of Chinese kanji that were temporarily used to represent the sounds of the Japanese language until a purely Japanese system could be developed. The word kana originally referred to the borrowed set of kanji and its derivative characters.

KATAKANA

Katakana is the word 'kana' with the kanji 'kata' (片), or *'fragment'* used as a prefix in front of it. (片仮名 - katakana) Kanji scholars assigned this name because first-generation katakana were merely fragments of the manyogana kanji that were clearly 100% Chinese. With such a close foreign origin, there's no doubt why this set is only used to write foreign words (and sounds) today.

HIRAGANA

Hiragana is the word 'kana' with the kanji 'hira' (平) in front of it (平仮名 - hiragana). Hira means *'even, smooth'*. Women of the era, who were not allowed formal schooling, enthusiastically adopted kana and modified the harsh-looking borrowed fragments into the graceful characters that eventually became the hiragana set. Today, this set is used as the standard to write all words of Japanese origin that do not have a kanji equivalent.

So, the kana characters of today are the offspring of the 'temps' used to represent the sounds of the Japanese language 1,500 years ago.

See 'The Origin and History of Kanji' on page 8.

HIRAGANA DESCRIPTION

The chart on these two pages shows the 46 basic "gojyu'uon" written in the phonetic katakana script. Most of the main variations and combinations are shown on the chart on page 10, but a few unusual ones are show in the insert on page 17.

STYLE

Katakana is characterized by mostly straight lines that are written in a bold style.

HOW TO USE THESE CHARTS

See page 14 for details.

HISTORY

Developed around the 8th century, katakana characters are (originally) derived from a very small set of Chinese kanji that were borrowed by Japanese for their sound. This set, eventually called manyogana, was used to mimic the sounds of the Japanese language. Each of the katakana characters is single fragment of the original Chinese character from which is was derived. (See the chart on page 8.) Katakana is the masculine complement to hiragana.

MODERN USAGE

Katakana is typically used to write foreign words that are not of Chinese origin, such as those from English and other European languages. (Words of Chinese origin are written with kanji.) It is also used to express animal or human emotional sounds; as heading markers in alphabetical lists; and also to place special emphasis on Japanese words within a context.

FURIGANA

Katakana characters are called furigana when they are used to show how a word or character is pronounced. Furigana is often used to show the pronunciation of:

1) words written in a foreign language script,

2) the onyomi pronunciation of kanji in kanji dictionaries,

3) proper nouns, like peoples names and the names of places. This is necessary for two reasons. One is that many of the kanji characters used in proper nouns are no longer taught in public schools. The other reason is that a proper name written in kanji characters may have two or three different pronunciations because most characters have multiple pronunciations. (Unlike most common nouns, the names of things, for example, when written in kanji usually have only one commonly used pronunciation. But, this is not true for proper nouns. So even a Japanese may look at another Japanese person's name and not be sure how to pronounce it.)

OKURIGANA ENDINGS

Katakana is not typically used for okurigana in modern writing.

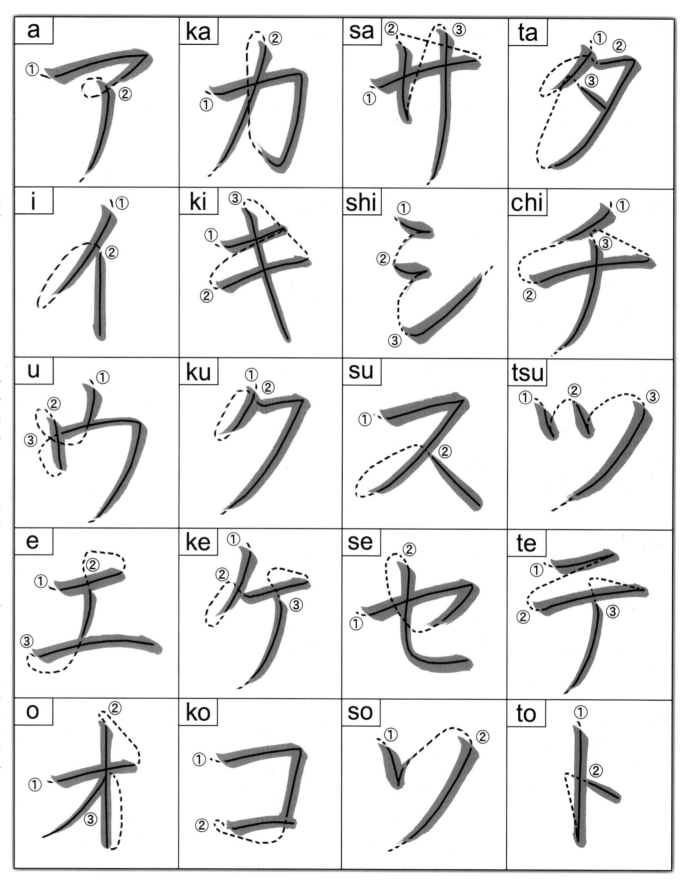

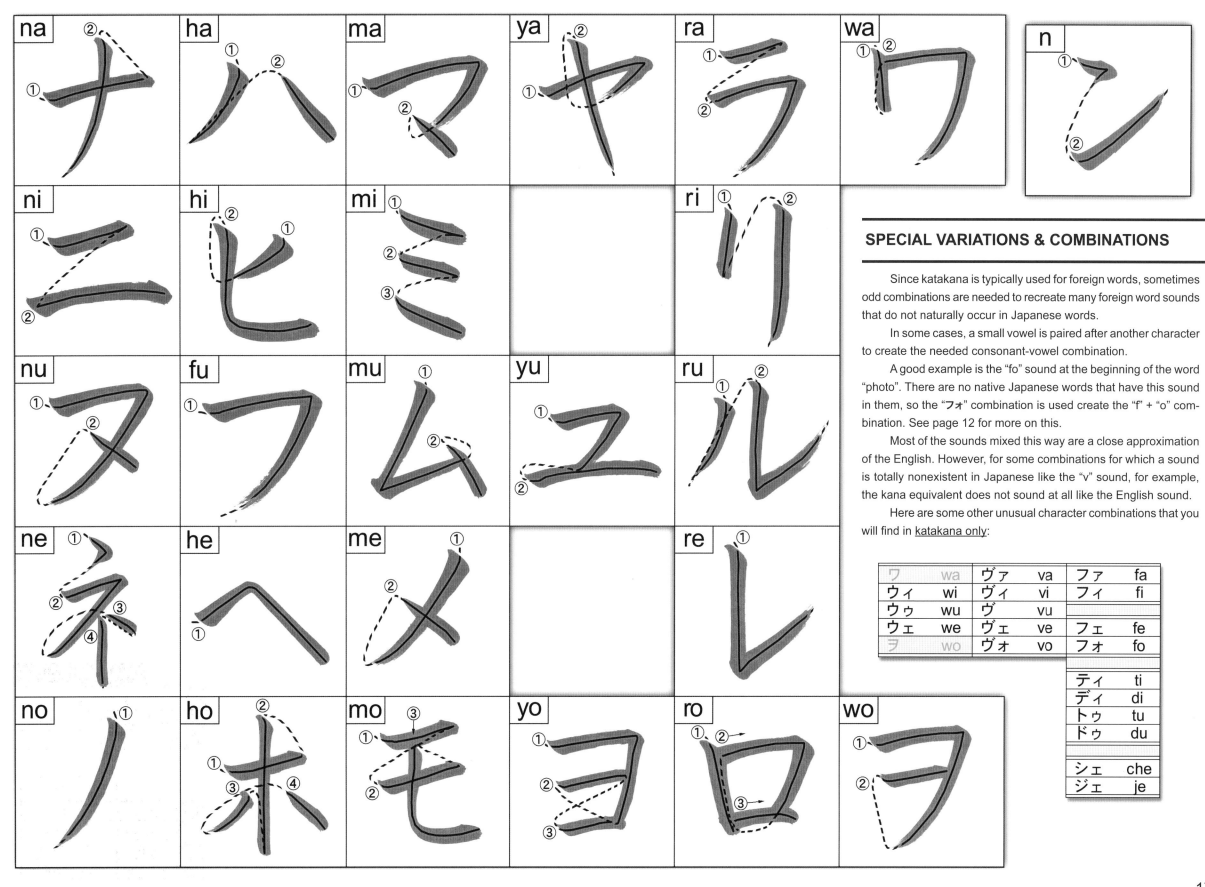

SPECIAL VARIATIONS & COMBINATIONS

Since katakana is typically used for foreign words, sometimes odd combinations are needed to recreate many foreign word sounds that do not naturally occur in Japanese words.

In some cases, a small vowel is paired after another character to create the needed consonant-vowel combination.

A good example is the "fo" sound at the beginning of the word "photo". There are no native Japanese words that have this sound in them, so the "フォ" combination is used create the "f" + "o" combination. See page 12 for more on this.

Most of the sounds mixed this way are a close approximation of the English. However, for some combinations for which a sound is totally nonexistent in Japanese like the "v" sound, for example, the kana equivalent does not sound at all like the English sound.

Here are some other unusual character combinations that you will find in <u>katakana only</u>:

ワ	wa	ヴァ	va	ファ	fa
ウィ	wi	ヴィ	vi	フィ	fi
ウゥ	wu	ヴ	vu		
ウェ	we	ヴェ	ve	フェ	fe
ヲ	wo	ヴォ	vo	フォ	fo
				ティ	ti
				ディ	di
				トゥ	tu
				ドゥ	du
				シェ	che
				ジェ	je

THE STRUCTURE OF KANJI

FORWARD

The information on the next four pages is not typically found in most calligraphy books and not necessary to begin learning to write kanji calligraphy. However, I've decided to include it because it will give the reader a much needed understanding of the fundamental structure of kanji.

The essential skill of calligraphy is to mentally visualize the complex structures of a kanji character, then to render them in a balanced manner using a brush. Thus, an understanding of kanji structure puts you far ahead of most beginners who write as if they were blindly following a maze.

To the untrained eye, individual kanji characters may at first look like a jumble of unique abstract lines. But, in fact, all kanji characters use a finite set of building-block components that are arranged into specific geometric patterns.

To refresh our memory on how various bits and pieces of language are used to put words together, let's first review the elements of written English, then compare them to the elements of kanji.

BUILDING BLOCKS OF ENGLISH

Modern written English uses the Roman alphabet, which consists of 26 letters, along with mathematical, logical, numerical, and other symbols.

First, let's divide all writing into three classes that I will call level-1, level-2, and level-3.

Level-1 elements are the rudimentary bits and pieces of written communication that have a function in the construction process, but do not have any further meaning or use. In English, the Roman letters and a number of other symbols fall into this category.

Level-2 components are intermediate structures that function to hold the major level-3 structures together, but are not used alone. Portions of words like prefixes, word roots, and suffixes fall into level-2.

Level-3 are words that can function in a sentence that are independent of other level-1 and 2 bits and pieces.

Level-1 Elements: Letters & Other Characters

The basic unit of written English is the letter. Since fragments of letters are not identifiable by themselves, I will say that the 26 letters of the Roman alphabet are the basic units of writing.

Of the 26 Roman letters, only the letters *"a"* (when used to mean *"one"* or *"any"*) and *"I"* can function as single words. These are the only level-1 elements that can also used as independent level-3 words. All the other letters are level-1 only.

In addition to the Roman letters, written English also uses Arabic numerals (1, 2, 3 etc.) and other symbols such as *"&"* and *"%"* that represent individual words, these elements, like the word *"a"*, are functional level-3 objects, as well.

Level-2 Components: Word Roots & Affixes

Without getting deeply into etymology and morphology, you may recall that English words are made of components called prefixes, roots, and suffixes.

Prefixes like *"de-"* and *"im-"*, for example, are word-fragments that are attached to the front of a word-root, or stem, that change its meaning.

Though some prefixes like: *"under-, over-, counter-"* can also be used independently as level-3 words, most of them are merely intermediate-level components used to build words.

Spelling is easier because of word fragments that we use over and over again. Writing long words like *"de•part•ment•al•ize"* or *"inter•nation•al•izatio n"* is like assembling pre-built components into a

PREFIX	ROOT	
	port	part
de-	deport	depart
im-	import	impart

SUFFIX	import
-able	importable
-ation	importation
-ant	important
-ance	importance

whole, and it also makes it possible for us to guess the meaning of long words when hearing them for the first time.

Level-3 Structures: Independent Words

Words are complete units of meaning, usable at the sentence level, that are made from a combination of level-1 elements, level-2 components, and in many cases, other words.

To be able to structurally analyze English words you must know 26 level-1 elements and thousands of prefixes, roots, and suffixes. If you do, you can not only split words into syllables, you can also guess the meaning of nearly any English word.

As different as it may appear to the beginner, written kanji is very similar in some ways, yet strikingly different in others.

THE BUILDING BLOCKS OF KANJI

In contrast to the 26 elements of English, Kanji uses only 8 level-1 symbols, called the basic brush strokes, that are used to build 214 level-2 components which act like prefixes, roots, and suffixes. These components are then combined in various patterns to form thousands of level-3 kanji characters.

To structurally analyze the thousands of level-3 kanji characters you must know the 8 level-1 elements and the 214 level-2 components.

Unlike English, a structural analysis of a given kanji character's components may or may not provide any hints as to its pronunciation or meaning.

Level-1 Elements: The Strokes

The most fundamental element of written kanji is the single brush stroke of which there are *eight basic strokes* and a number of variations. Each stroke is a single coordinated brush movement from the point the brush tip touches the paper until it's removed.

Only one of the 8 strokes, *"ichi"* (一) which means *"one"*, can be used independently as a level-3 word. All of the other basic strokes are mere building-block elements that are used to build level-2 and level-3 structures.

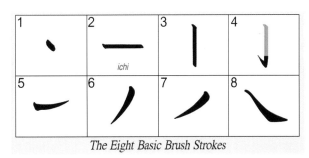

The Eight Basic Brush Strokes

These eight strokes were first defined as the basis of kanji in ancient Chinese writing called "The Eight Ways of Eternity". The symbol for *"eternity"* was used because it contains all eight of the basic strokes.

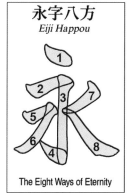

永字八方
Eiji Happou

The Eight Ways of Eternity

Level-2 Components: Radicals

The level-2 structure is called the radical. There are 214 radicals that play a very important role as the building blocks of kanji.

Of the 214 level-2 radicals, 134 of them are used as *fully* independent level-3 kanji characters in Japanese, and many of those are very common characters.

For students, learning to recognize the radicals as soon as possible will help you remember new characters much quicker. It will also help you memorize the stroke order of characters you see for the first time.

See the radical chart on page 20.

Radical Variations

Some radicals change their shape or stroke count when occurring in specific pattern positions inside of a kanji character. The radical chart on page 20 shows the major variations for each radical in commonly used positions.

Level-3 Structures: Kanji Characters

Effectively speaking, kanji characters are words that can be used independently in a sentence. Level-3 structures may be build in several ways, here are some of the possible combinations:

1) A single level-1 basic stroke. (Only 1 character) [一]
2*) A combination of two level-1 strokes. (14 characters) [二 人 入 八 刀 カ 十 又 七 九 丁 了 之]
 The blue characters are also defined as a radicals.
3) A level-2 radical alone. (About 134 characters) [二 人 入 八 刀 カ 十 又 口 土 士 夕 大 女 子 寸 小 山 川 工 己 巾 干 心 戸 手 支 etc.]
4) Level-1 stroke(s) and a level-2 radical mixed. (Uncounted) [天 旦 旧 刃 勺 凡 主 系 etc.]
5) A combination of level-2 radicals. (Uncounted) [寺 件 林 筆 昏 料 相 雰 etc.]
6) A combination of level-3 characters. (Uncounted) [時 梅 晴 鋸 声 肩 韻 etc.]

From this point on, I will refer to level-3 kanji as simply, kanji.
Anything less I will call either a stroke, a combination of strokes, or a radical.

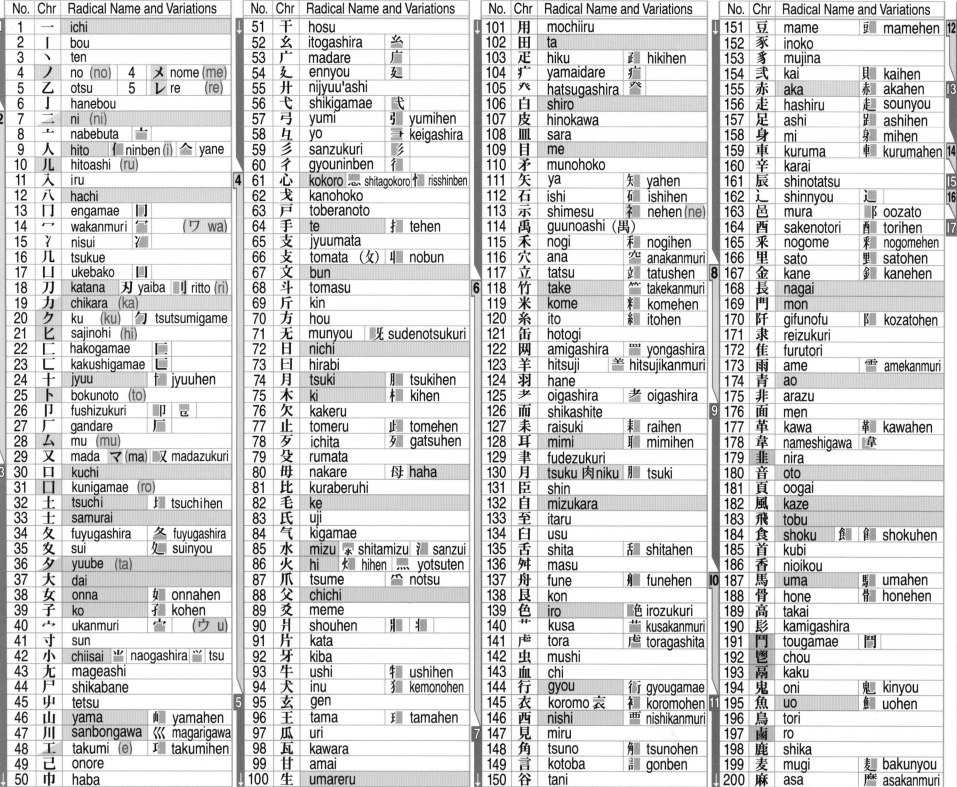

No.	Chr	Radical Name and Variations			
1	一	ichi			
2	丨	bou			
3	丶	ten			
4	丿	no (no)	4	乂	nome (me)
5	乙	otsu	5	乚	re (re)
6	亅	hanebou			
7	二	ni (ni)			
8	亠	nabebuta 亠			
9	人	hito 亻 ninben (i) 𠆢 yane			
10	儿	hitoashi (ru)			
11	入	iru			
12	八	hachi			
13	冂	engamae 冂			
14	冖	wakanmuri 冖 (ワ wa)			
15	冫	nisui			
16	几	tsukue			
17	凵	ukebako 凵			
18	刀	katana 刃 yaiba 刂 ritto (ri)			
19	力	chikara (ka)			
20	勹	ku (ku) 勹 tsutsumigame			
21	匕	sajinohi (hi)			
22	匚	hakogamae			
23	匸	kakushigamae			
24	十	jyuu 十 jyuuhen			
25	卜	bokunoto (to)			
26	卩	fushizukuri			
27	厂	gandare 厂			
28	厶	mu (mu)			
29	又	mada マ(ma) 又 madazukuri			
30	口	kuchi			
31	囗	kunigamae (ro)			
32	土	tsuchi 圵 tsuchihen			
33	士	samurai			
34	夂	fuyugashira 夂 fuyugashira			
35	夊	sui 夊 suinyou			
36	夕	yuube (ta)			
37	大	dai			
38	女	onna 女 onnahen			
39	子	ko 孑 kohen			
40	宀	ukanmuri 宀 (ウ u)			
41	寸	sun			
42	小	chiisai 光 naogashira 小 tsu			
43	尢	mageashi			
44	尸	shikabane			
45	屮	tetsu			
46	山	yama 山 yamahen			
47	川	sanbongawa 巛 magarigawa			
48	工	takumi (e) 工 takumihen			
49	己	onore			
50	巾	haba			

No.	Chr	Radical Name and Variations		
51	干	hosu		
52	幺	itogashira 幺		
53	广	madare 广		
54	廴	ennyou 廴		
55	廾	nijyuu'ashi		
56	弋	shikigamae 弋		
57	弓	yumi 弓 yumihen		
58	彐	yo 彐 keigashira		
59	彡	sanzukuri 彡		
60	彳	gyouninben 彳		
61	心	kokoro 忄 shitagokoro 忄 risshinben		
62	戈	kanohoko		
63	戸	toberanoto		
64	手	te 扌 tehen		
65	支	jyuumata		
66	攴	tomata (攵) 攵 nobun		
67	文	bun		
68	斗	tomasu		
69	斤	kin		
70	方	hou		
71	无	munyou 旡 sudenotsukuri		
72	日	nichi		
73	曰	hirabi		
74	月	tsuki 月 tsukihen		
75	木	ki 朩 kihen		
76	欠	kakeru		
77	止	tomeru 止 tomehen		
78	歹	ichita 歹 gatsuhen		
79	殳	rumata		
80	毋	nakare 母 haha		
81	比	kuraberuhi		
82	毛	ke		
83	氏	uji		
84	气	kigamae		
85	水	mizu 氺 shitamizu 氵 sanzui		
86	火	hi 火 hihen 灬 yotsuten		
87	爪	tsume 爫 notsu		
88	父	chichi		
89	爻	meme		
90	爿	shouhen 爿		
91	片	kata		
92	牙	kiba		
93	牛	ushi 牜 ushihen		
94	犬	inu 犭 kemonohen		
95	玄	gen		
96	王	tama 𤤽 tamahen		
97	瓜	uri		
98	瓦	kawara		
99	甘	amai		
100	生	umareru		

No.	Chr	Radical Name and Variations		
101	用	mochiiru		
102	田	ta		
103	疋	hiku 疋 hikihen		
104	疒	yamaidare 疒		
105	癶	hatsugashira 癶		
106	白	shiro		
107	皮	hinokawa		
108	皿	sara		
109	目	me		
110	矛	munohoko		
111	矢	ya 矢 yahen		
112	石	ishi 石 ishihen		
113	示	shimesu 礻 nehen (ne)		
114	禸	guunoashi (禹)		
115	禾	nogi 禾 nogihen		
116	穴	ana 穴 anakanmuri		
117	立	tatsu 立 tatushen		
118	竹	take 竹 takekanmuri		
119	米	kome 米 komehen		
120	糸	ito 糸 itohen		
121	缶	hotogi		
122	网	amigashira 罒 yongashira		
123	羊	hitsuji 羊 hitsujikanmuri		
124	羽	hane		
125	老	oigashira 耂 oigashira		
126	而	shikashite		
127	耒	raisuki 耒 raihen		
128	耳	mimi 耳 mimihen		
129	聿	fudezukuri		
130	肉	tsuku 肉 niku 月 tsuki		
131	臣	shin		
132	自	mizukara		
133	至	itaru		
134	臼	usu		
135	舌	shita 舌 shitahen		
136	舛	masu		
137	舟	fune 舟 funehen		
138	艮	kon		
139	色	iro 色 irozukuri		
140	艸	kusa 艹 kusakanmuri		
141	虍	tora 虍 toragashita		
142	虫	mushi		
143	血	chi		
144	行	gyou 行 gyougamae		
145	衣	koromo 衣 礻 koromohen		
146	西	nishi 覀 nishikanmuri		
147	見	miru		
148	角	tsuno 角 tsunohen		
149	言	kotoba 訁 gonben		
150	谷	tani		

No.	Chr	Radical Name and Variations		
151	豆	mame 豆 mamehen		
152	豕	inoko		
153	豸	mujina		
154	貝	kai 貝 kaihen		
155	赤	aka 赤 akahen		
156	走	hashiru 走 sounyou		
157	足	ashi 足 ashihen		
158	身	mi 身 mihen		
159	車	kuruma 車 kurumahen		
160	辛	karai		
161	辰	shinotatsu		
162	辵	shinnyou 辶		
163	邑	mura 阝 oozato		
164	酉	sakenotori 酉 torihen		
165	釆	nogome 釆 nogomehen		
166	里	sato 里 satohen		
167	金	kane 金 kanehen		
168	長	nagai		
169	門	mon		
170	阜	gifunofu 阝 kozatohen		
171	隶	reizukuri		
172	隹	furutori		
173	雨	ame 雨 amekanmuri		
174	青	ao		
175	非	arazu		
176	面	men		
177	革	kawa 革 kawahen		
178	韋	nameshigawa 韋		
179	韭	nira		
180	音	oto		
181	頁	oogai		
182	風	kaze		
183	飛	tobu		
184	食	shoku 食 飠 shokuhen		
185	首	kubi		
186	香	nioikou		
187	馬	uma 馬 umahen		
188	骨	hone 骨 honehen		
189	高	takai		
190	髟	kamigashira		
191	鬥	tougamae 鬥		
192	鬯	chou		
193	鬲	kaku		
194	鬼	oni 鬼 kinyou		
195	魚	uo 魚 uohen		
196	鳥	tori		
197	鹵	ro		
198	鹿	shika		
199	麦	mugi 麦 bakunyou		
200	麻	asa 麻 asakanmuri		

No.	Chr	Radical Name and Variations		
201	黄	kiiro		
202	黍	kibi		
203	黒	kuro		
204	黹	futsu		
205	黽	ben		
206	鼎	kanae		
207	鼓	tsuzumi		
208	鼠	nezumi (鼠)		
209	鼻	hana		
210	齊	sei (斉)		
211	歯	ha 齒 齒 hahen		
212	竜	ryuu (龍 tatsu)		
213	亀	kame (龜)		
214	龠	yaku		

LEGEND & NOTES

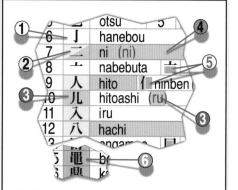

Blue bands show the official stroke count which is sometimes based on the ancient character.

① White - used as radical component only.
② Yellow - used as independent kanji also.
③ Purple - also used as katakana, name is in [].
④ Orange - listed in the library of this book.
⑤ Gray block - position for other elements when used as radical component.
⑥ Gray - either not used, in Japanese, or only occurs in a handful of nearly obsolete words.

RADICAL NAME CHANGES

All radicals are identified with a name. When a radical occurs in one of the named positions within a character, its name is often amended with the name of the position added to the end. For example, *"ito"* in the hen position becomes *"itohen"* etc. However, two types of exceptions exist. Those whose names do not change and only occur in a specific position, such as radicals 8 and 17. And those whose names already reflect the name of the only position in which they occur, such as 13, 14, 27, 31, 40, etc.

KANJI PATTERNS

Each kanji character is a unique combination of either strokes and/or radicals that are arranged in a specific pattern. Replacing any one of its components or changing its pattern completely changes its identity.

Kanji are divided into a number of geometric patterns into which the strokes and radicals of a character are arranged. Here are some common paterns:

For the beginner, seeing which pattern a kanji character uses may seem difficult at first, but after you've learned to recognize the strokes and radicals (even if you don't remember their names), you can easily see the pattern of their layout.

As a student, rather than concerning yourself with trying to memorize a large number of patterns, you should simply try to remember the pattern of each character by the unique layout of its components relative to each other.

RADICAL POSITIONS

All complex kanji characters have some type of pattern, and all patterns have at least one key position. This key radical position is used as a reference location to classify kanji characters in the *"bushu"*, or radical classification system.

Of the many patterns, the greatest majority of kanji can be divided into either a left-right pattern or a top-bottom pattern. For this reason, of the seven key positions (see the chart), the first four say 'many radicals' because there is a huge number of characters in which these key radical positions are used.

Radicals occurring in key positions often have their names changed by the addition of the position name onto the end of the radical name.

For example, when the radical #120 *"ito"*, or thread (糸), occurs in the *"hen"* position, it's name is changed to *"itohen"*. There are about 170 Japanese kanji that are classified as itohen characters (糺 紀 約 納 etc.). Note that in some cases the hen position name may change to *"-ben"* because of rendaku (see page 13), such as *"gonben"*, which is radical #149 in the hen position.

Another example is radical #118 *"take"*, or bamboo (竹), in the *"kanmuri"*, or crown position results in *"takekanmuri", or bamboo crown*. There are about 125 bamboo crown characters used in Japanese. (筆, 筋, 節, 算, 箸, etc.)

KEY RADICAL POSITIONS

Hen (-ben)	Tsukuri (-zukuri)	Kanmuri (-ganmuri) Kashira (-gashira)	Ashi	Nyou	Tare (-dare)
many radicals	many radicals	many radicals	many radicals	34/35[夂],54[廴], 162[辶],194[鬼], 199[走]	27[厂],44[尸], 53[广],104[疒], 105[癶]

Kamae (-gamae)

engamae 13 [冂] tsutsumigamae 20 [勹]	hakogamae 22 [匚] kakushigamae 23 [匸]	ukebako 17 [凵]	kunigamae 31 [囗]	shikigamae 56 [弋] kigamae 84 [气]	gyougamae 144 [行]

The name of each key position is shown in blue (daku'on pronunciation in green). Many radicals are used in the first four positions. Both 'nyou' and 'tare' positions are filled by five separate radicals each. There are six 'kamae' named positions with only 1 or 2 radicals per pattern. Note that 'ukebako' does not follow the (-gamae) naming convention, and 'gyougamae' is the only radical split into 2 pieces with other components in the middle.

A characteristic of many radicals that are also used as independent words, such as bamboo (竹), is that, as a radical component, it occurs in certain positions only. For example, bamboo occurs as a radical in the crown position only. Most of the other radicals have similar peculiarities as to which positions they may occur in.

Radicals that habitually occur in certain positions have that information listed in each row of the radical chart on the left page. Since some radicals occur in several positions, only the most common positions are listed.

Radicals for the key positions are also shown in the graphic above.

KANJI CATEGORIZATION & LOOKUP METHODS

Over the years, many systems have been devised to sort kanji into various categories that are used in kanji dictionaries. Knowledge of these methods is necessary for foreign students who are studying Japanese or Chinese kanji.

English dictionaries typically have their words arranged alphabetically according to their spelling. However, sorting Japanese kanji by the spelling of their Romanized sound creates complex problems because most characters have two

or more ways that they can be pronounced. So unless you have the various sounds of each character memorized, searching by sound spelling is not always possible.

Generally speaking, when we search for a character, we know nothing about it other than its appearance. For these reasons, kanji-specific methods are used.

The Stroke Count Method

In this method, commonly used in dictionaries for Japanese readers, the characters are placed in order according to number of brush strokes they contain. So you must be able to accurately count strokes. The difference between counting 11 strokes, verses 12 strokes, may take you hundreds of characters off in the character index.

Since a good dictionary may list well over 500 characters with 12 strokes, next, they're ordered (usually) according to the radical used in the character's key position. If you don't know which radical is in the key position, it may take you a while.

The bottom line is that counting strokes is sometimes useful, but not always.

The Bushu Method

The bushu (部首) method is a system that classifies kanji according to which radical falls into the character's key position, as explained in the previous section on patterns. The fact that most characters have several radicals can make locating characters a kanji dictionary very confusing. Also, variations in radical shapes and differences between dictionaries further complicate its use.

The SKIP Method

The SKIP method is a modern system of kanji classification designed for foreign students and researchers and is used in several excellent kanji dictionaries. It classifies characters according to a three segment number which is based on four basic patterns and simpler stroke count method. This system is probably the easiest for beginners to master. Some of my students who use this system can locate nearly any kanji character in a large dictionary in about ten seconds.

For a complete description, see Jack Halpern's *"The Kodansha Kanji Learner's Dictionary"* or the *"New English-Japanese Character Dictionary (NEJCD)"*.

Other Methods

There is a variety of other new methods that have been developed in the last few decades, but most of them require extensive knowledge of kanji and/or the radicals to be of practical use. Also, most of newer methods have not been implemented in printed dictionaries, so their usefulness is somewhat limited.

KANJI PRONUNCIATION METHODS

Japanese kanji are pronounced with the sounds of kana, so if you can pronounce the kana alphabet, you can pronounce Japanese kanji correctly.

Nearly all Japanese kanji have sounds that fall into three different categories, and some characters have as many as five or more different sounds.

Which sound one should use for any given character is determined by the type of word it is used to make.

Onyomi

The *"onyomi"* (音読み) method of reading kanji produces the kana sounds that mimic the character's original Chinese language pronunciation. In kanji dictionaries, onyomi sounds are normally written in katakana.

As a rule of thumb, the onyomi pronunciation is most often used for any word that is comprised of two or more kanji characters. The majority of these words are nouns, their adjective derivatives, and type 3 Japanese verbs. Type 3 verbs, also called irregular verbs, are two character Japanese nouns that become verbs when *"suru"* (する), or 'do', is added onto the end. For example, the noun *"shinpai"* (心配), 'anxiety', and its verb form *"shinpai suru"* (心配する), 'to worry'.

Kunyomi

The *"kunyomi"* (訓読み) method of reading kanji produces kana sounds for words that are considered to be entirely of Japanese origin. In kanji dictionaries, kunyomi sounds are normally written in hiragana.

Once again, as a general rule, the kunyomi pronunciation is most often used in words that are written with a single kanji character, or a single kanji character whose pronunciation is completed by one or more hiragana characters.

There are many nouns in this group, but most are type-1 and type-2 verbs. In these verbs, a single kanji character represents the word root, and the inflection on the end is written in hiragana. For more information about this, see the paragraph entitled "Okurigana Endings" on the hiragana chart on page 14.

Jinmeiyomi

"Jinmeiyomi" (人名読み) is the way characters are read when they are used in proper nouns -- people's names and, often, in the names of places. At times, the sounds may be the same or similar the character's onyomi or kunyomi sounds, but usually, they are not.

THE TOOLS OF CALLIGRAPHY

As with any art, having appropriate tools and knowing how to use them correctly is very important. Though the cost and quality of your tools may reflect the level of importance you place on this art, a skilled calligrapher can produce impressive results with even the most inexpensive tools.

THE BRUSH

The brush, or *"fude"* (筆), is the most important tool of the calligrapher.

Calligraphy brushes consist of two main parts; the bamboo handle called the *"fudejiku"* (筆軸), and animal hair bristles that forms the tip, or *"fudesaki"* (筆先). Though brushes come in many different sizes, their basic design and use is the same.

Brushes are selected according to the size of the characters desired, as well as artistic affect. Soft tipped brushes are better for smooth flowing lines, while brushes with stiff bristles render characters with a scratchy, brash look.

Beginning students should select a brush similar to ② in the picture, with a total length of about 10 inches (25 cm) with bristles of medium stiffness.

Brushes should always be thoroughly washed after use to be sure the ink does not dry on them.

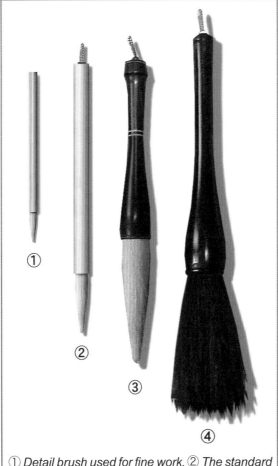

① *Detail brush used for fine work.* ② *The standard brush.* ③ *Large tipped brush with short handle.* ④ *Large brush with flared tip for creating bold effects.*

INK & INDIA INK

Traditionally, calligraphers used solid blocks or bars of ink made of lampblack. These blocks, called *"kokeizumi"* (固形墨), are preferred by many instructors because it gives the artist the ability to control the thickness of the ink. Also, the process of mixing also allows the calligrapher to reflect on ones work and slowly consider how to artistically render the next character to achieve the desired result.

The thickness of the ink should be adjusted according to the type of paper being used. It should not be so thin as to run, yet, ink that is too thick will not flow well from the brush onto the paper.

Thin ink is generally favored for cursive styles since all of the characters are written consecutively with a smooth flowing motion, but it tends to run quickly on porous paper.

Kokeizumi is seldom used by students due to its high cost and inconvenience. These days, most students use premixed bottled ink, or *"sumi"* (墨), which is inexpensive and widely available in art supply shops. Though most of these are very similar in thickness and quality, you may wish to try a variety of them to find one that matches your personal preferences.

Normally sold in beautiful boxes, kokeizumi has a much richer tone of color than bottled ink and particles in the ink leave a fine texture on the paper. This small 1" x 5" block will out last several bottles of ink.

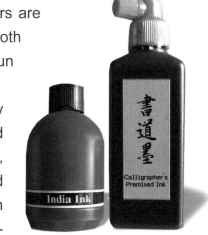

THE INK STONE

The ink stone, or *"suzuri"* (硯), is used to prime the brush and wipe off excess ink before you begin to write.

The standard design has a flat basin with an ink well at the rear, which is called the 'sea', or *"umi"* (海), and gradually shallows to a flatted area in the front, which is called the 'land', or *"riku"* (陸). Other simpler designs just have a sunken well, but are equally as functional.

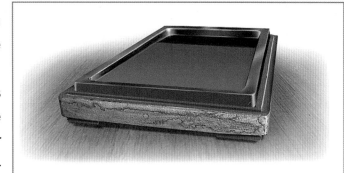

This large suzuri measures about 8" x 10" and is mounted in a wooden base and comes with a matching cover.

Suzuri made of carved stone can be expensive, so most students use modern inexpensive ones made of ceramic and other synthetic materials which is fine for bottled ink. But, if you are using kokeizumi, you should use a suzuri made of stone. Stone has a rough surface that help the kokeizumi break up into fine particles when mixing. Ceramic and other types are extremely smooth which makes dissolving the solidified ink particles a lot more difficult.

After use, the ink stone should be thoroughly washed to prevent ink from drying on the surface.

CALLIGRAPHY PAPER

Standard Japanese calligraphy paper is called *"washi"* (和紙) and comes in many sizes, colors, and qualities.

Washi paper is made in a process using the mitsumata tree, bamboo, hemp, mulberry, or a variety of other natural fibers. Generally, its fibers can be seen in the paper's grain. Because washi is much stronger than paper made from wood pulp, it is also used for origami, lanterns, umbrellas, and many other uses.

The calligrapher normally selects paper for its color, grain, roughness, and durability. The grain and roughness effects how well the ink permeates into the paper and changes the appearance of the kanji. For practice purposes, *"hanshi"* (半紙) sized paper is most commonly used due to its convenient size.

THE PAPER WEIGHT

"Bunchin" (文鎮), or paper weights, are a long thin bars used to hold the paper in place while you are writing.

Paper weights are commonly made of metal or stone and available at craft shops that carry calligraphy supplies. The bottom should be smooth so it does not damage the paper.

A single weight is normally placed at the top of the paper pior to writing.

THE BRUSH MAT

The brush mat, or *"shitajiki"* (下敷), is a thin felt mat on which the paper is placed during calligraphy work. Its purpose is to provide a soft surface on which the paper can flex while the brush moves over the surface.

THE BRUSH HOLDER

The brush holder, or *"fudemaki"* (筆巻), is a rollable mat commonly made of bamboo slats woven together. It is used to store or carry brushes in order to protect the bristles from being bent or otherwise damaged.

Unless you carry your supplies around often, the fudemaki is not an absolute necessity since most brushes come with a plastic cap that can be used to protect the bristles when they're being transported.

POSTURE AND HOLDING THE BRUSH

WRITING POSTURE

The traditional position to write calligraphy is called *"seiza"* (正座), which is seated on a mat on the floor with your back straight and erect.

However, you may also be seated in a chair or be standing when you're writing on a standard height table.

The flexibility to be able to swivel and bend at the waist is very important because you are going to use your body to write, not just your hands.

BALANCE OF THE SHOULDERS

The elbows of both arms should be pointed away from the body at about a 45° angle.

The arm of the hand that you write with is held away from the body to allow for plenty of maneuverability, while the opposite arm is held out to maintain body balance and symmetry.

USING THE BODY

When writing calligraphy, the movement of your arm muscles should account for only about half of the brush's total movement. The other half should be induced by the positioning of your body, almost as if an imaginary brush mounted on your shoulder was writing the same character in the air at half the normal size.

Calligraphy written using your body tends to be more lively and expressive than hand-only written characters.

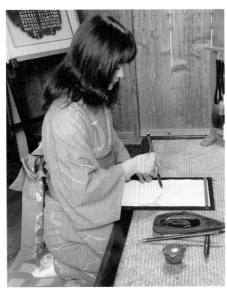

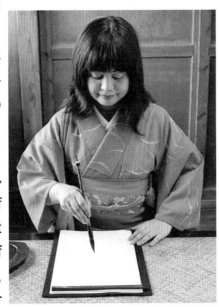

HOLDING THE BRUSH

The brush should be held between the fingers firmly and not allowed to rest on top of the hand as it does when writing with a pen or pencil. The wrist should be relatively straight and your four fingers should be slightly bent and pointing toward the tip of the brush. The thumb should be nearly straight.

The brush should be pointed down toward the paper at about an 80° to 90° angle. This angle may change slightly as the brush is pulled along the surface, but not by much.

BRUSH PRESSURE & STROKE SHAPE

As you learn to use the brush, you'll quickly find that changing the amount of pressure that you apply drastically changes the shape of the stroke that's rendered.

The brush is always, to some degree, 'floating', even when it's touching the paper. And as it floats, the calligrapher constantly adjusts the amount of pressure applied to the paper in order to achieve the desired result.

Like when using a pen, the left-right and forward-backward axises affect the path that the tip takes. But unlike the pen, the 3rd axis, which is brush pressure, changes the thickness of that path, critically affecting the shape of each stroke.

Manipulation of the brush in all three axises is necessary to render good calligraphy and involves the coordinated movement of both the body and the hand.

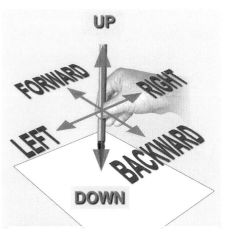

The three axises of calligraphy brush movement.

BASIC BRUSH STROKE TECHNIQUE

GENERAL

In this section you will learn some of the basic do's and don'ts about using the brush, as well as several important techniques that will make all of your brush strokes look consistent.

The method taught in this book uses eight basic strokes, but one stroke is actually a combination of strokes. This optimized group will allow you to more easily write any character you see without having to guess which strokes to use.

After reading these two pages, try to memorize the name of each of the strokes from page 28 and 29 by their characteristics, which is easy. To help you remember their names, recite the name of each stroke in your head when you practice kanji. This will help you associate the stroke sequence names with each character. For example, reciting *"horizontal, vertical, left, handle"* as you write 木 .

Before we get into the details of each particular stroke, let's first define what a stroke actually is, then we'll look to see what a stroke is made of.

THE BRUSH STROKE

Many beginning students are under the assumption that a stroke is simply a line. Well, each stroke certainly follows a line, but they are much more.

Calligraphy uses brushes and brushes make shapes, not lines. Lines are what you get when you write with a pen or a pencil.

A brush stroke is a shape that changes thickness and character as it travels along the path to creating a shape. Each brush stroke has a specific shape or outline. Naturally, the shape may be magnified or diminished by the style used or the brush size.

Love expressed with lines.	Love expressed with strokes.
愛	愛

Kanji written with mere *lines* is not calligraphy. It's handwriting.

From this point on, pay close attention to the shape of each stroke.

COMMON TRAITS OF THE 8 BASIC STROKES

When looking at any given character, we normally don't focus much attention on the appearance of individual strokes unless they stand out for some reason. But the shape and consistency of each stroke has a big impact on the way we perceive a character and using the proper technique is what produces consistent results.

Though there are a few exceptions that I will point out, most of the eight basic brush strokes have 3 segments in common: a head, a body, and a tail.

The Head

The head is the portion of a stroke where the brush first makes contact with the paper. A properly rendered head makes each stroke look more defined and also gives each stroke a sense of direction.

The manner in which the brush initially touches the paper determines the shape and orientation of the head on each stroke, so proper technique is very important.

First touch the tip and pull back to lay the bristles down on the paper at a 45 degree angle. Approximately 1/3 to 1/2 of the total length of the bristles should be laying flat on the paper. Once the brush is fully seated, then continue on to render the body.

Remember this while practicing and you will be able to consistently make nice-looking stroke heads.

Depending upon the style effect, brush stroke heads may be very pronounced or nearly imperceptible, but they should be consistent.

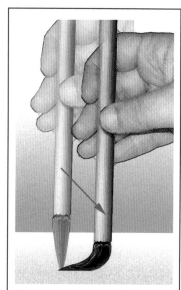

First touch the tip, then pull back at a 45° angle to lay down about 1/3 to 1/2 of the length of the bristles.

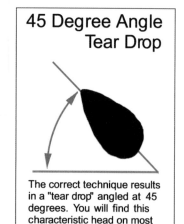

45 Degree Angle Tear Drop

The correct technique results in a "tear drop" angled at 45 degrees. You will find this characteristic head on most strokes.

The Body

The section between the head and the tail is called the body and, in the case of most strokes, is the largest part of a stroke. As such, the body carries a great deal of influence over a character's appearance.

The two things that affect the body the most are the path and the brush pressure. The path includes direction and distance, so you must take into account how the stroke fits into the space of each particular character. And the brush pressure will affect the stroke's thickness which changes as you move along the path.

Mastering the body requires close coordination between the different movements made for path and pressure. You should mentally visualize the movements you are going to make before you begin to move the brush.

The Tail

The tail is where the stroke ends and the brush is pulled away from the paper. As another main point that defines the shape of the stroke, it must be executed in a specific manner.

You may notice that different strokes may have several types of tails on them, in particularly, you may notice the four different tails on the vertical line stroke.

Tails can be generalized into three main types: plain, tapered, and styled.

The Plain Tail

The plain tail is of medium weight and does not stand out. It is rendered by simply stopping the brush at the end of the body and lifting the brush from the paper.

The plain tail is found on nearly every tear drop stroke, and most horizontal and vertical line strokes.

The Plain Tail

On the Tear Drop

On the Horizontal Line

On the Vertical Line

The Tapered Tail

The tapered tail is used at the end of nearly all left and right strokes, and is also represented by the floating needle tail on the vertical line stroke. Strokes with the tapered tail have a high degree of directionality because the head is strongly complemented by the gradually taper-

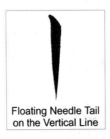

Floating Needle Tail on the Vertical Line

ing point of the tail.

To make the tapered tail, slowly decreased the amount of brush pressure from about the middle of the body. Then lift the brush tip completely away from the paper while the brush is still in motion.

Styled Tails

Of the two types of styled tails, the first one, the hooked tail, occurs quite frequently and is counted as one of the eight basic strokes. This tail is commonly found on the vertical line, the bend, and the handle stroke.

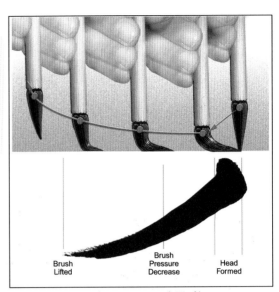

Brush Lifted Brush Pressure Decrease Head Formed

The Tapered Tail

To make the hooked tail, complete the body as if it were going to have a plain tail on it. But after coming to a stop at the end of the body, instead of lifting the brush, hook it in the desired direction while slowly lifting the brush from the paper. The lifting movement is very similar to that of the tapered tail.

The other styled tail, the iron post, is very heavy and tends to stand out as the central stroke of a character. It is not very common and only found on the vertical or horizontal line stroke.

To make the iron post, complete the body as if it were going to have a plain tail on it. Then after just barely beginning to pull the brush away a 1/16 of an inch, perhaps, reseat the brush down on the paper as if you were rendering a head on a new stroke. Then pull the brush completely away from the paper.

Styled Tails

Hooked Tail on the Horizontal Line

Iron Post Tail on the Horizontal Line

PRACTICING THE BASIC STROKES

Use the next eight pages to study and practice the basic strokes. Practice them repeatedly until you have learned the proper hand and body movements and can write them instinctively, without having to thinking about each little movement.

Mastering the basic strokes is the first step in learning kanji calligraphy. Putting them together in a balanced manner and in the correct stroke order is the next step.

TEAR DROP

The "Tear Drop" is a very short stroke that starts at 45°, has a very short body and ends with a plain tail. The body may point to the bottom left or to the bottom right, and sometime has a curve. Tear drops occur alone, or in sets of two or four.

This stroke is made by simply placing the brush tip down, then moving slightly in the desired direction, then lifting the brush.

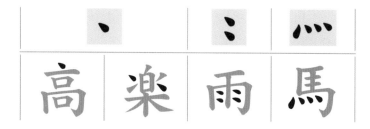

高 楽 雨 馬

VERTICAL LINE

The "Vertical Line" starts with a 45° head, continues with a straight body, and ends in one of four tails.

After taking a second to form the head, pull the body through smoothly and complete the tail.

For the plain tail, the brush is stopped and lifted gently.	For the floating needle, the brush is slowly lifted as it nears the bottom.	The iron post has a head applied to the tail of a stroke.	The hooked tail is the hook stroke added onto the tail.
論	用	木	水
Plain Tail	Floating Needle	Iron Post	Hooked Tail

HORIZONTAL LINE

The "Horizontal Line" has a 45° head, a relatively straight body, and a plain tail. Both the head and tail may be either pronounced or subtle. The body can be straight or may be slightly angled. If angled, all other horizonal lines are generally angled, also.

After forming the head, pull the body through smoothly and complete the tail.

The classic horizontal line has a 45° head and tail.

義	義	義
Straight	Angled	Converging

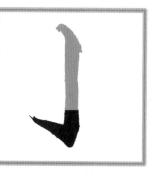

HOOK STROKE

The "Hook Stroke" is a partial stroke because it has no head or body of its own. It is applied to the tail of other basic strokes to modify their appearance. It can also hook left or hook right depending upon the stroke it's connected to. The most common hooks are shown below.

To add a hooked tail to another stroke, first plan where to end the body. When you reach the point where the hook starts, after a momentary pause turn up in the desired direction while lifting the brush away from the paper.

Left-Hooked Vertical Line	Left-Hooked Right Bend	Right-Hooked Handle
⅃ 水	フ 却	㇄ 式

BEND STROKE

The "Bend Stroke" is a line that suddenly bends 90° or greater. There are many variations of this stroke and some may have a hooked tail attached. The names below should help you remember the characteristics of each main variation.

It's okay to pause in the corners to form the 45° elbows.

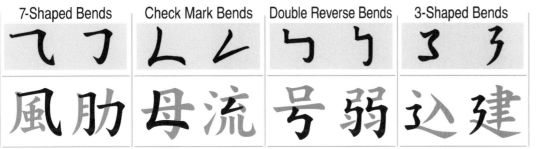

7-Shaped Bends	Check Mark Bends	Double Reverse Bends	3-Shaped Bends

RIGHT STROKE

The "Right Stroke" is a three segment stroke that can be written at different angles and lengths. The head is a consistent 45° and the body may or may not curve. The tail is always tapered.
In some characters, it may be directly connected to the left stroke to form a right-left stroke.

After forming the head, the arm is pushed up and to the right as the brush is slowly lifted to taper the tail.

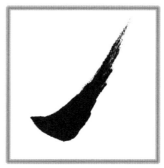

Stroke angle is limited within this range.

JOINED RIGHT-LEFT STROKE

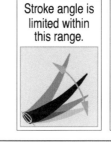

LEFT STROKE

The "Left Stroke" is a full stroke containing all three segments and can be written at many different angles and lengths. Despite this, the head is a consistent 45°, the body makes a slight curve, and the tail seldom shows any sign of deviation.

After taking a second to form the head, the arm is pulled down and to the left in a semi-arch to create the curve. The brush is lifted slowly as the stroke approaches the tail.

Extremely short strokes may have no curve.

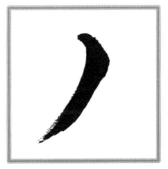

Stroke angle is limited within this range.

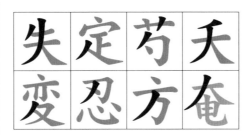

HANDLE STROKE

The "Handle Stroke" is the complement of the left stroke, but you will notice that it is not a mirror image of it. Since the body's direction is about 45°, the head does not predominate. This stroke begins with an elongated tear drop head, then the body makes a slight counter-clockwise curve, then one of several tails can be rendered. It also can be written at slightly different angles and lengths.

Start with a tear drop head pulling your arm down and to the right in a semi-arch to create the curve desired.

The classic handle tail is rendered by slowly adding brush pressure, then pulling it away while still in motion.

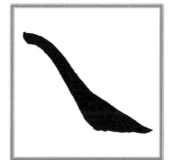

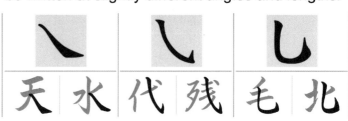

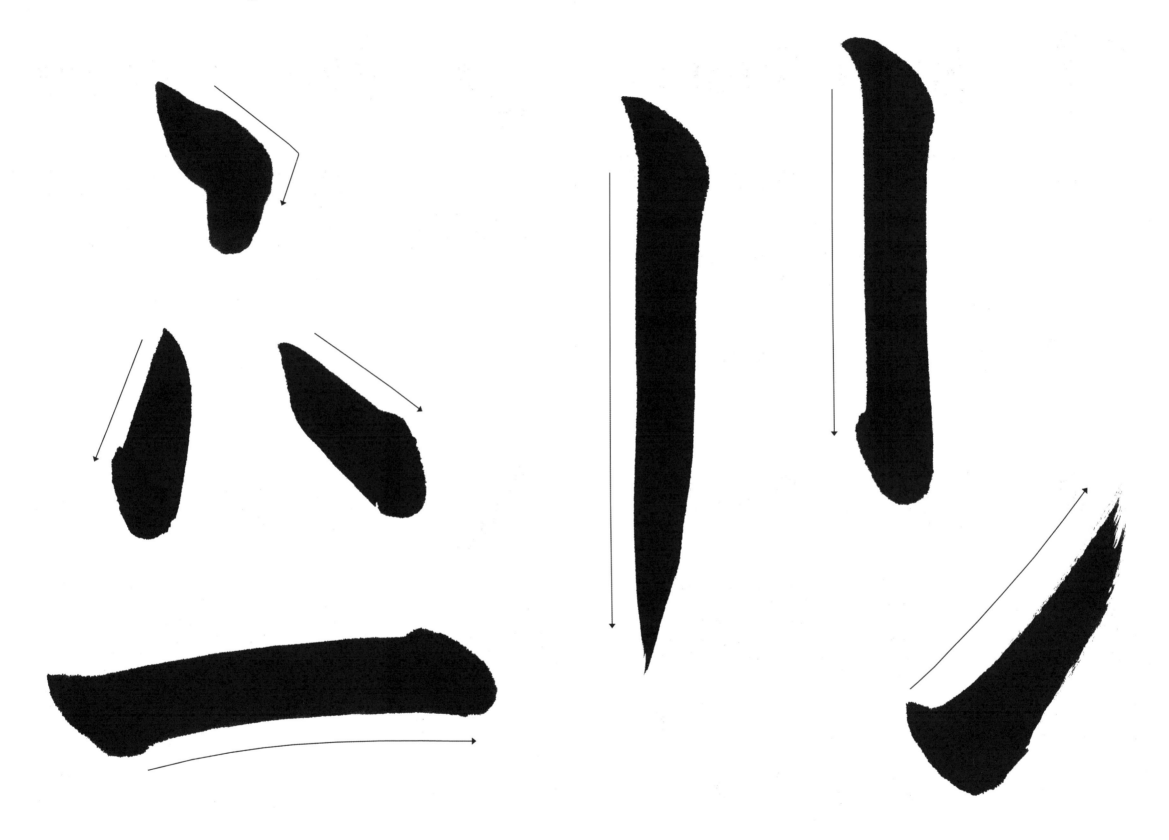

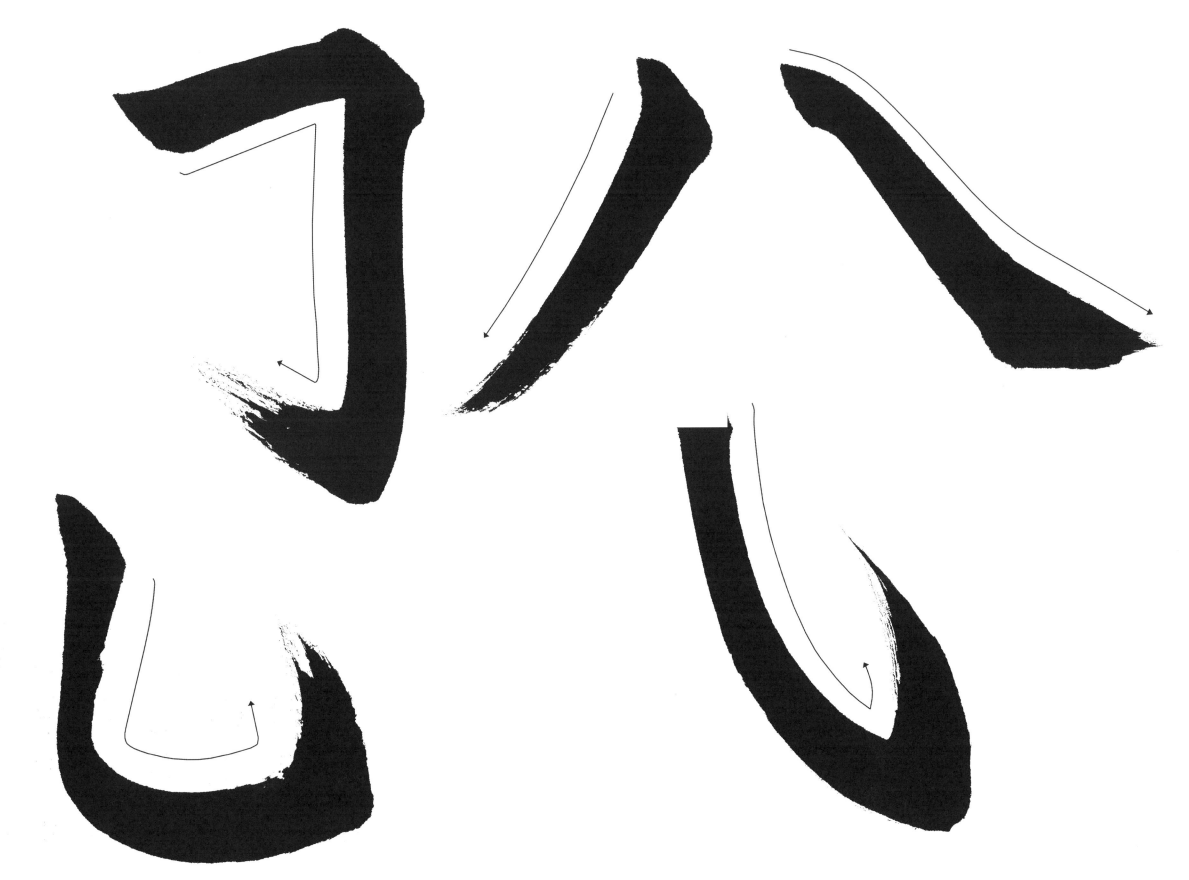

BEGINNING KANJI CALLIGRAPHY

Now that we've covered kanji from the ground up, let's finish up with a few very important things about putting all the pieces together.

THE STROKE ORDER

Long ago, those who first developed kanji placed special emphasis on establishing the specific order in which the strokes of each and every character should be written. This is called stroke order, or *"hitsujun"* (筆順). The correct order renders the character in the optimum number of strokes with no wasted movements. Also, elements, such as radicals, that are instrumental in building-up the character are written first, so you are more likely to end up with a nicely shaped character by following the correct stroke order.

Deviations in the stroke order will result in a character with an altered shape. As a beginner, you may doubt this, but once you begin memorizing the strokes of the radicals, and make that order a habit, soon you'll find the same radicals repeated over and over again in other characters. So an error in the stroke order of one radical is now multiplied into all characters that share that radical.

The correct stroke order for each character in this book is located in the kanji character library.

GENERAL ORDER OF CONSTRUCTION

For guidance when writing characters you see elsewhere, this is the general order of priority, but many characters make exceptions to these rules.

Characters using the hen-tsukuri (left-right) pattern are built from left to right. Characters using the crown-foot (top-bottom) pattern are built from the top down.

Horizontal lines usually precede vertical lines, and the left stroke usually precedes the right stroke.

In solid characters like (口,日,月), the left side vertical stroke is first and the bottom enclosing horizontal stroke is last.

In solid characters that are enclosed in a box, or semi-box, such as the first 4 kamae patterns in the chart on page 21, the outside box is written before the inside.

Vertical, horizontal, left stroke or right strokes that cut through the entire character generally come last.

CHARACTER SHAPE VARIATIONS

Just as each brush stroke has its own characteristic shape, each kanji character also has a natural shape to it.

The seasoned calligrapher tries to accentuate the natural shape of each character when writing because variations in the geometry of successive characters looks more visually interesting than the same shape repeated over and over again.

Here are a number of characters and the shapes they have.

To help you find a character's natural shape, surround its outer edges within lines. Then compare it to the standard geometric shapes.

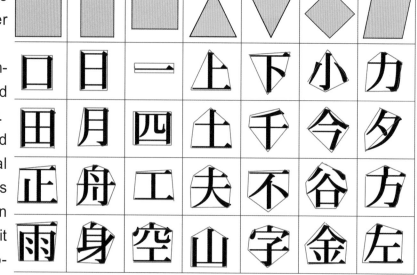

ABOUT THE LIBRARY

The following section is the Kanji Library which contains 166 characters that are commonly found in Japanese calligraphy. These characters have been selected for their functionality, as well as their beauty.

The first ten characters are the numbers one through ten. Not only are the numbers used commonly in many calligraphy works, but they are also used as components within the patterns of other complex kanji characters.

All of the characters after the numbers are arranged in stroke order so you learn the simplest ones first. This is important since all of the complex characters are built with simpler components. Naturally, you can skip around if you like, but writing the complex ones will be easier if you practice the simpler ones first.

WRITING PREPARATIONS

Before beginning to write, preparations must be done. First prepare the writing space by setting all of your tools in the correct location. Place a piece of paper on the shitajiki and weight in down, then ink the stone.

Before beginning to write any characters, most calligraphers do a practice exercise as a warm-up and to calibrate their hand-to-eye coordination. It consists of drawing a grid of successive horizontal and vertical lines that looks like a screen. You should make the lines thick and very close, but not touching.

Next, open the book to the page with the character you wish to practice and study it closely. Notice how it's balanced within the open space, the angles and thickness of the strokes, and memorize the stroke order.

After the review, some new students like to write the character several times on scratch paper with a pencil to help them remember the stroke sequence. If you can, call out the names of the strokes as suggested in the section on the basic eight strokes. This is not suggested if you already know the character.

RENDERING THE CHARACTERS

Finally, prime your brush with just enough ink for one character and begin writing using the techniques taught. Immediately after rendering a character, compare it to the example in the book. Be critical and site specific differences between yours and the example. Write the character again, and this time, try to minimize the differences you noticed the first time.

Repeat these steps until you can write the character accurately without looking at the example.

Notes About the Kanji Charts

Use the kanji charts in this section when praticing the kanji covered in this book. Notes and detailed explanations are as follows:

Shows the character divided into its main components. The orange section shows which radical the character is based on according to the traditional bushu (部首) method of kanji classification. (key position)

SKIP information including pattern number, diagram, and SKIP reference number.

The character's meaning(s).

A brief explanation of the character and if it occurs within other characters.

This is the number of brush strokes used to write the character.

Here you can see the character being written one stroke at a time.

Additional notes about the character may appear here.

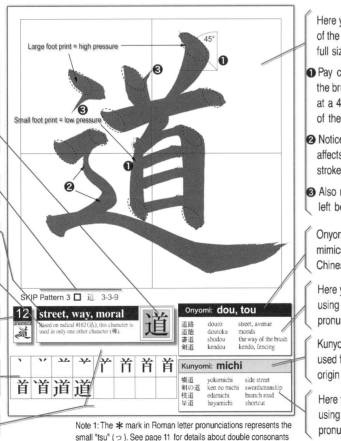

Large foot print = high pressure

Small foot print = low pressure

45°

Here you will find an example of the character rendered in full size.

❶ Pay close attention to how the brush's foot print is kept at a 45° angle regardless of the pressure applied.

❷ Notice how brush pressure affects the thickness of the strokes.

❸ Also note the brush trails left between strokes.

Onyomi pronunciation mimics the character's Chinese pronunciation.

Here you will find words using the onyomi pronunciation. (✴See note 1.)

Kunyomi pronunciation is used for words of Japanese origin only.

Here you will find words using the kunyomi pronunciation.

SKIP Pattern 3 □ 道 3-3-9

12 street, way, moral

Based on radical #162 (辶), this character is used in only one other character (導).

Onyomi: **dou, tou**

道路	douro	street, avenue
道徳	doutoku	morals
書道	shodou	the way of the brush
剣道	kendou	kendo, fencing

Kunyomi: **michi**

横道	yokomichi	side street
剣の道	ken no michi	swordsmanship
枝道	edamichi	branch road
早道	hayamichi	shortcut

Note 1: The ✴ mark in Roman letter pronunciations represents the small "tsu" (っ). See page 11 for details about double consonants and geminate sounds.

SKIP Pattern 4 ■ 一 4-1-4

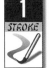 **1** STROKE

one
Used independently or as a radical (#1) in many other characters.

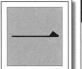

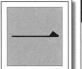

Onyomi: **ichi, itsu, i*-**

一月	ichigatsu	January
一字	ichiji	one letter
同一	douitsu	the same, identity
一回	ikkai	once

Kunyomi: **hito-**

一つ	hitotsu	one
一筆	hitofude	in a single stroke
一人	hitori	one people
一目	hitome	at a glance

SKIP Pattern 2 ▭ 二 2-1-1

 2 STROKES

two
Used independently or as a radical (#7) in many other characters.

Onyomi: **ni**

二月	nigatsu	February
二階	nikai	second floor, upstairs
二百	nihyaku	two hundred
二色	nishoku	two colors

Kunyomi: **futa-, futsu**

二つ	futatsu	two
二通り	futatouri	two ways
二人	futari	two people
二日	futsuka	two days, 2nd of the month

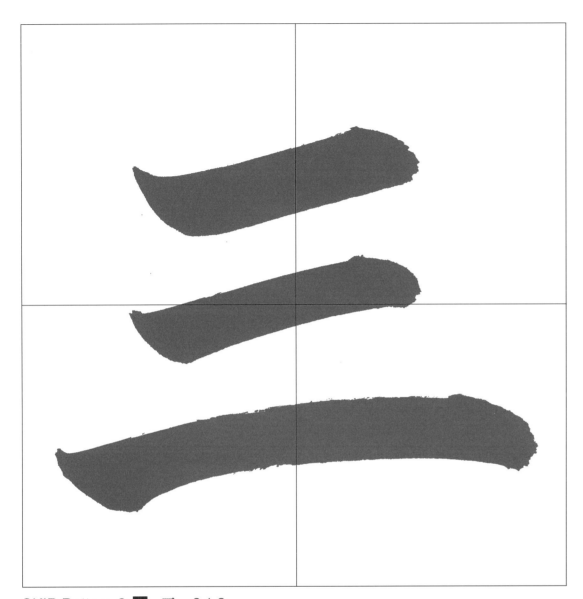

SKIP Pattern 2 ▬ 三 2-1-2

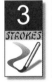

3 STROKES	three
	Based on radical #1 (一) and occurs inside of few other characters.

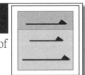

Onyomi: san		
三月	sangatsu	March
三角	sankaku	triangle
三百	sambyaku	three hundred
三食	sanshoku	3 meals a day

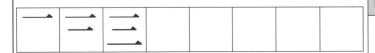

Kunyomi: mitsu, mi-, mi*-		
三菱	mitsubishi	three diamonds
三通り	mitouri	three ways
三つ	mitsu	three
三日間	mikkakan	three days

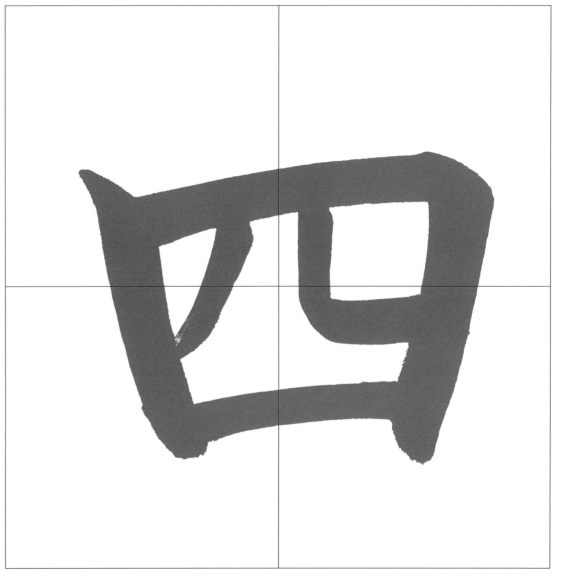

SKIP Pattern 3 □ 四 3-3-2

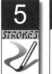

5 STROKES	four
	Based on radical #31 (口), this character is normally used independently, but does occur inside of a few other characters.

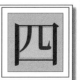

Onyomi: shi		
四月	shigatsu	April
四角	shikaku	square
四国	shikoku	Shikoku Island
四季	shiki	the four seasons

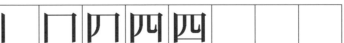

Kunyomi: yo-, yon, yo*-		
四次元	yojigen	the fourth dimension
四つ	yottsu	four
四日	yokka	four days, 4th of the month
四百	yonhyaku	four hundred

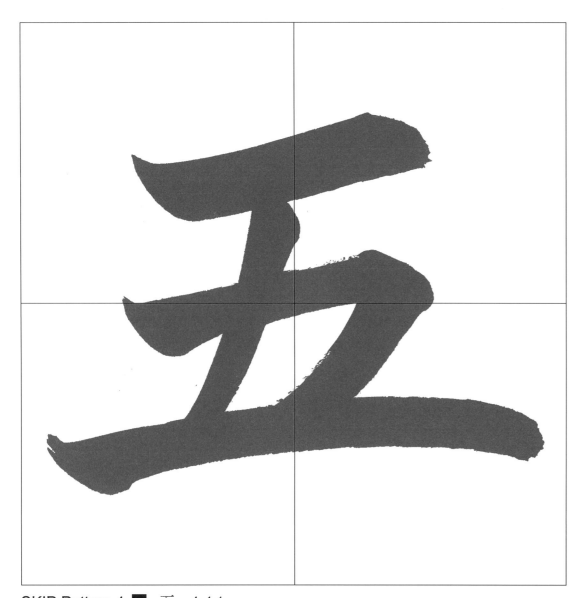

SKIP Pattern 4 ■ 五 4-4-1

4 STROKES	**five** Based on radical #7 (二) and occurs inside of some other characters.	五

Onyomi: go

五月	gogatsu	May
五角形	gokakkei	pentagon
五十音	gojuuon	50 sounds (kana)
五感	gokan	the five senses

Kunyomi: itsu-

| 五つ | itsutsu | five |
| 五日 | itsuka | five days, 5th of the month |

一 丁 五 五

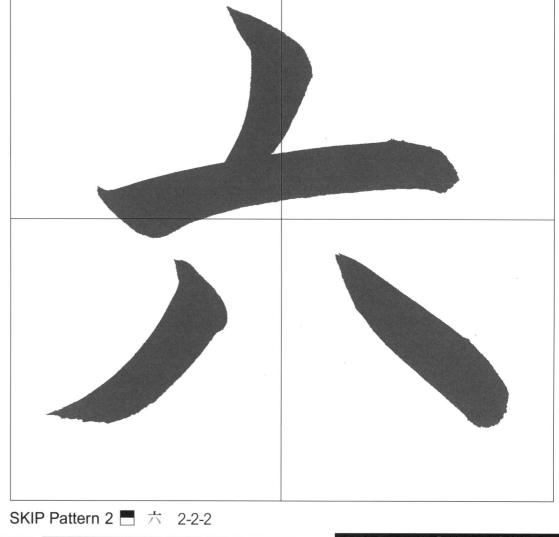

SKIP Pattern 2 ▭ 六 2-2-2

4 STROKES	**six** Based on radical #12 (八) and occurs inside of no other characters.	六

Onyomi: roku, ro*-

六月	rokugatsu	June
六本木	roppongi	Roppongi
第六感	dairokkan	6th sense, intuition
六角形	rokkakukei	hexagon

Kunyomi: mu(tsu), mu-, mui-

六つ子	mutsugo	sextuplets
六つ	mutsu	six
六日	muika	six days, 6th of the month

` 亠 六 六

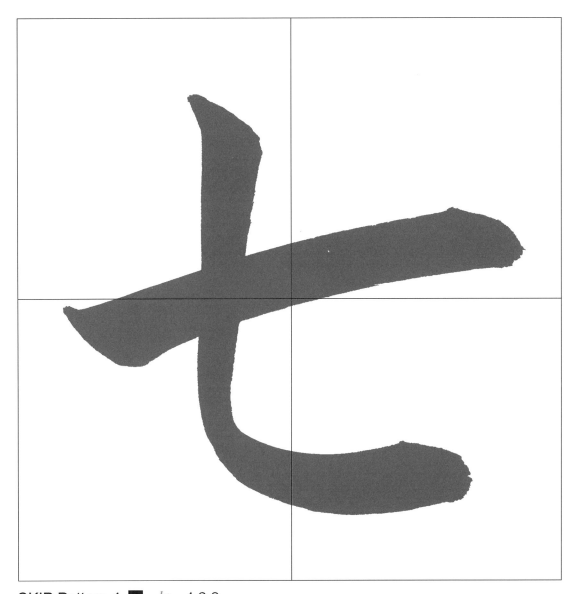

SKIP Pattern 4 ■ 七 4-2-2

 seven

2 STROKES

Based on radical #1 (一) and occurs inside of some other characters.

Onyomi: shichi

七月	shichigatsu	July
七面鳥	shichimenchou	turkey
七五三	shichigosan	lucky 7, 5 and 3

Kunyomi: nana-, nano

七つ	nanatsu	seven
七割	nanawari	seventy percent
七不思議	nanafushigi	the seven wonders
七日	nanoka	seven days, the 7th of the month

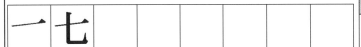

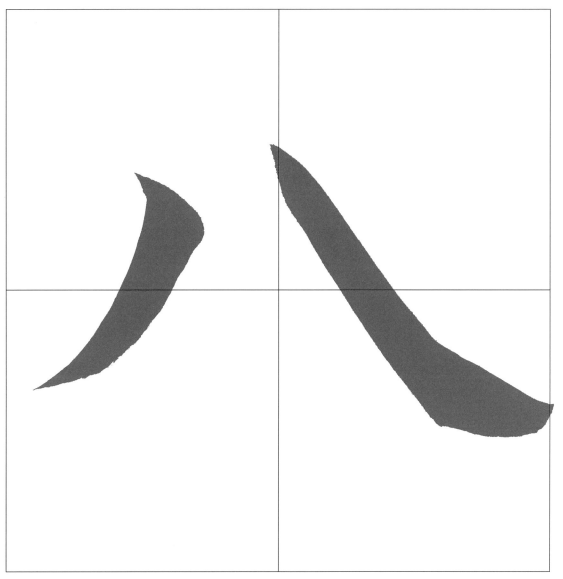

SKIP Pattern 3 □ 八 3-1-1

 eight

2 STROKES

Used independently or as a radical (#12) in many other characters. In the crown position, changes appearance to ⌄.

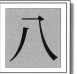

As a radical within another character, it may by written without the horizontal line on the right hand portion (八).

Onyomi: hachi, ha*-

八月	hachigatsu	August
八十	hachijuu	eighty
八の字	hachi no ji	figure eight
八百	happyaku	eight hundred

Kunyomi: ya-, yatsu, you

八百屋	yaoya	greengrocery
八つ	yattsu	eight
八目鰻	yatsumeunagi	lamprey eel
八日	youka	eight days, 8th of the month

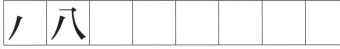

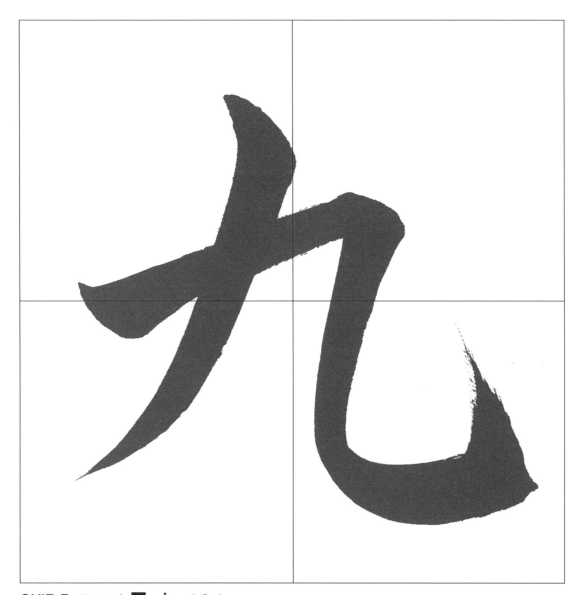

SKIP Pattern 4 ■ 九 4-2-4

2 STROKES	nine, kokono	
	Based on radical #5 (乙) and occurs inside of some other characters.	

 九

Onyomi: **kyuu, ku**

九州	kyuushuu	Kyushu Island
九月	kugatsu	September
九九の表	kuku no hyou	mulitplication tables
十中八九	jutchuuhakku	8 or 9 times out of 10

Kunyomi: **kokono-**

九つ	kokonotsu	nine
九日	kokonoka	nine days, 9th of the month

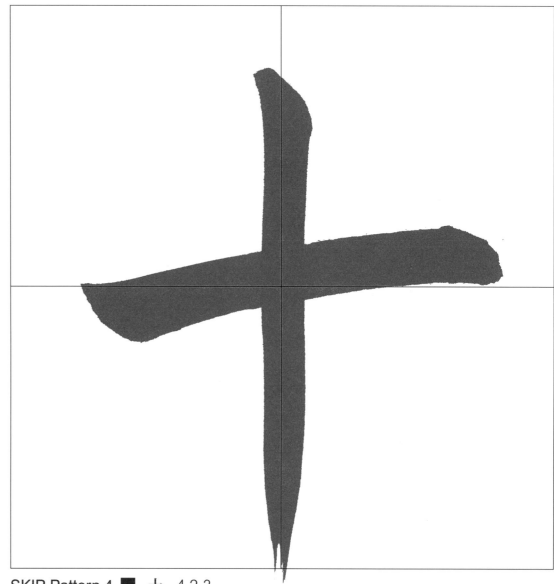

SKIP Pattern 4 ■ 十 4-2-3

2 STROKES	ten	
	Used independently or as a radical (#24) in many other characters. In the hen position, changes appearance to 十.	

 十

Onyomi: **juu, ju-, ji*-**

十月	juugatsu	October
赤十字	sekijuuji	the Red Cross
十分	ju/jippun	ten minutes
十進法	jusshinhou	the decimal system

Kunyomi: **tou, to**

十	tou	ten
十日	touka	ten days, 10th of the month
十人十色	juunin toiro	To each his own.

SKIP Pattern 4 ■ 力 4-2-4

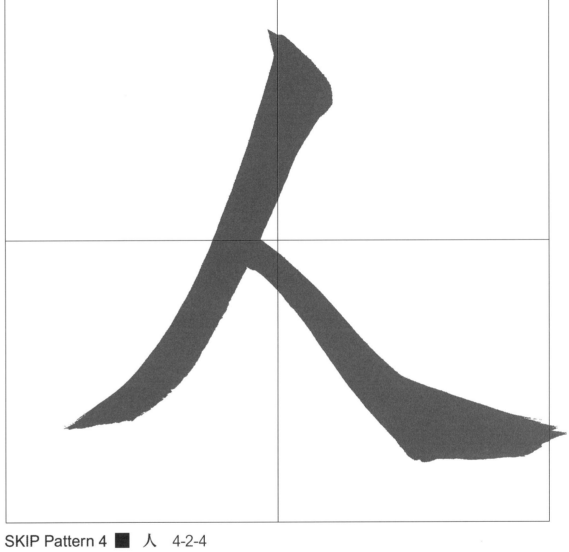

SKIP Pattern 4 ■ 人 4-2-4

2 STROKES	**power** Used independently or as a radical (#19) in many other characters.	力

Onyomi: **ryoku, riki**

努力	doryoku	effort
電力	denryoku	electric power
力士	rikishi	sumo wrestler
力作	rikisaku	literary masterpiece

Kunyomi: **chikara**

力一杯	chikara ippai	work hard
力持ち	chikaramochi	strong, poweful
力仕事	chikarashigoto	manual labor
馬鹿力	bakajikara	enormous strength

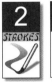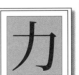

2 STROKES	**person** Used independently or as a radical (#9) in many other characters. In the hen position, changes appearance to 亻.	人

Onyomi: **nin, jin**

人間	ningen	human, a person
他人	tanin	other people
美人	bijin	beautiful woman
人生	jinsei	life

Kunyomi: **hito, -ri, -to**

いい人	ii hito	good natured person
人前	hitomae	in public
一人	hitori	by oneself
素人	shirouto	amateur

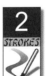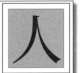

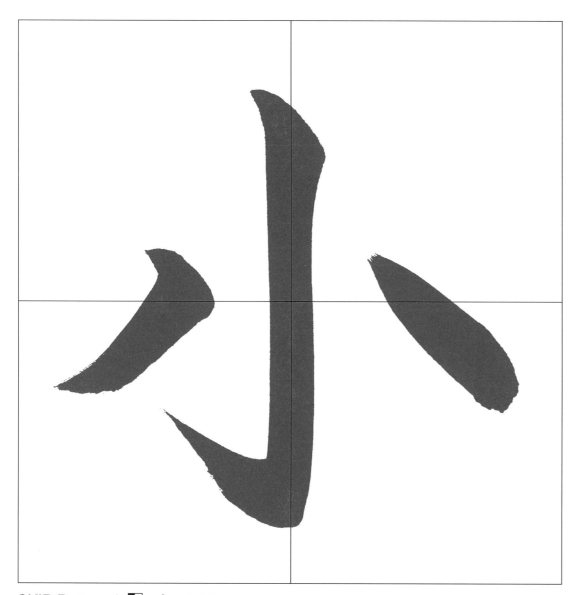

SKIP Pattern 1 ▮▯ 小 1-1-2

3 STROKES	**small**
	Used independently or as a radical (#42) in many other characters. Has two different shapes in the crown position. ⬚ and ⬚.

Onyomi: shou		
小学校	shougakkou	elementary school
最小	saishou	minimum, the smallest
小説	shousetsu	novel, short story
大中小	daichuushou	large/medium/small

Kunyomi: chii(sai), ko, o		
小さい	chiisai	small
小屋	koya	hut, cabin, shed
小指	koyubi	small finger, pinky
小川	ogawa	stream, brook

 丿 小 小

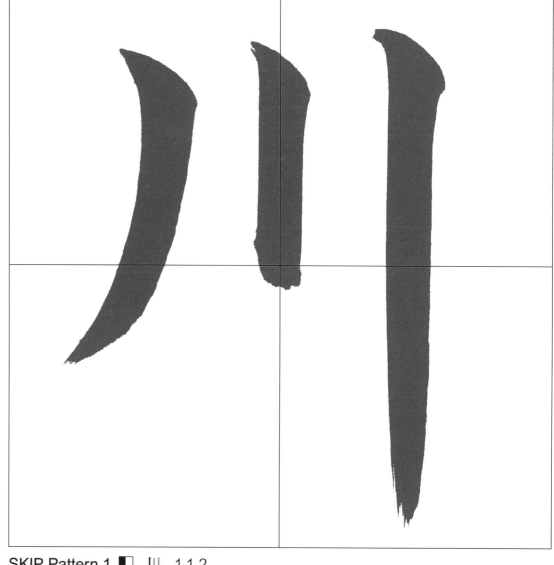

SKIP Pattern 1 ▮▯ 川 1-1-2

3 STROKES	**river**
	Used independently or as a radical (#47) in many other characters. May change shape to ⺌ in some characters and positions.

Onyomi: sen		
山川	sansen	mountains and rivers
河川	kasen	rivers
四川	shisen	Szechuan (China)
川柳	senryuu	senryuu poem

Kunyomi: kawa, -gawa		
川辺	kawabe	riverside
川魚	kawauo	fresh water fish
谷川	tanigawa	mountain stream

 丿 川 川

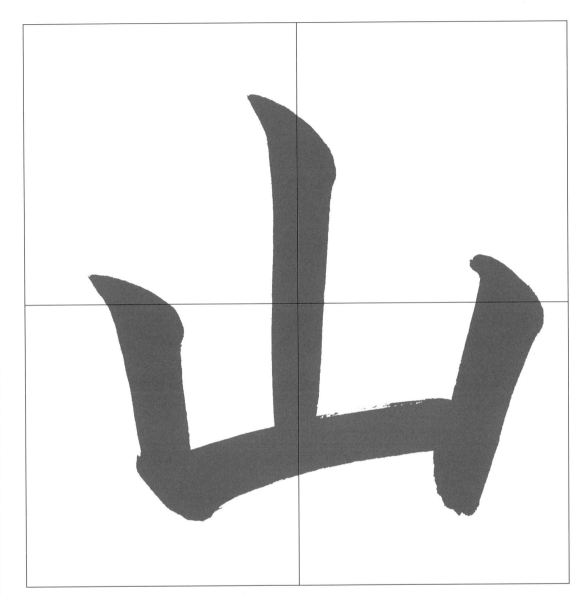

SKIP Pattern 3 ☐ 山 3-2-1

3 STROKES

mountain

Used independently or as a radicle (#46) in many other characters.

Onyomi: **san, -zan**		
富士山	fujisan	Mt. Fuji
山脈	sanmyaku	mountain range
火山	kazan	volcano
登山	tozan	mountain climbing

Kunyomi: **yama**		
山里	yamazato	mountain village
岩山	iwayama	rocky mountain
雪山	yukiyama	snowy mountain
山道	yamamichi	mountain pass

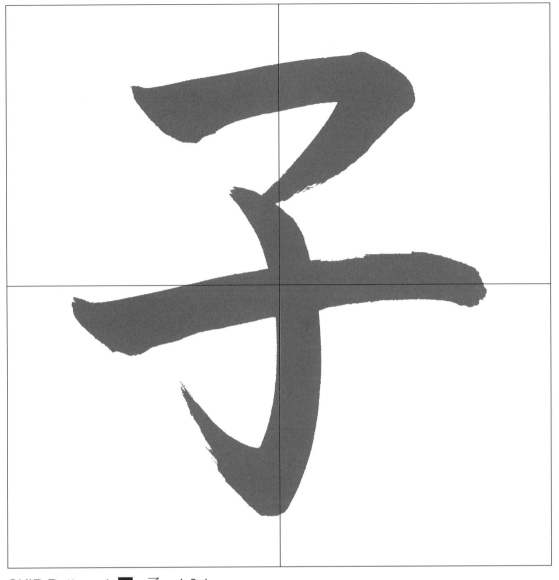

SKIP Pattern 4 ■ 子 4-3-1

3 STROKES

child, element

Used independently or as a radical (#39) in many other characters. In the hen position, changes appearance to 孑.

Onyomi: **shi, -ji, -su**		
子孫	shison	descendant
お菓子	okashi	sweets, candy
王子	ouji	prince
様子	yousu	appearance, situation

Kunyomi: **ko, -go, ne**		
子供	kodomo	child, children
竹の子	takenoko	bamboo shoot
双子	futago	twins
子の核	ne no koku	midnight

41

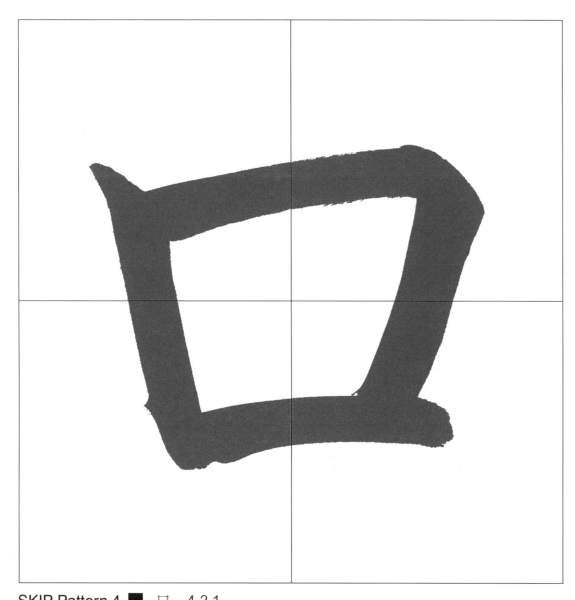

SKIP Pattern 4 ■ 口 4-3-1

3 STROKES	mouth	口
	Used independently or as a radical (#30) in many other characters. In the hen position, changes appearance to 口.	

Onyomi: kou, ku

口語	kougo	spoken language
口座	kouza	account
利口	rikou	clever, smart
口調	kuchou	accent, tone of voice

Kunyomi: kuchi, -guchi

一口	hitokuchi	in a word, mouthful
辛口	karakuchi	spicy taste
入口	iriguchi	entrance
非常口	hijouguchi	emergency exit

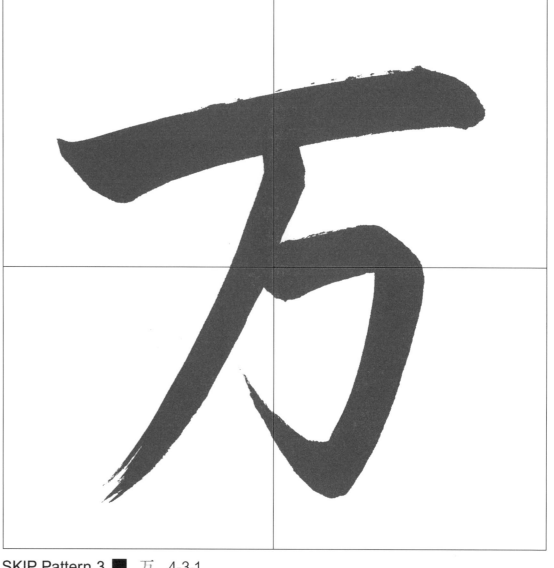

SKIP Pattern 3 ■ 万 4-3-1

3 STROKES	ten thousand, all kinds	万
	Based on radical #1 (一) and occurs inside of some other characters.	

Onyomi: man, ban

五万	goman	50,000
万一	man'ichi	in case
万人	bannin	everybody, 10,000 people
万物	banbutsu	all things, everything

一 丁 万

Kunyomi: yorozu

八百万	yaoyorozu	myriads
万屋	yorozuya	jack-of-all-trades
万代	yorozuyo	thousands of years, generations

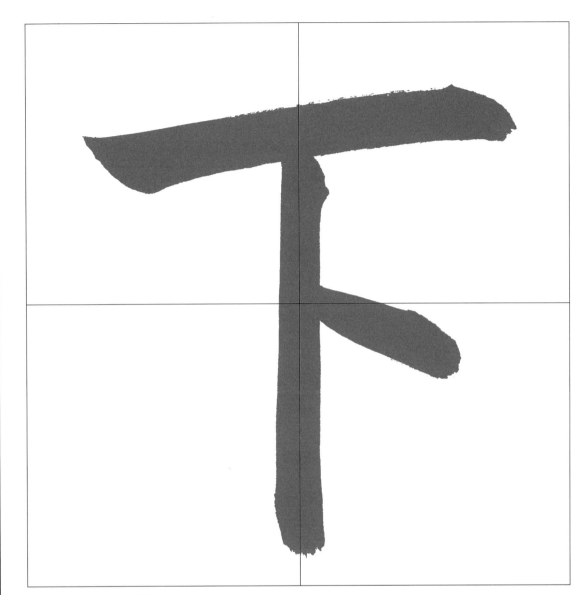

SKIP Pattern 4 ■ 下 4-3-1

 3 STROKES **under, inferior**
Based on radical #1 (一) and occurs inside of only a few other characters.

下

Onyomi: **ka, ge**		
以下	ika	below, less
下流	karyuu	downstream
下品	gehin	indecency, coarse-ness, vulgarity
上下	jouge	ups and downs

 一 丁 下

Kunyomi: **shita, sa-, kuda-, o-, shimo, moto**		
下心	shita gokoro	one's real intention
下がる	sagaru	to hang down
下る	kudaru	to descend, to drop
下りる	oriru	to go down, to get off
下手	shimote	the lower part

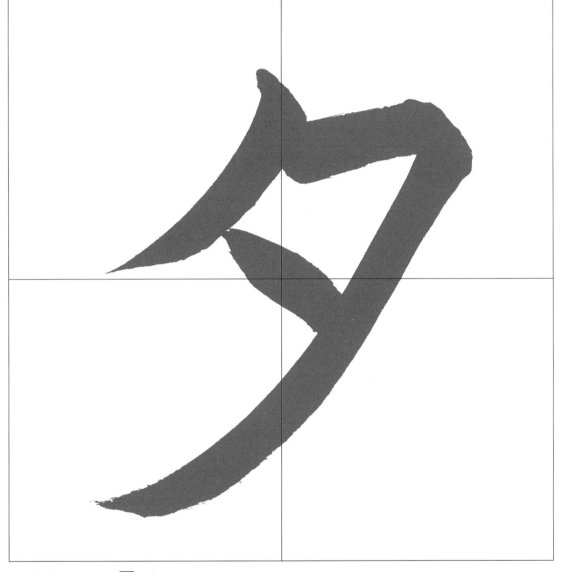

SKIP Pattern 4 ■ 夕 4-3-1

 3 STROKES **evening**
Used independently or as a radicle (#36) in many other characters.

夕

Onyomi: **seki**		
夕陽	sekiyou	setting sun
一朝一夕	icchouisseki	in a very short time
今夕	konseki	this evening

 ノ ク 夕

Kunyomi: **yuu**		
夕方	yuugata	evening
夕焼け	yuuyake	sunset
夕日	yuuhi	setting sun
夕食	yuushoku	dinner

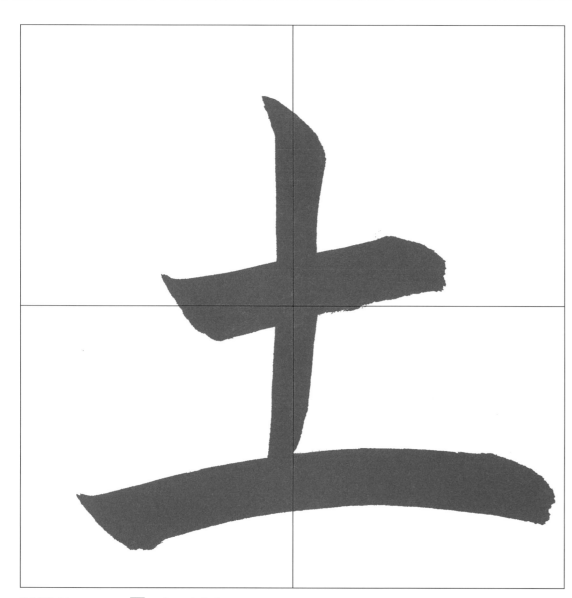

SKIP Pattern 4 ■ 土 4-3-2

3 STROKES **dirt**

Used independently or as a radical (#32) in many other characters. In the hen position, changes appearance to .

Onyomi: **to, do**

土地	tochi	plot of land, soil
土曜日	doyoubi	Saturday
土星	dosei	the planet Saturn
粘土	nendo	clay

Kunyomi: **tsuchi**

土踏まず	tsuchifumazu	arch of the foot
赤土	akatsuchi	red clay
土色	tsuchiiro	muddy brown

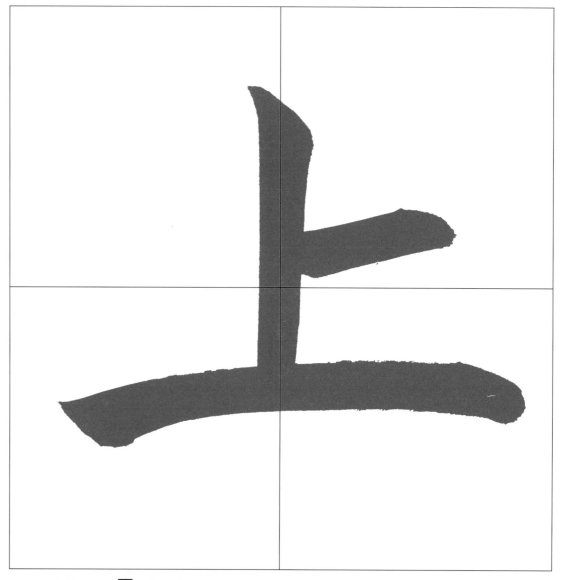

SKIP Pattern 4 ■ 上 4-3-2

3 STROKES **over**

Based on radical #1 (一) and occurs inside of only a few other characters.

Onyomi: **jyou, shou**

向上	koujyou	progress, rise, improve
上下	jyouge	up & down, both ways
紙上	shijyou	on paper
上司	jyoushi	boss

Kunyomi: **ue, uwa, a-, nobo-, kami**

上の地位	ue no chii	a higher position
上書き	uwagaki	to overwrite
上がる	agaru	to rise, to be raised
上る	noboru	to go up
上手	kamite	upper part, left stage

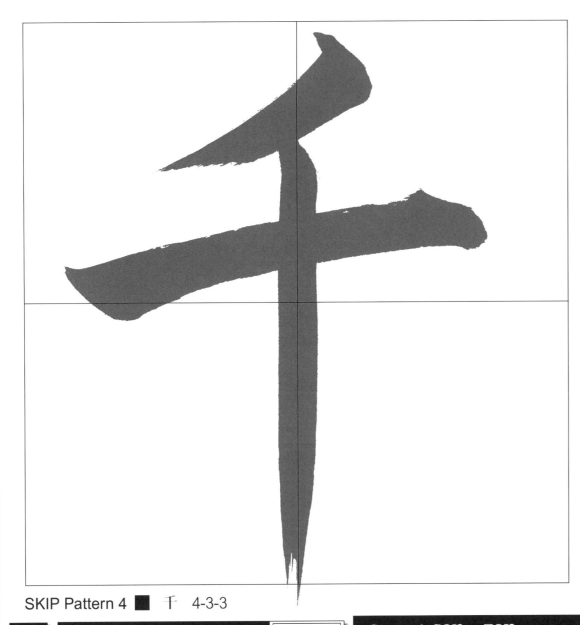

SKIP Pattern 4 ■ 千 4-3-3

thousand

Based on radical #24 (十) and occurs inside of few other characters.

千

Onyomi: sen, -zen

千日	sen nichi	thousand days
千回	senkai	thousand times
千円札	sen'en satsu	thousand yen bill
三千	sanzen	three thousand

Kunyomi: chi

千草	chigusa	thousand grasses
千代	chiyo	thousand years, long time
千切る	chigiru	chop into pieces
千鳥足	chidoriashi	stagger, tipsy

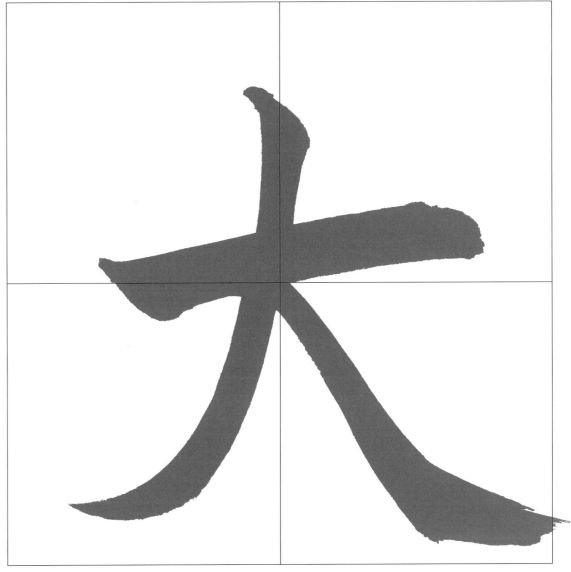

SKIP Pattern 4 ■ 大 4-3-4

big

Used independently or as a radical (#37) in many other characters. In the crown position, changes appearance to 𠆢.

大

Onyomi: dai, tai

大学	daigaku	college
最大	saidai	maximum, the biggest
大丈夫	daijyoubu	right, okay
大陸	tairiku	continent

Kunyomi: oo-

大きい	ookii	big, large, great
大雨	ooame	heavy rain
大声	oogoe	loud voice
大当たり	oo'atari	big hit

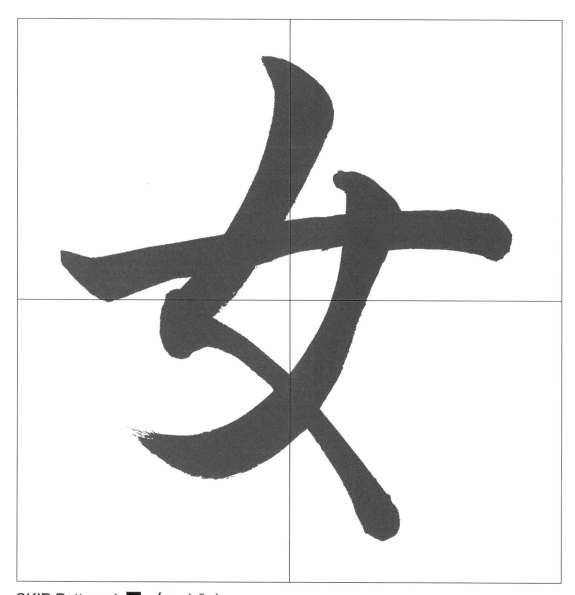

SKIP Pattern 4 ■ 女 4-3-4

3 STROKES	**woman, female** Used independently or as a radical (#38) in many other characters. In the hen position, changes appearance to 女.	女

Onyomi: jyo, nyo, nyou

美女	bijyo	beautiful woman
女医	jyoi	female doctor
女性	nyoshou	woman
女房	nyoubou	wife

Kunyomi: onna, me

女達	onnatachi	women, womenfolk
女らしい	onnarashii	womanlike, feminine
女の子	onna no ko	girl
乙女	otome	young girl, virgin

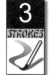 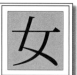

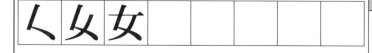

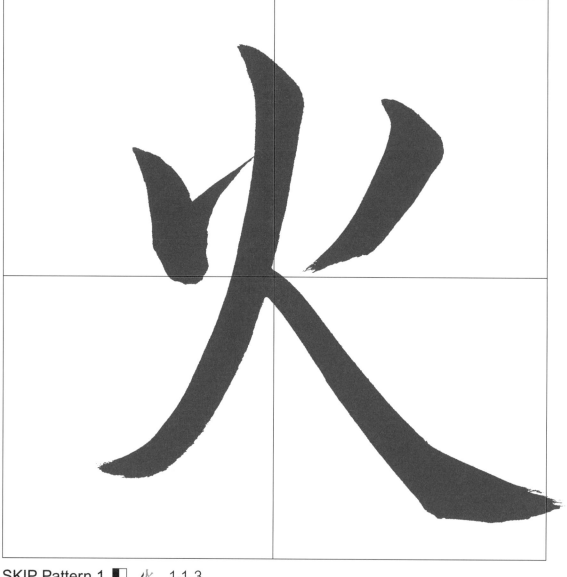

SKIP Pattern 1 ▮ 火 1-1-3

4 STROKES	**fire, Tuesday** Used independently or as a radical (#86) in many other characters. In the hen position, changes appearance to 火.	火

Onyomi: ka

火曜日	kayoubi	Tuesday
火事	kaji	a fire
火星	kasei	Mars
点火	tenka	lighting, ignition

Kunyomi: hi, -bi, ho-

火の用心	hi no youjin	be careful with fire
火花	hibana	spark
花火	hanabi	fireworks
火影	hokage	firelight

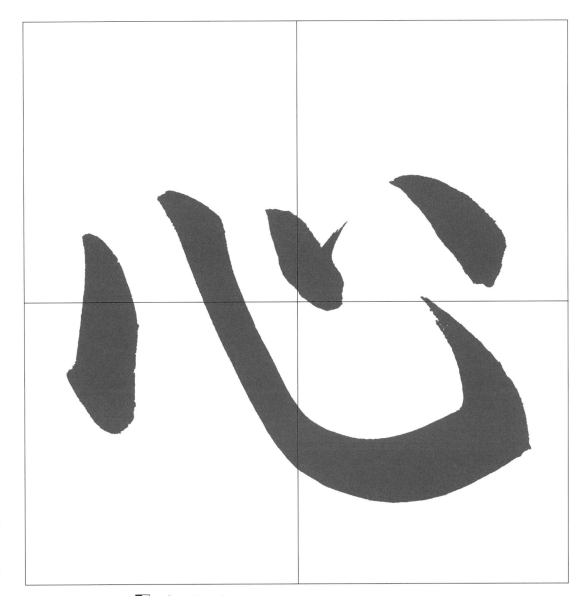

4 STROKES	heart, mind, spirit

Used independently or as a radical (#61) in many other characters.

 心

This radical may occur is several positions and can change shape and stroke count depending upon its position.

Hen position	Tsukuri	Centered	Ashi	"Shitagokoro" form in ashi position
忙	沁	愛	志	忝
3 strokes	4 strokes	4 strokes	4 strokes	4 strokes

Onyomi: shin

心配	shinpai	worry, concern
心理学	shinrigaku	psychology
安心	anshin	peace of mind
決心	kesshin	determination

Kunyomi: kokoro, -gokoro

心の中	kokoro no naka	in one's mind
心配り	kokorokubari	attention, consideration
親心	oyagokoro	parental affection
真心	magokoro	sincerity, devotion

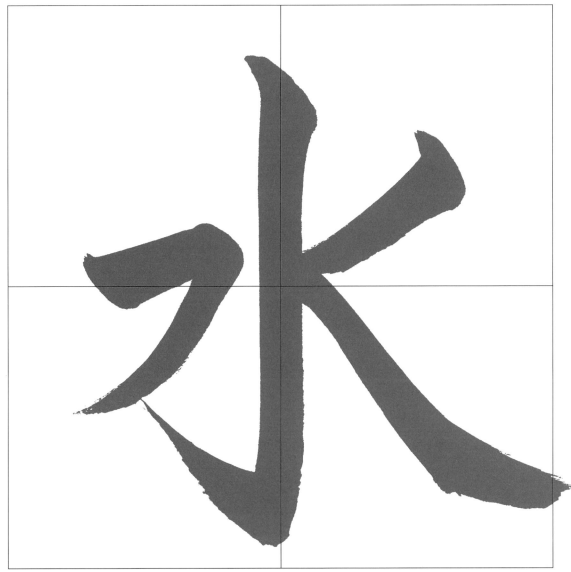

4 STROKES	water

Used independently or as a radical (#85) in many other characters. Takes on a different shape when used in hen or foot position.

水

NORMAL SHAPE

丨 刁 水 水

"SANZUI" IN THE "HEN" POSITION.

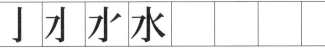

EX: 海、池、沖、泊

"SHITAMIZU" IN THE "ASHI" POSITION.

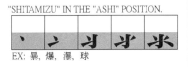

EX: 暴、爆、瀑、球

Onyomi: sui

水曜日	suiyoubi	Wednesday
水泳	sui'ei	swimming
水道	suidou	waterworks, water pipes
水星	suisei	(the planet) Mercury

Kunyomi: mizu

飲み水	nomimizu	drinking water
水不足	mizubusoku	water shortage
水着	mizugi	swimsuit, bathing suit
鼻水	hanamizu	runny nose

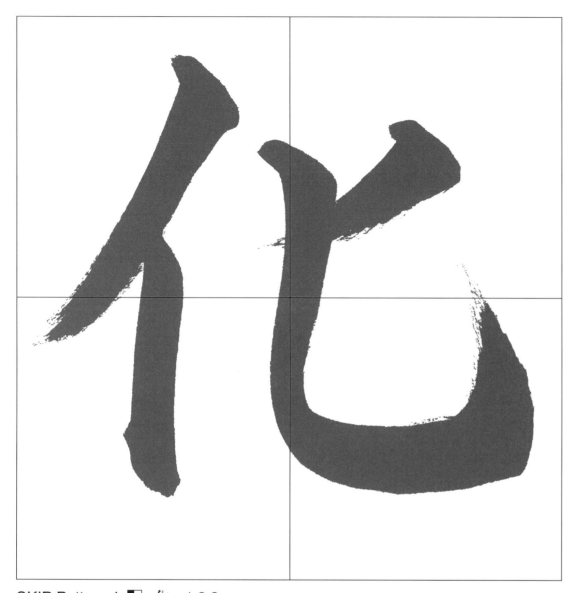

SKIP Pattern 1 ■ 化 1-2-2

4 STROKES	**change** Based on radical #9 (人), this character is used independently and occurs as a component in a few other complex characters.	化

Onyomi: ka, ke

化学	kagaku	chemistry
変化	henka	change, variation
自由化	jiyuuka	liberization
化粧	keshou	make-up, cosmetics

Kunyomi: ba-

| 化ける | bakeru | to change into |
| 化け物 | bakemono | monster, ghost |

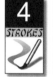 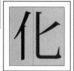

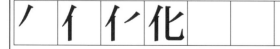

SKIP Pattern 2 ▬ 文 2-2-2

4 STROKES	**sentence, culture** This radical (# 67) is used independently and also occurs as a component in a few other complex characters.	文

Onyomi: bun, mon

文学	bungaku	literature
文章	bunshou	sentence
文化	bunka	culture
注文	chuumon	request, order

Kunyomi: fumi-, -bumi, fu

文使い	fumizukai	letter messenger
恋文	koibumi	love letter
文箱	fubako	letter box
文月	fuzuki	September

SKIP Pattern 2 ▬ 父 2-2-2

4 STROKES

father

Used independently or as a radical (#88) in many other characters.

父

Onyomi: **fu**		
父子	fushi	father and son
義父	gifu	father-in-law
祖父	sofu	grand father
父母	fubo	father and mother

丿 八 ⺇ 父

When used as a radical within other characters, it may sometimes have a sword blade leader on the last stroke:

EXAMPLES:

Kunyomi: **chichi**		
父母	chichihaha	father and mother
父親	chichioya	father
父方	chichikata	father's side of family
父の日	chichi no hi	Father's day

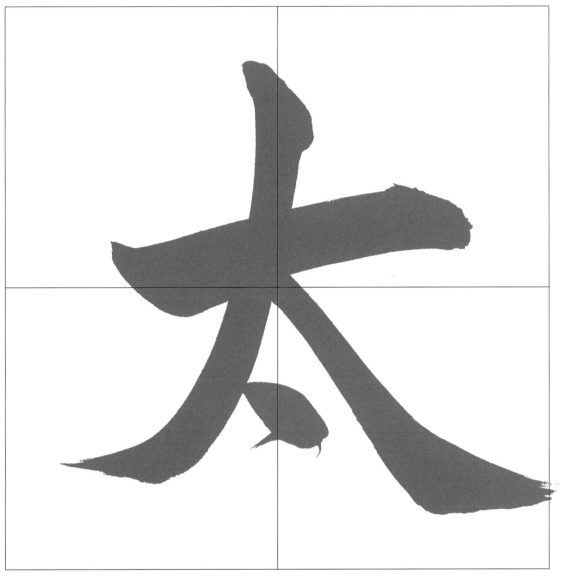

SKIP Pattern 2 ▬ 太 2-3-1

4 STROKES

huge, thick

Based on radical #37 (大), this character is used independently and occurs as a component in only a few other complex characters.

太

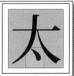

Onyomi: **tai, ta**		
太陽	taiyou	the sun, solar
太鼓	taiko	the taiko drum
太平洋	taiheiyou	the Pacific ocean
丸太	maruta	log

一 ナ 大 太

Kunyomi: **futo-**		
太る	futoru	to become fat
太い	futoi	fat, thick
太巻	futomaki	large sushi roll
太股	futomomo	thigh

49

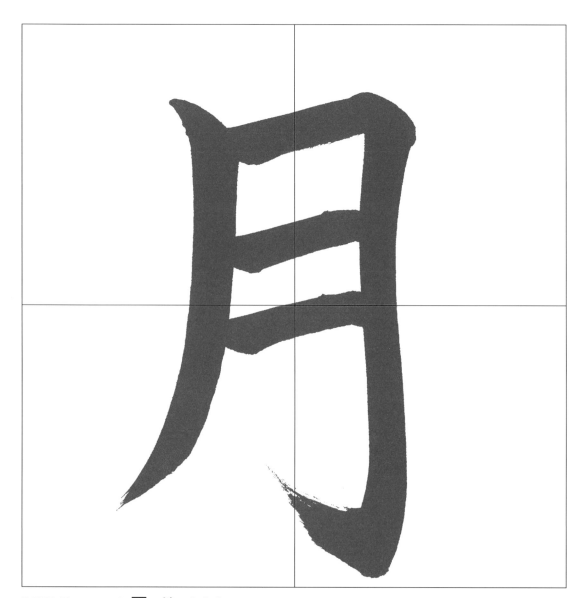

SKIP Pattern 3 □ 月 3-2-2

4 STROKES	**moon, Monday** 月	Onyomi: **getsu, gatsu**

Used independently or as a radicle (#74) in many other characters.

Onyomi: **getsu, gatsu**		
月曜日	getsuyoubi	Monday
先月	sengetsu	last month
満月	mangetsu	full moon
何月	nangatsu	what month

 丿 刀 月 月

Kunyomi: **tsuki, -zuki**		
月夜	tsukiyo	moonlit evening
毎月	maitsuki	every month
三日月	mikazuki	crescent
月々	tsukizuki	each month

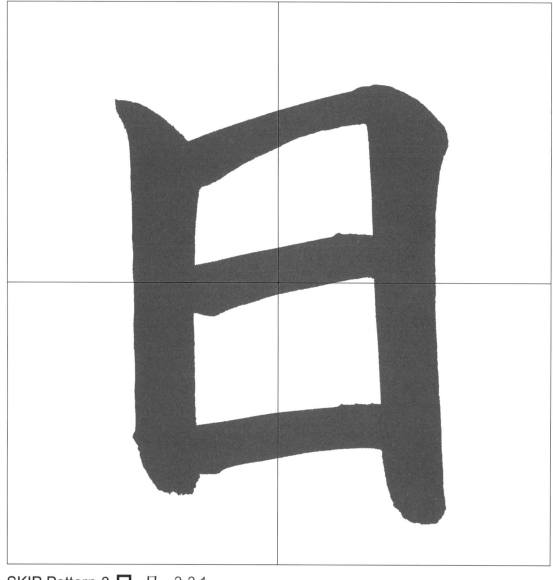

SKIP Pattern 3 □ 日 3-3-1

4 STROKES	**day, Japan, Sunday** 日	Onyomi: **nichi, ni, jitsu**

Used independently or as a radical (#72) in many other characters. In the hen position, changes appearance to 日.

Onyomi: **nichi, ni, jitsu**		
日曜日	nichiyoubi	Sunday
毎日	mainichi	everyday
日本	nihon (nippon)	Japan
平日	heijitsu	weekdays

 丨 冂 冃 日

Kunyomi: **hi, -bi, -pi, -ka**		
日頃	higoro	usually
誕生日	tanjyoubi	birthday
年月日	nengappi	year-month-day
二十日	hatsuka	twenty days, the 20th of the month

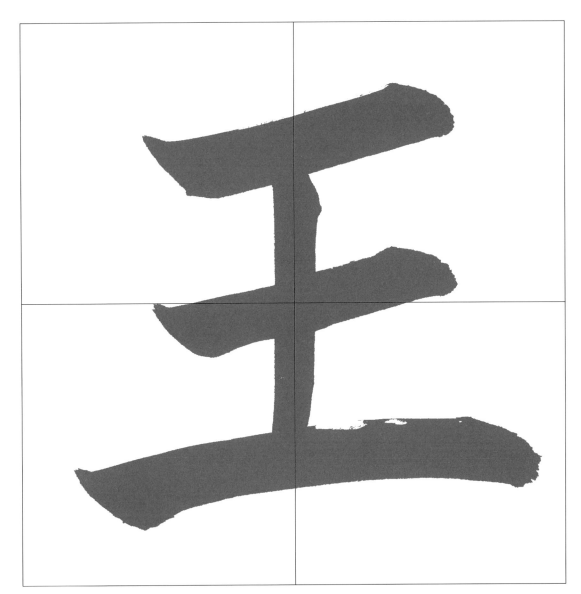

SKIP Pattern 4 ■ 王 4-4-1

 4(5) **STROKES**

king

Used independently or as a radical (#96) in many other characters. In the hen position, changes appearance to 王.

Onyomi: ou

王様	ousama	king
王族	ouzoku	royality, royal family
王国	oukoku	kingdom, monarchy
王妃	ouhi	queen

Kunyomi: <none>

一 丁 千 王

ALTERNATE:

When used as an independent character, radical #96 may also appear with an extra stroke (玉). In this form its meaning and pronunciation changes:

MEANING: gem, jewel **ONYOMI:** gyoku **KUNYOMI:** tama, -dama

Ex: 宝玉 *hōgyoku* precious stone　玉子 *tamago* egg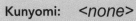

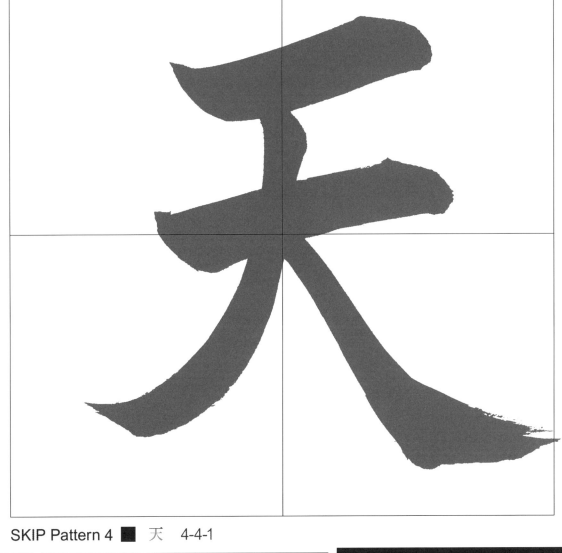

SKIP Pattern 4 ■ 天 4-4-1

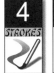 **4** **STROKES**

heavens, sky

Based on radical #37 (大) and occurs inside of some other characters, but not in the hen position. *(See below.)*

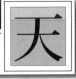

Onyomi: ten

晴天	seiten	fine weather, sunshine
天国	tengoku	heaven, paradise
天気	tenki	weather
天ぷら	tempura	tempura (Japanese food)

NORMAL:

一 二 チ 天

Kunyomi: ama-, ame

天つ	amatsu	heavenly
天邪鬼	amanojaku	contrary person
天の川	ama no gawa	the Milky Way

ALTERNATE:

As a component in some complex kanji, the top line may be sloped and the legs may be spread further apart than normal.

KANMURI POSITION　ASHI POSITION　TSUKURI POSITION

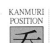 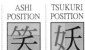

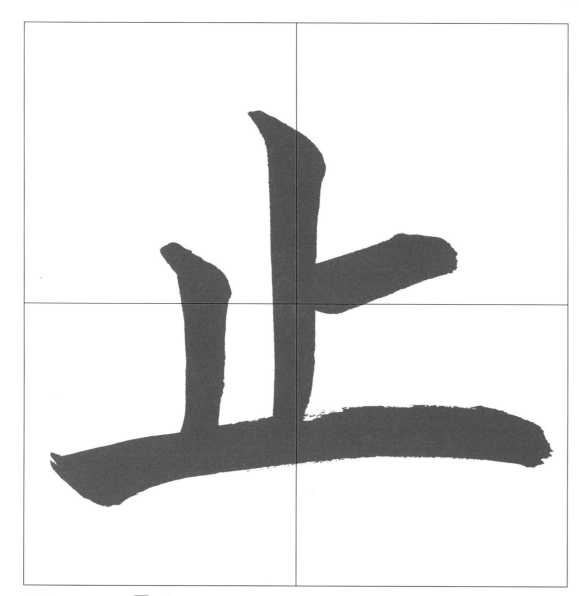

SKIP Pattern 4 ■ 止 4-4-2

 4 STROKES **stop**
Used independently or as a radical (#77) in many other characters. Bottom line may be sloped (止) when used inside other kanji.

止

Onyomi: shi

禁止	kinshi	forbidden, ban
停止	teishi	halt, suspend
休止	kyuushi	pause, rest
防止	boushi	prevention

Kunyomi: to-, -do-, todo-, ya-

止まる	tomaru	to stop
口止め	kuchidome	seal
止まる	todomaru	to stay, to remain
止める	yameru	to stop, to cease

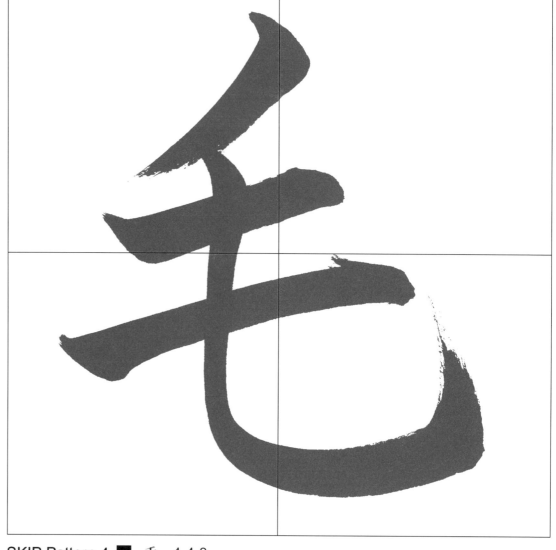

SKIP Pattern 4 ■ 毛 4-4-3

 4 STROKES **hair, fur, down**
Used independently or as a radical (#82) in other characters.

毛

Onyomi: mou

羽毛	umou	feather, down
短毛	tanmou	short hair
毛筆	mouhitsu	writing brush
毛布	moufu	blanket

Kunyomi: ke, -ge

毛糸	ke'ito	wool
毛深い	kebukai	hairy
鼻毛	hanage	nostril hairs
枝毛	edage	split ends

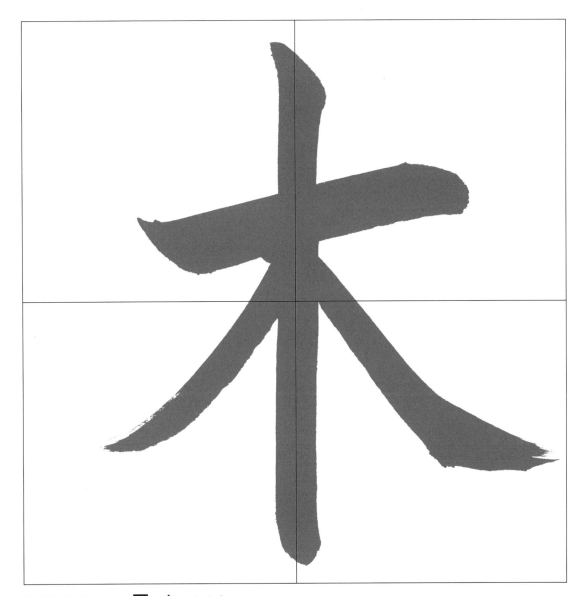

SKIP Pattern 4 ■ 木 4-4-3

4 STROKES **tree**

Used independently or as a radical (#75) in many other characters. In the hen position, changes appearance to 木.

Onyomi: **boku, moku**		
大木	taiboku	big tree
木曜日	mokuyoubi	Monday
木星	mokusei	the planet Jupiter
木材	mokuzai	lumber, timber

Kunyomi: **ki, ko-**		
草木	kusaki	plants, vegetation
木目	kime	wood grain
積木	tsumiki	block, brick
木立	kodachi	row of trees

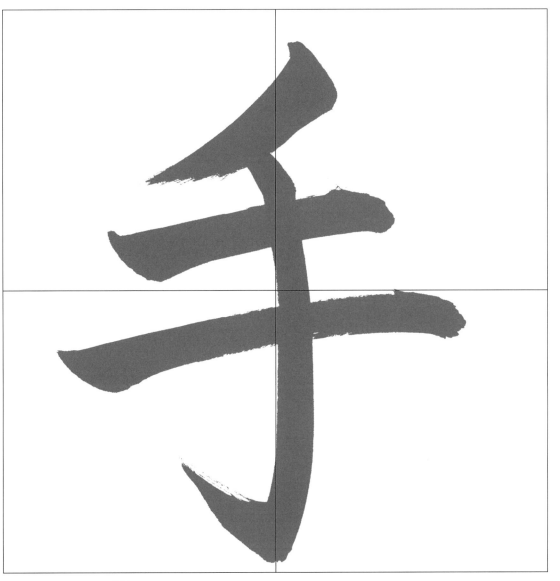

SKIP Pattern 4 ■ 手 4-4-3

4 STROKES **hand**

Used independently or as a radical (#64) in many other characters. In the hen position, changes appearance to 扌.

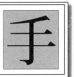

Onyomi: **shu, zu**		
拍手	hakushu	applause
握手	akushu	handshake
手話	shuwa	sign language
上手	jyouzu	skillful (at something)

Kunyomi: **te, -ta**		
手作り	tezukuri	hand-made
手首	tekubi	wrist
手本	tehon	pattern, model
下手	heta	poor (at something)

SKIP Pattern 4 ■ 犬 4-4-4

4	dog	犬
STROKES	Used independently or as a radical (#94) in other characters.	

Onyomi: ken		
愛犬	aiken	pet, loved dog
犬歯	kenshi	dogtooth, cuspid
野犬	yaken	stray dog
番犬	banken	watchdog

Kunyomi: inu		
犬小屋	inugoya	doghouse, kennel
子犬	koinu	puppy
負け犬	makeinu	loser, underdog

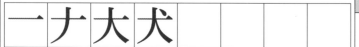

一 ナ 大 犬

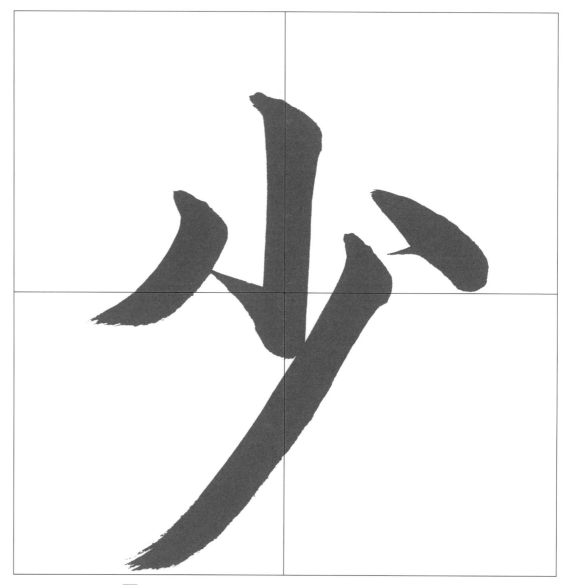

SKIP Pattern 4 ■ 少 4-4-4

4	few	少
STROKES	Based on radical #42(小),this character is normally used independently, but does occur inside of a few other characters.	

Onyomi: shou		
少年	shounen	juveniles, boys
少人数	shouninzuu	small number of people
少々	shoushou	just a minute, a little
多少	tashou	more or less, some

Kunyomi: suku(nai), suko(koshi)		
少ない	sukunai	few, little, not enough
少し	sukoshi	a little bit, a few

亅 小 小 少

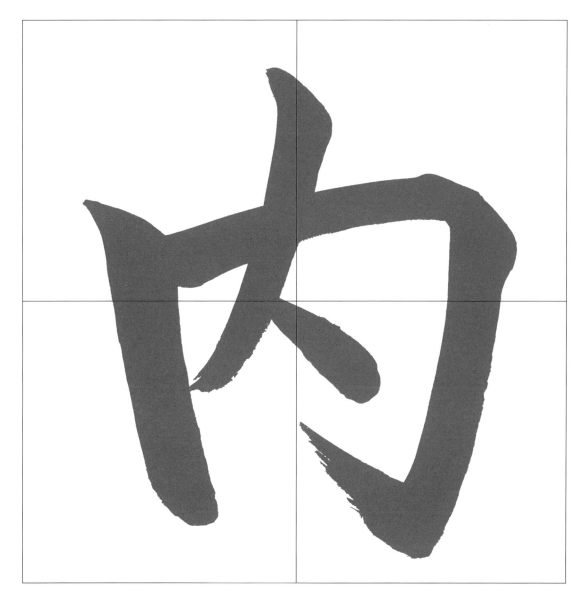

SKIP Pattern 4 ■ 内 4-4-4

 4 **inside, among**

STROKES

Based on radical #11(入),this character is normally used independently, but does occur inside of a few other characters.

内

Onyomi: **nai, dai**

内容	naiyou	contents, subject, matter
国内	kokunai	domestic, internal
案内	annai	guidance, information
内部	naibu	internal, interior

Kunyomi: **uchi**

内気	uchiki	shyness
内側	uchigawa	inside
身内	mi'uchi	relative
その内	sonouchi	sooner or later

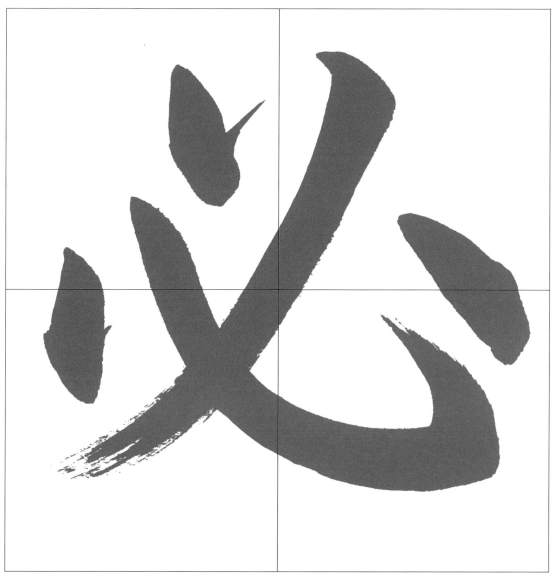

SKIP Pattern 1 ▯ 必 1-1-4

 5 **certain**

STROKES

Based on radical #3 （丶）, this character is used independently and occurs as a component in only a few other complex characters.

必

Onyomi: **hitsu, hi*-**

必要	hitsuyou	necessary
必然	hitsuzen	necessity, inevitablity
必見	hikken	a must-see, worth seeing
必死	hisshi	frantic, desperate

Kunyomi: **kanara(zu)**

| 必ず | kanarazu | without fail, always |

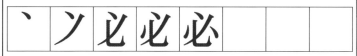

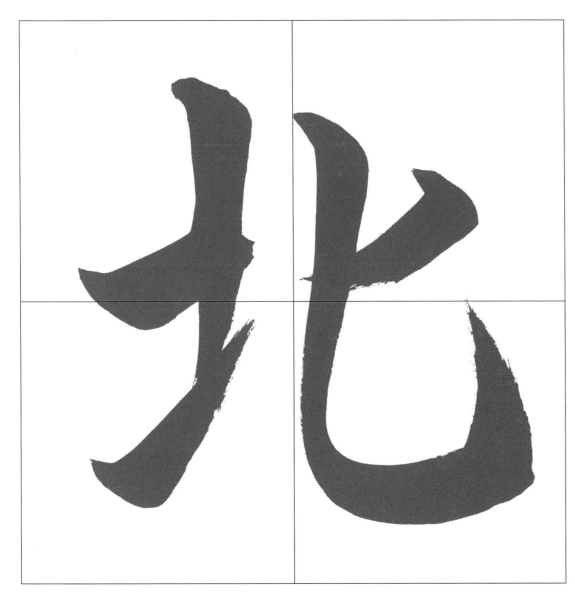

SKIP Pattern 1 ▌ 北 1-3-2

 5
STROKES

north

Based on radical #21 (ヒ), this character is normally used independently, but does occur inside of a few other characters.

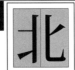

Onyomi: **hoku, boku, ho*-**

北米	hokubei	North America
南北	nanboku	north and south
北極	hokkyoku	the North Pole
北海道	hokkaidou	Hokkaido

Kunyomi: **kita**

北門	kitamon	north gate
北風	kitakaze	north wind
北半球	kitahankyuu	the Northern Hemisphere
北国	kitaguni	the north, northern country

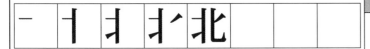

SKIP Pattern 1 ▌ 功 1-3-2

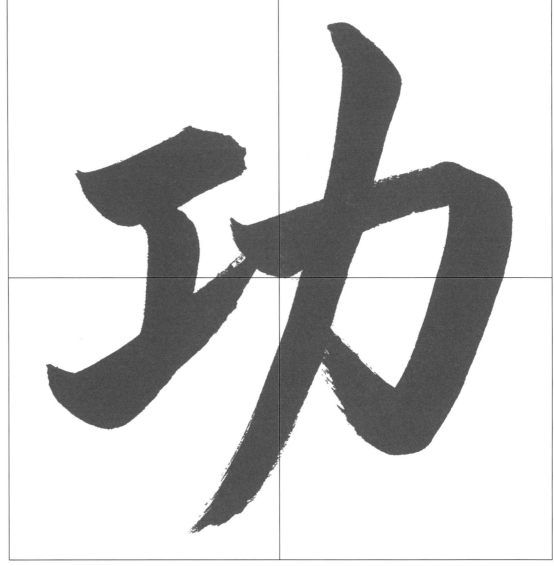

 5
STROKES

success

Based on radical #19 (力), this character is normally used independently, but does occur inside of a few other characters.

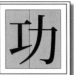

Onyomi: **kou, ku**

成功	seikou	success, a hit
功績	kouseki	expoit, achievement
有功	yuukou	valid, effective
功徳	kudoku	act of charity

INDEPENDENT FORM:

Kunyomi: **isao**

| 功 | isao | accomplishment |

COMPONENT FORMS:

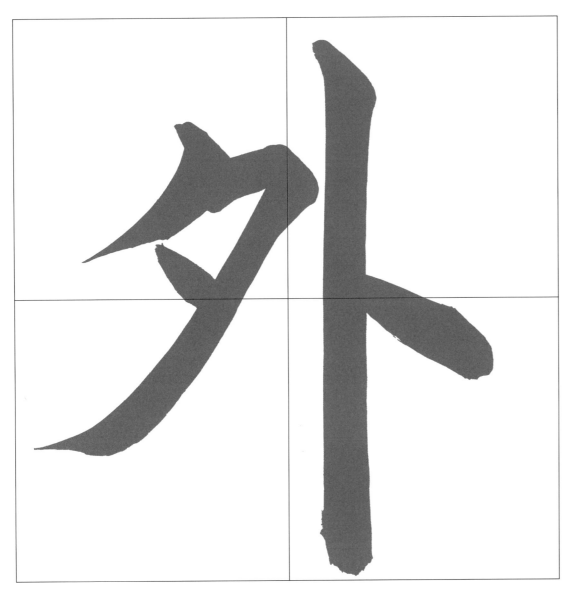

SKIP Pattern 1 ▮☐ 外 1-3-2

	outside Based on radical #36 (夕), this character is normally used independently, but does occur inside of a few other characters.	

Onyomi: gai, ge

外国	gaikoku	foreign country
外交	gaikou	diplomacy
外見	gaiken	outward, appearance
例外	reigai	exception
外科	geka	surgery

ノ	ク	タ	列	外			

Kunyomi: soto, hoka, hazu-

外枠	sotowaku	border
外側	sotogawa	exterior, outside
外に	hoka ni	besides, in addition
外れる	hazureru	to miss, to fail

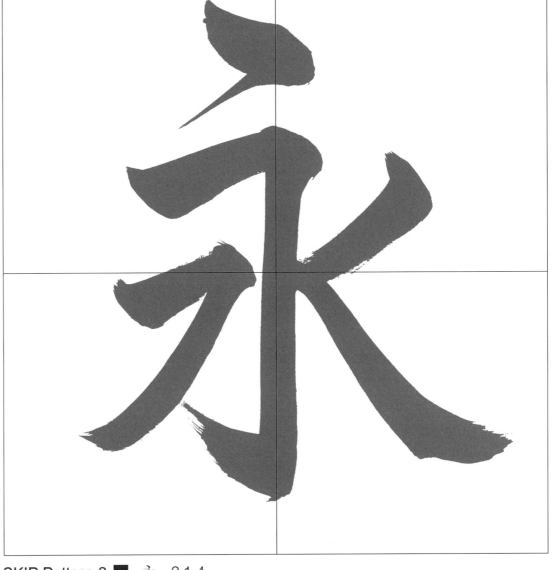

SKIP Pattern 2 ☐ 永 2-1-4

	eternity Based on radical #85 (水), this character is normally used independently, but does occur inside of a few other characters.	

Onyomi: ei

永遠	ei'en	for ever, eternity
永続	eizoku	permanence, durability
永久	eikyuu	eternity
永住	eijyuu	permanent residence

`	丁	才	永	永			

Kunyomi: naga-

永い	nagai	long time
永らく	nagaraku	for a long time

※ This character is used as the standard when learning calligraphy. See the section titled "The Structure of Kanji".

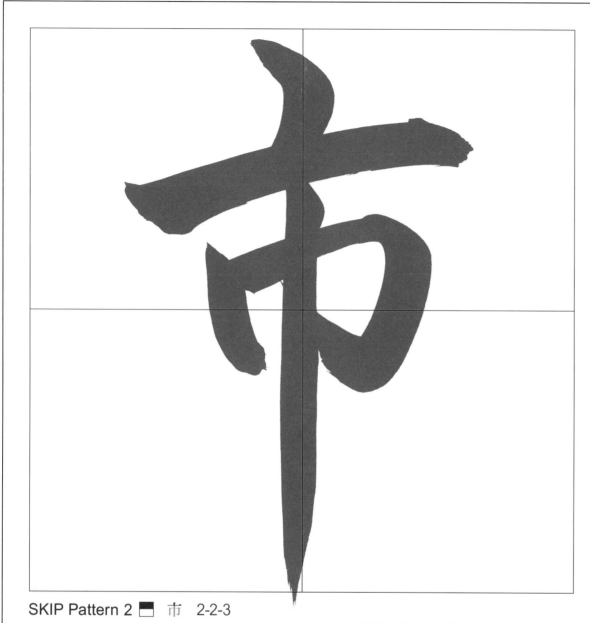

SKIP Pattern 2 ▭ 市 2-2-3

5 STROKES	**city, market, town**	市
	Based on radical #50 (巾), this character is normally used independently, but does occur inside of a few other characters.	

Onyomi: shi

市長	shichou	city mayor
市民	shimin	citizen
都市	toshi	city
市町村	shichouson	cities, towns and villages

 亠 亣 亣 市

Kunyomi: ichi

市場	ichiba	city market
ガラクタ市	garakutaichi	rummage sale
やみ市	yamiichi	black market
朝市	asaichi	morning market

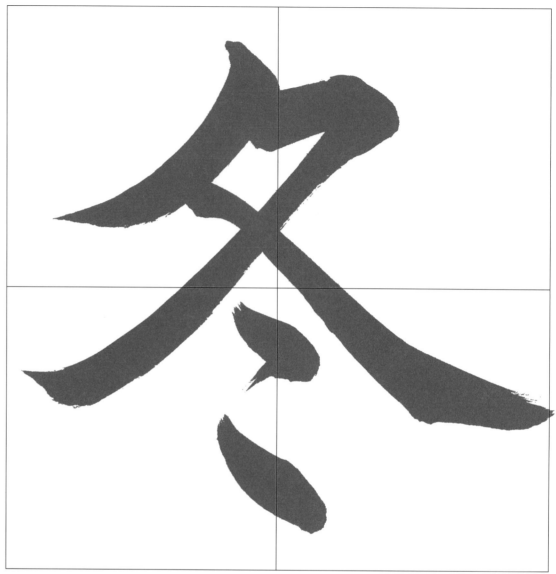

SKIP Pattern 2 ▭ 冬 2-3-2

5 STROKES	**winter**	冬
	Based on radical #15 (冫), this character is normally used independently, but does occur inside of a few other characters.	

Onyomi: tou

冬季	touki	winter season
冬期	touki	winter time
冬眠	toumin	hibernation
暖冬	dantou	mild winter

 ノ 夂 冬 冬

Note that "nisui" (冫) is used in an alternate form for the ashi position in this character.

Kunyomi: fuyu

冬休み	fuyu yasumi	winter vacation
冬物	fuyumono	winterclothes
冬空	fuyuzora	winter sky
冬仕度	fuyu jitaku	prepare for the winter

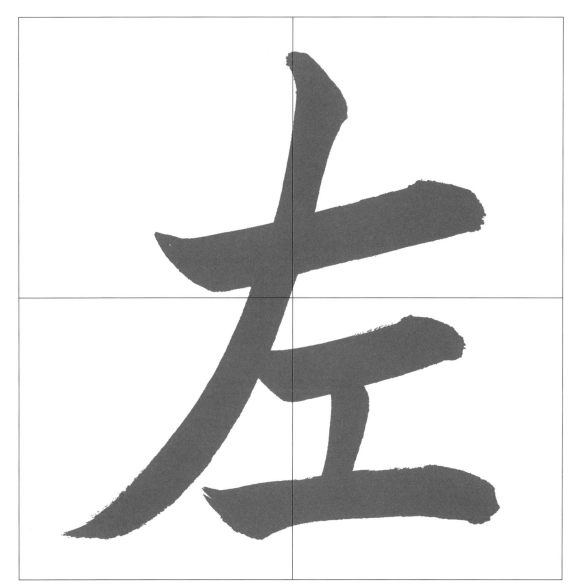

SKIP Pattern 3 □ 左 3-2-3

5 STROKES — left

Based on radical #48 (工), this character is used independently and does not occur inside of other characters.

Onyomi: sa

左折	sasetsu	left turn
左脳	sanou	left brain
左右	sayuu	left-right
左翼	sayoku	left wing

Note that despite the similarities between the two characters for "right" and "left", "right" begins with a right to left stroke., while "left" begins with a left to right stroke.

Kunyomi: hidari

左手	hidarite	left hand
左足	hidariashi	left leg
左利き	hidarikiki	left-handed
左回り	hidarimawari	counter clockwise direction

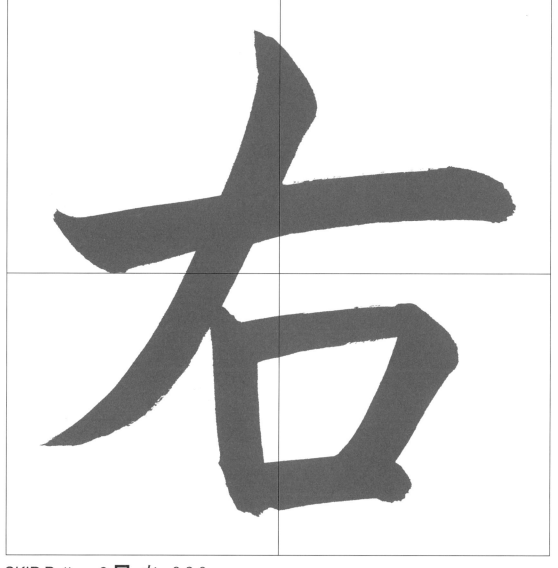

SKIP Pattern 3 □ 右 3-2-3

5 STROKES — right

Radical #112 is based on radical #30 (口) and is used independently and as a component of many other complex kanji.

Onyomi: u, yuu

右折	usetsu	turn right
右脳	unou	right brain
右翼	uyoku	right wing
座右の銘	zayuu no mei	motto

Note that despite the similarities between the two characters for "right" and "left", "right" begins with a right to left stroke., while "left" begins with a left to right stroke.

Kunyomi: migi

右手	migite	right hand
右足	migi'ashi	right leg
右利き	migikiki	right-handed
右回り	migimawari	clockwise direction

ノ ナ オ 右 右

SKIP Pattern 3 ☐ 目 3-3-2

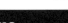

5 STROKES eye

Used independently or as a radical (#109) in many other characters. May become very narrow (目) in several positions.

	Onyomi: **moku, boku**	
目前	mokuzen	before one's eyes
目次	mokuji	contents
科目	kamoku	course, subject
面目	menboku	face, honor

	Kunyomi: **me, ma-**	
一目	hitome	at a glance, a look
目薬	megusuri	eyewash
目印	mejirushi	mark, sign
目ぶた	mabuta	eyelid

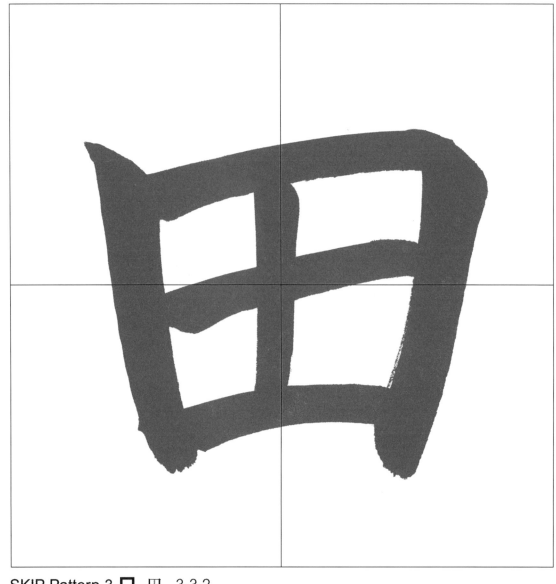

SKIP Pattern 3 ☐ 田 3-3-2

5 STROKES field

Used independently or as a radical (#102) in many other characters.

	Onyomi: **den**	
田園	den'en	rural areas, countryside
水田	suiden	rice paddy, flooded field
田野	denya	fields
油田	yuden	oil field

	Kunyomi: **ta, i***	
田んぼ	tambo	rice paddy field
田植え	taue	rice planting
成田	narita	Narita
田舎	inaka	suburbs, countryside

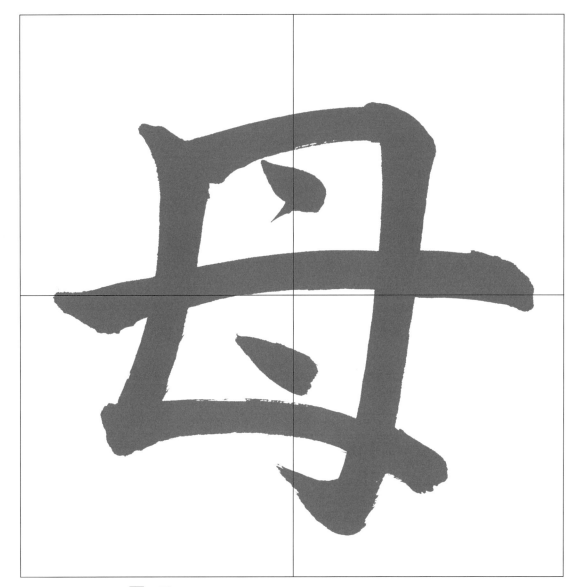

SKIP Pattern 4 ■ 母 4-5-1

5 STROKES

mother

This radical (# 80) is used independently and also occurs as a component in a few other complex characters.

母

 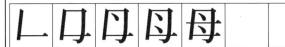

Onyomi: **bo, mo**

母性	bosei	maternal
祖母	sobo	grandmother
母国語	bokokugo	mother tongue
母音	bo'in	vowel sound
雲母	unmo	mica

Kunyomi: **haha, kaa**

母の日	haha no hi	Mother's Day
母親	hahaoya	mother
お母さん	okaasan	mother, mom

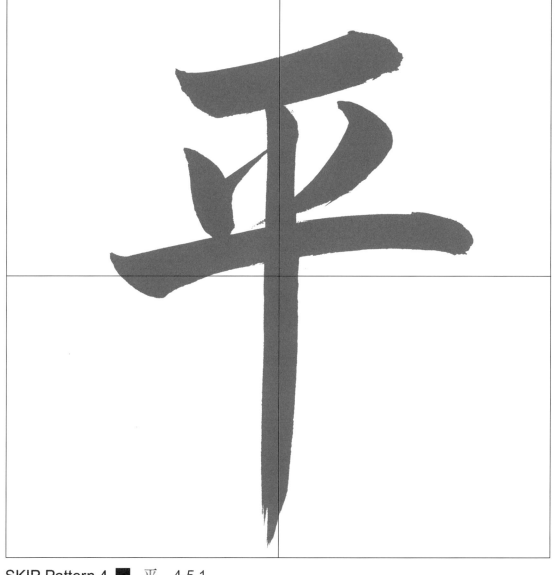

SKIP Pattern 4 ■ 平 4-5-1

5 STROKES

even

Based on radical #51 (干), this character is normally used independently, but does occur inside of a few other characters.

平

Onyomi: **hei, byou**

平和	hiewa	peace
水平	suihei	water level, horizon
平均	heikin	equilibrium, average
平等	byoudou	equality, impartiality

NORMAL:

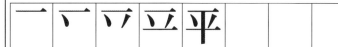

ALTERNATE: _____

As a component in some complex kanji, the top line may be sloped and the bottom may be hooked.

STRAIGHT | SLOPED WITH HOOK

Kunyomi: **tai(ra), hira**

平ら	tiara	flat
手の平	tenohira	palm of the hand
平手	hirate	evenhanded, equality
平仮名	hiragana	hiragana

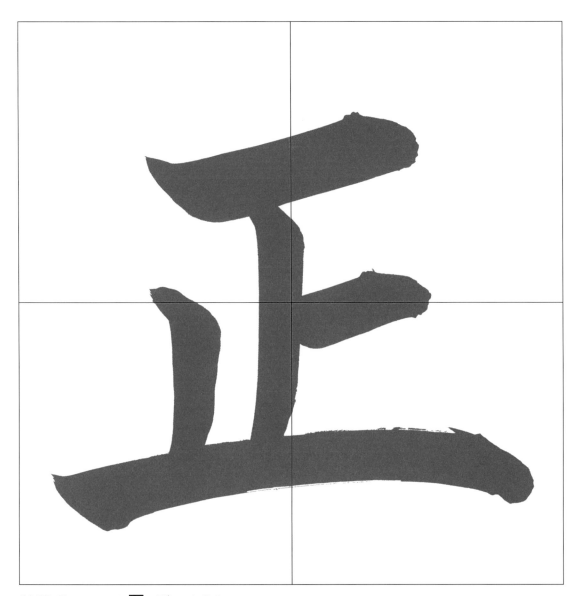

SKIP Pattern 4 ■ 正 4-5-1

 correct, righteous
5 STROKES

Based on radical #77(止),this character occurs in other kanji also. In the hen position, it changes appearance to 正.

Onyomi: **sei, shou**

正確	seikaku	correct, accurate
公正	kousei	justice
不正	fusei	unfairness, impropriety
正直	shoujiki	honesty

Kunyomi: **tada-, masa**

正しい	tadashii	proper, correct
正す	tadasu	to correct
正しい答え	tadashii kotae	correct answer
正に	masani	surely

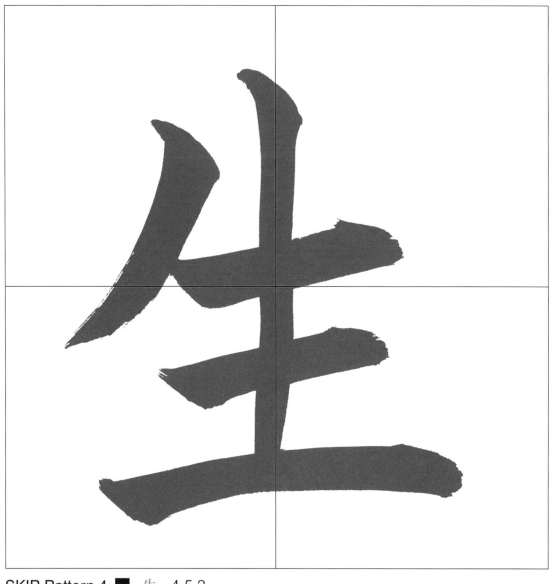

SKIP Pattern 4 ■ 生 4-5-2

 life, birth, pure
5 STROKES

Used independently or as a radical (#100) in some other characters. In the hen position, changes appearance to 生.

Onyomi: **sei, shou**

人生	jinsei	human life
生産	seisan	production
生活	seikatsu	living, daily life
一生	isshou	lifetime

Kunyomi: **i-, u-, ha-, nama, ki, o-**

生まれる	umareru	to be born
生きる	ikiru	to live
生える	haeru	to grow, to sprout
生ビール	namabiiru	draft beer
生糸	kiito	raw silk
生い立ち	oitachi	personal history

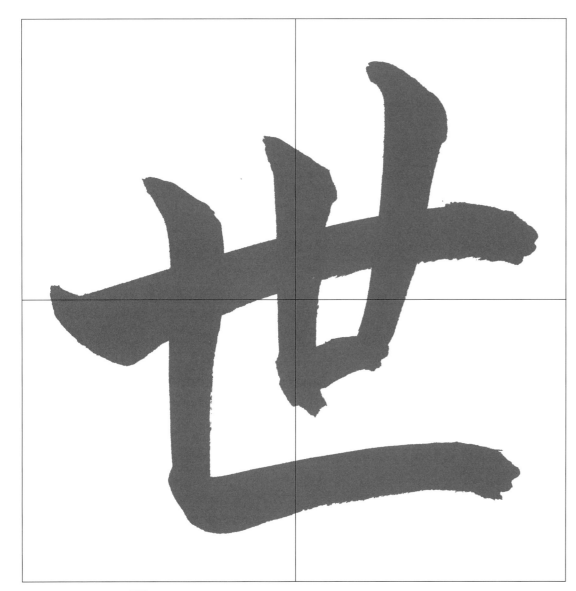

SKIP Pattern 4 ■ 世 4-5-2

5 STROKES **world**

Based on radical # 1 (一), this character is normally used independently, but does occur inside of a few other characters.

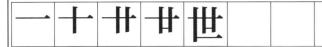

Onyomi: se, sei

世間	seken	the world, life, society
世代	sedai	generation
世界	sekai	the world
世紀	seiki	century, era

Kunyomi: yo

世の中	yononaka	the world, the times
あの世	anoyo	the next/other world, hearafter, underworld
世論	yoron	public opinion

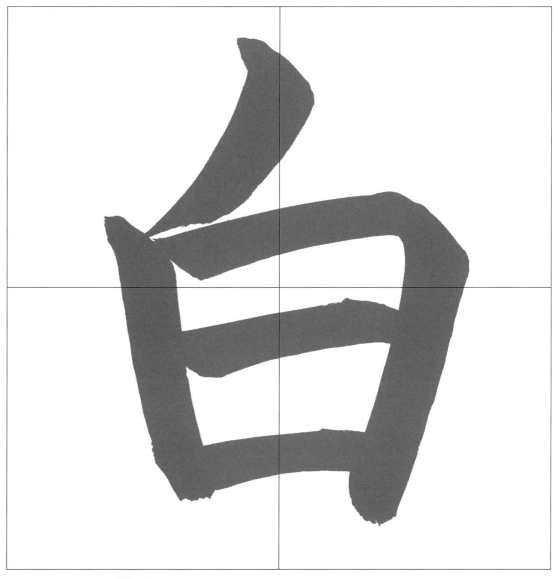

SKIP Pattern 4 ■ 白 4-5-2

5 STROKES **white**

This radical (#106) is used independently and also occurs as a component in many other complex characters.

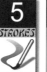 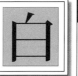

Onyomi: haku, byaku

白紙	hakushi	white (blank) paper
白鳥	hakuchou	swan
白米	hakumai	white rice
白夜	byakuya	the midnight sun

Kunyomi: shiro, shira-

白い	shiroi	white
白旗	shirohata	white flag
真白	masshiro	pure white
白浜	shirahama	white beach

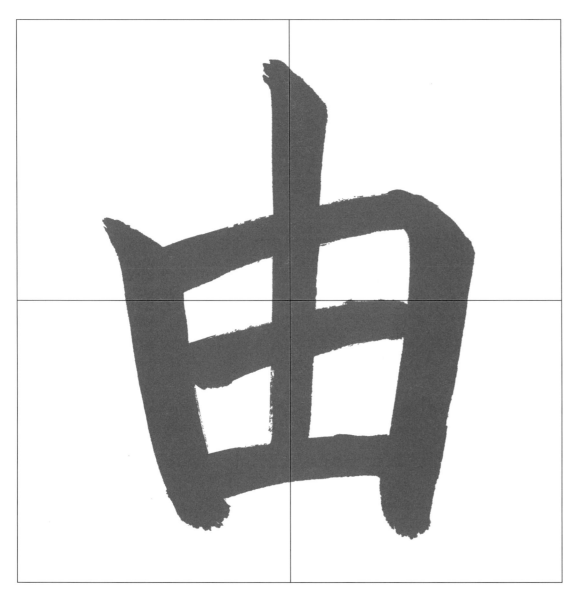

SKIP Pattern 4 ■ 由 4-5-2

5 STROKES **reason**

Based on radical #102 (田), this character is used independently and occurs in many complex characters.

由

Onyomi: yuu, yu, yui

自由	jiyuu	freedom, liberty
理由	riyuu	reason, motive
経由	keiyu	via, way of
由緒	yu'isho	venerable, time-honored

Kunyomi: yo-, yoshi

| 由る | yoru | due to |
| 由 | yoshi | cause, reason |

 一 冂 冋 甶 由

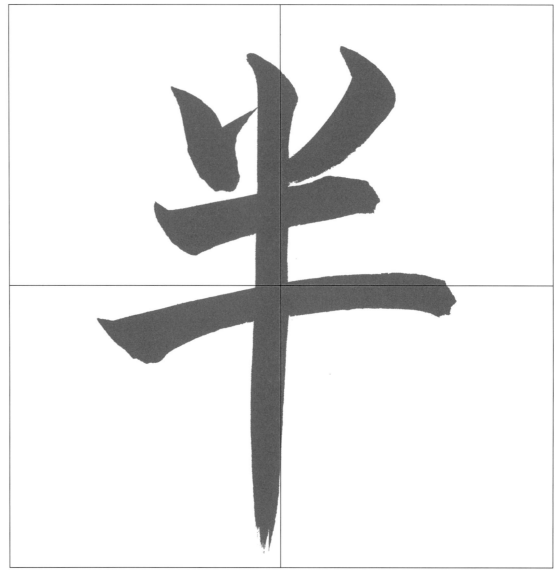

SKIP Pattern 4 ■ 半 4-5-3

5 STROKES **half, odd number, semi**

Based on radical #24 (十), this character is normally used independently, but does occur inside of a few other characters.

半

Onyomi: han

半分	hanbun	half
半島	hantou	peninsula
前半	zenhan	the first half
半紙	hanshi	calligraphy paper

Kunyomi: naka(ba)

半ば	nakaba	middle, half-way
月半ば	tsuki nakaba	
		middle of the month

 丶 丷 䒑 半 半

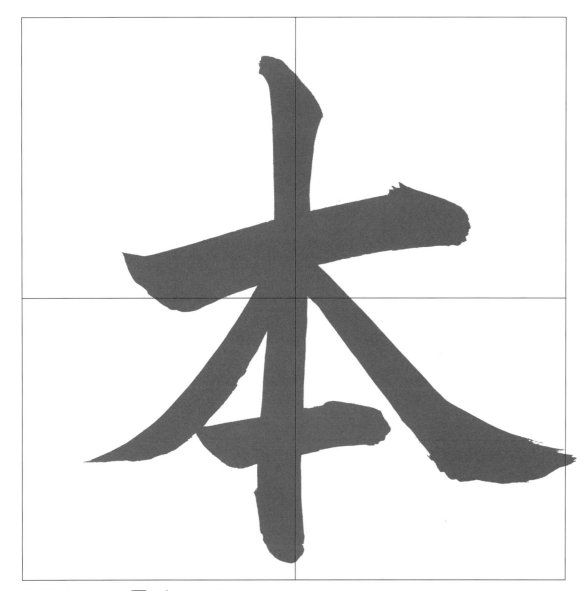

SKIP Pattern 4 ■ 本 4-5-3

 5 STROKES

book, main, actual
Based on radical #75(木), this character is normally used independently, but does occur inside of a few other characters.

本

一 十 才 木 本

Onyomi: hon

古本	furuhon	used book, old book
本部	honbu	headquarters
本物	honmono	the real thing, authentic
本気	honki	serious

Kunyomi: moto

大本	oomoto	foundation, origin
国の本	kuni no moto	
		national principles
根本	nemoto	foundation, source

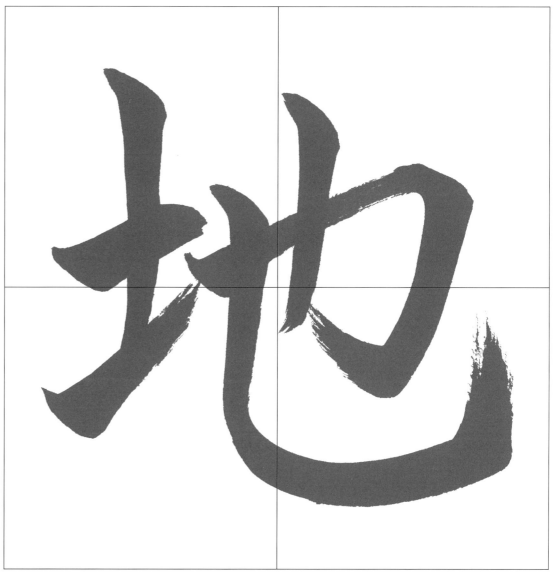

SKIP Pattern 1 ■ 地 1-3-3

 6 STROKES

ground, earth
Based on radical #32(土), this character is used independently and does not occur inside of other characters.

地

一 十 土 圠 圳 地

Onyomi: chi, ji

地下	chika	underground
地図	chizu	map
地面	jimen	ground, earth's surface
意地	iji	willpower, stubbornness

Kunyomi: *<none>*

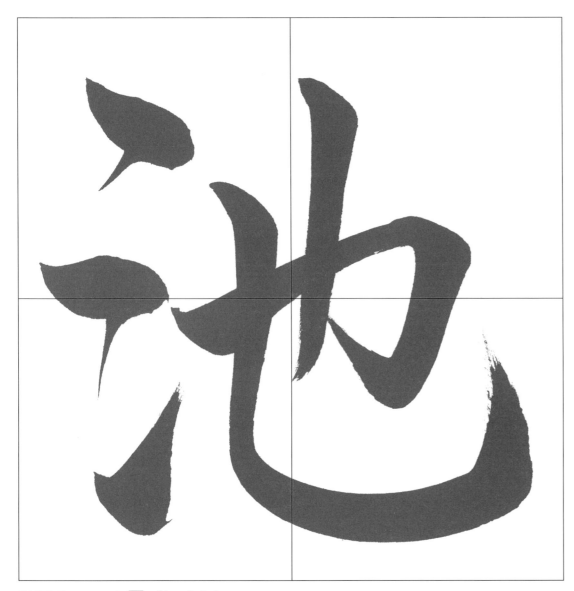

SKIP Pattern 1 ▌☐ 池 1-3-3

6 STROKES	**pond, reservoir**	池

Based on radical #85(水), this character is used independently and does not occur inside of other characters.

 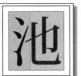

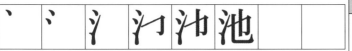

Onyomi: chi

貯水池	chosuichi	reservoir
電池	denchi	battery
乾電池	kandenchi	dry cell battery

Kunyomi: ike

溜池	tame'ike	reservoir, pond
庭池	niwa'ike	garden pond

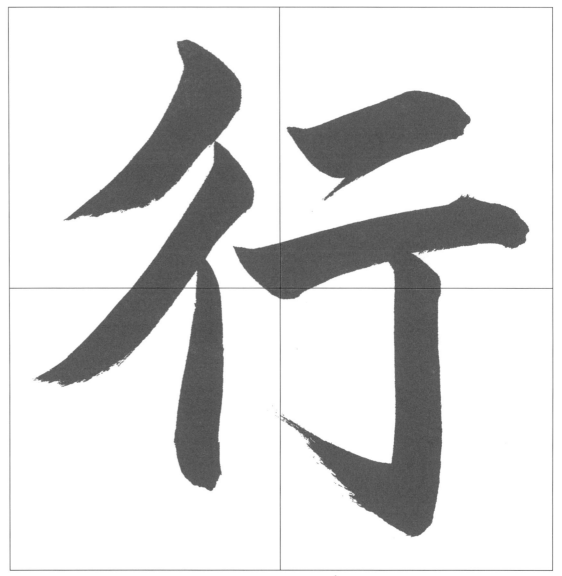

SKIP Pattern 1 ▌☐ 行 1-3-3

6 STROKES	**act, go**	行

This radical (#144) is used independently and also occurs as a component in many other complex characters, often split in the middle.

COMPONENT FORMS

NORMAL SPLIT IN THE MIDDLE

Onyomi: kou, gyou

実行	jikkou	carry out, practice
飛行	hikou	aviation, flying
行進	koushin	march, parade
行事	gyouji	event, function

Kunyomi: i-, yu-, okona-

行く	iku	go
行く	yuku	go
行う	okonau	to perform, to do

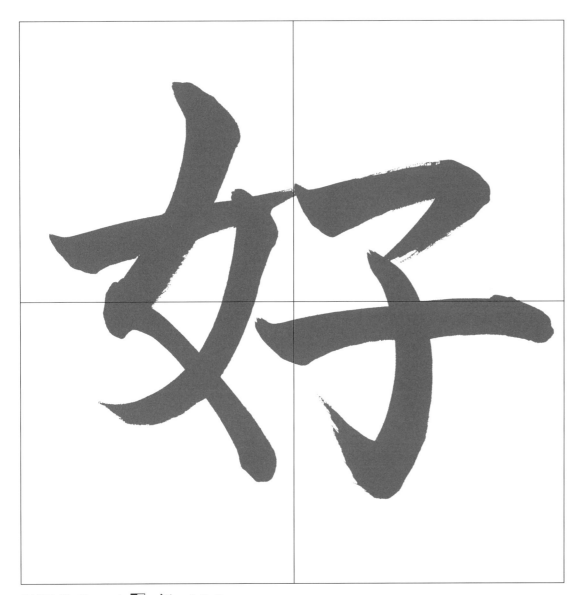

SKIP Pattern 1 ■☐ 好 1-3-3

| **6** STROKES | **fondness, pleasing** Based on radical #38(女),this character is used independently and does not occur inside of other characters. | 好 |

Onyomi: kou

好物	koubutsu	favorite food
好奇心	koukishin	curiosity, inquisitiveness
格好いい	kakkouii	cool, stylish, looking good
愛好者	aikousha	enthusiast, fan

Kunyomi: su-, kono-, yo-, i-

好き	suki	to like
好み	konomi	liking, taste, preference
仲好し	nakayoshi	close friend
好い	ii, yoi	good, excellent

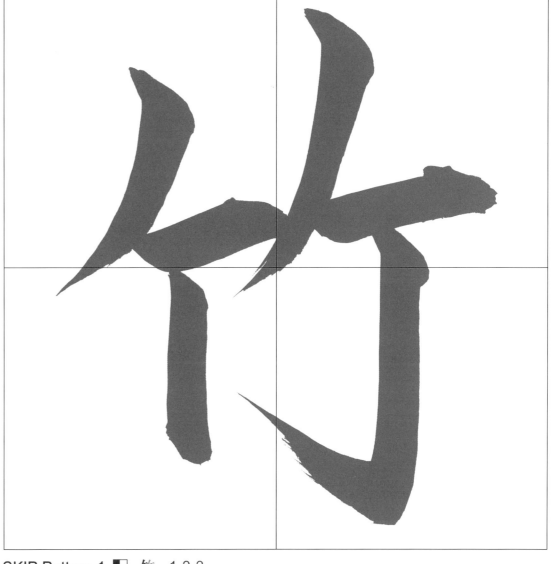

SKIP Pattern 1 ■☐ 竹 1-3-3

| **6** STROKES | **bamboo** Used independently or as a radical (#118) in the *kanmuri* position of many other characters. Changes appearance to ⺮. | 竹 |

Onyomi: chiku

竹材	chikuzai	bamboo material
竹輪	chikuwa	fish paste sausage
爆竹	bakuchiku	firecracker
竹林	chikurin	bamboo grove

Kunyomi: take, -dake

竹の子	takenoko	bamboo shoot
竹細工	takezaiku	bamboo works
竹馬	takeuma	stilt
青竹	aodake	green bamboo

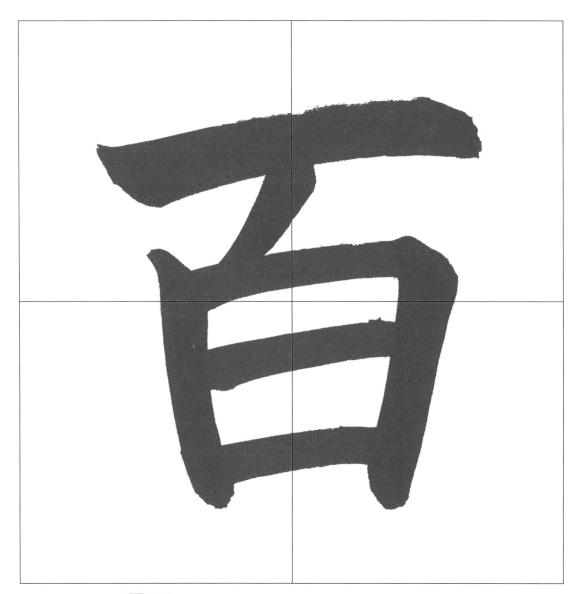

SKIP Pattern 2 ■ 百 2-2-4

6 STROKES

hundred

Based on radical #106 (白), this character is normally used independently, but does occur inside of a few other characters.

百

Onyomi: hyaku, -byaku, -hya*-

百円	hyaku'en	one hundred yen
三百	sambyaku	three hundred
百回	hyakkai	one hundred times
百貨店	hyakkaten	department store

Kunyomi: momo

| 百千 | momochi | large amount or number |
| 百敷 | momoshiki | the Imperial Court |

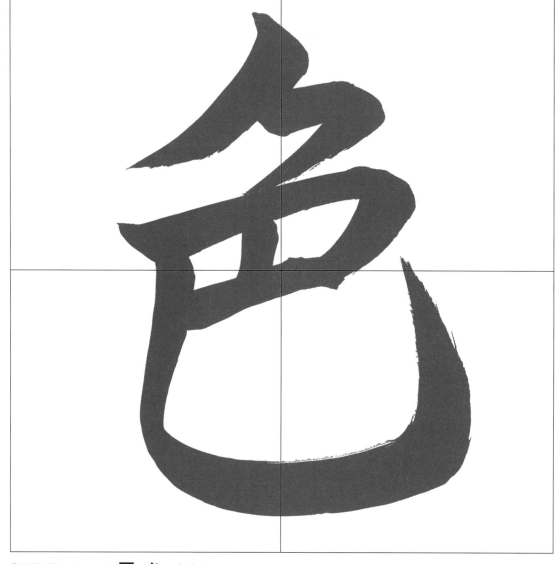

SKIP Pattern 2 ■ 色 2-2-4

6 STROKES

color

This radical (#139) is used independently and also occurs as a component in a few other complex characters.

色

Onyomi: shoku, shiki

原色	genshoku	primary colors
才色	saishoku	intelligence and beauty
色彩	shikisai	color, tinct
景色	keshiki	scenery

Kunyomi: iro

色紙	irogami	colored paper
金色	kin'iro	golden color
色男	iro'otoko	handsome man, ladykiller
色っぽい	iroppoi	amorous, erotic

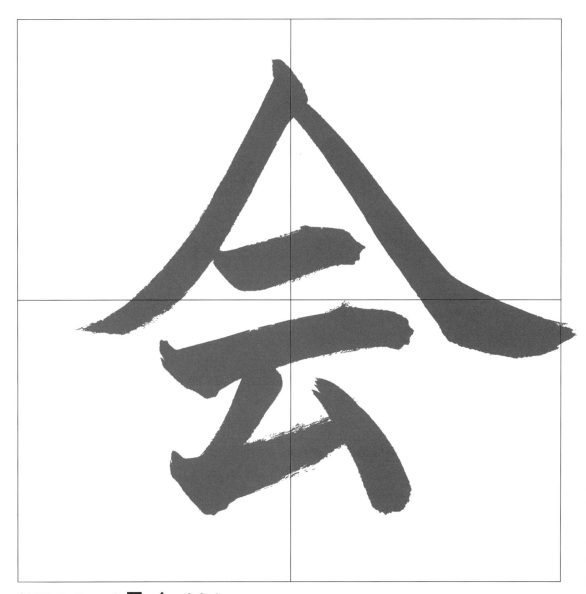

SKIP Pattern 2 ▬ 会 2-2-4

6 STROKES **meeting, join**
Based on radical #9 (人), this character is used independently and occurs as a component in only one other complex character. (絵)

会

Onyomi: kai, e

会議	kaigi	meeting. conference
会社	kaisha	company
社会	shakai	society
図会	zue	picture

Kunyomi: a-

会う	au	to meet
会いたい	aitai	to want to meet
出会い	de'ai	encounter, meeting

SKIP Pattern 2 ▬ 糸 2-3-3

6 STROKES **thread**
Used independently or as a radical (#120) in many other characters. In the hen position, changes appearance to 糸.

糸

Onyomi: shi

金糸	kinshi	gold thread
銀糸	ginshi	silver thread
抜糸	basshi	removal of stitches
糸帛	shihaku	silk fabrics

Kunyomi: ito

糸車	itoguruma	spinning wheel
毛糸	ke'ito	wool
釣り糸	tsuri'ito	fishing line
色糸	iro'ito	colored thread

 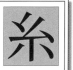

Most printed fonts and some calligraphy styles make *"ito"* look like seven or eight strokes, but it is taught as only six in public schools.

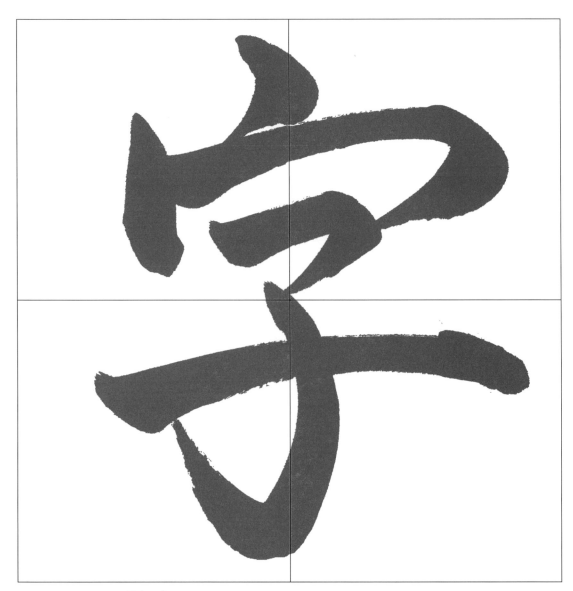

SKIP Pattern 2 ■ 字 2-3-3

6 STROKES	**character, letter, area**	字
	Based on radical # 39 (子), this character is used independently and does not occur inside of other characters.	

Onyomi: ji

文字	moji	letter, character
大文字	oomoji	capital letters
赤字	akaji	red letters, deficit
名字	myouji	sir name

Kunyomi: aza

字	aza	village district

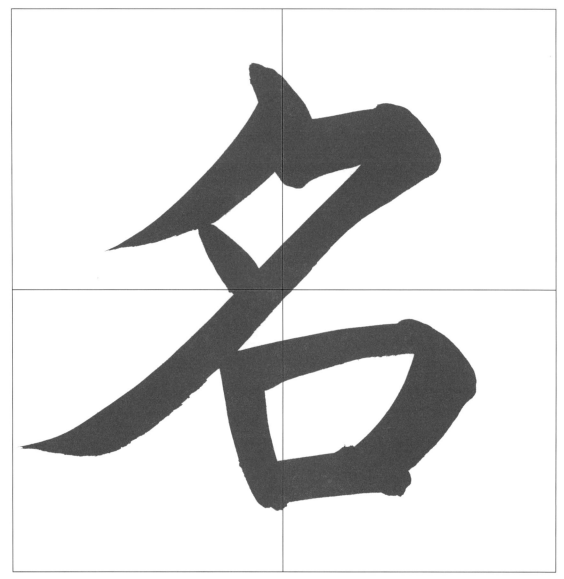

SKIP Pattern 2 ■ 名 2-3-3

6 STROKES	**name, reputed**	名
	A combination of radical#30 (口) and #36 (夕), this character is used independently and as a component in only a few complex kanji.	

Onyomi: mei, myou

有名	yuumei	famous
名言	meigen	wise saying
名刺	meishi	business (name) card
名字	myouji	sir name

Kunyomi: na

名前	namae	name
仮名	kana	the Japanese syllabary
仮の名	kari no na	alias, assumed name
あだ名	adana	nickname

ノ ク タ タ 名 名

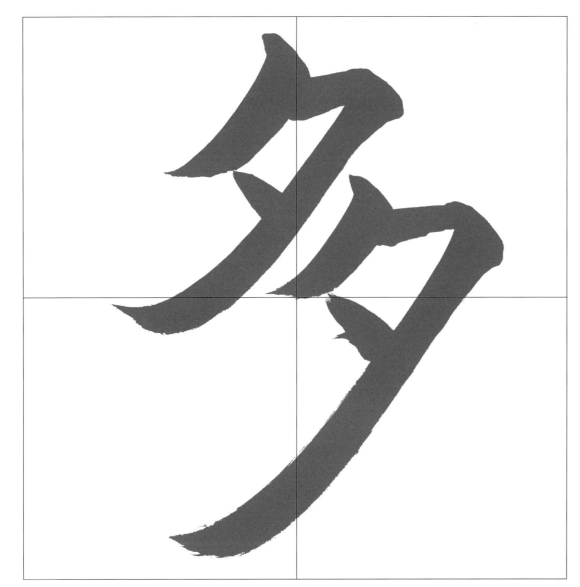

SKIP Pattern 2 ▣ 多 2-3-3

6 STROKES	**many, frequent, much** Based on radical #36 (夕), this character is used independently and seldomly occurs in complex characters.	多

Onyomi: ta

多数	tasuu	many, majority
多分	tabun	probably, maybe
多重	tajyuu	multiple
多面	tamen	multifaceted, many sided

Kunyomi: 00-

| 多い | ooi | many |
| 数多く | kazu'ooku | in great numbers |

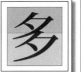

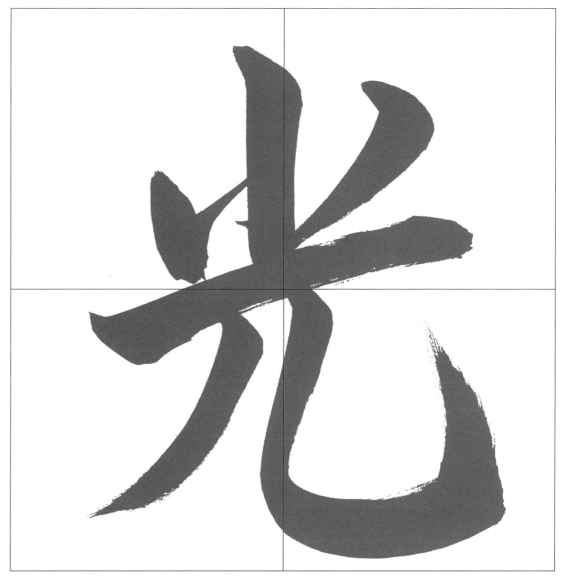

SKIP Pattern 2 ▣ 光 2-4-2

6 STROKES	**light** Based on radical #10 (儿), this character is normally used independently, but does occur inside of a few other characters.	光

Onyomi: kou

光線	kousen	ray, beam
光年	kounen	light year
日光	nikkou	sunlight
栄光	eikou	glory, luster

Kunyomi: hikari, hika-

光の早さ	hikari no hayasa	speed of light
光り輝く	hikari kagayaku	brilliant, glorious
光る	hikaru	shine

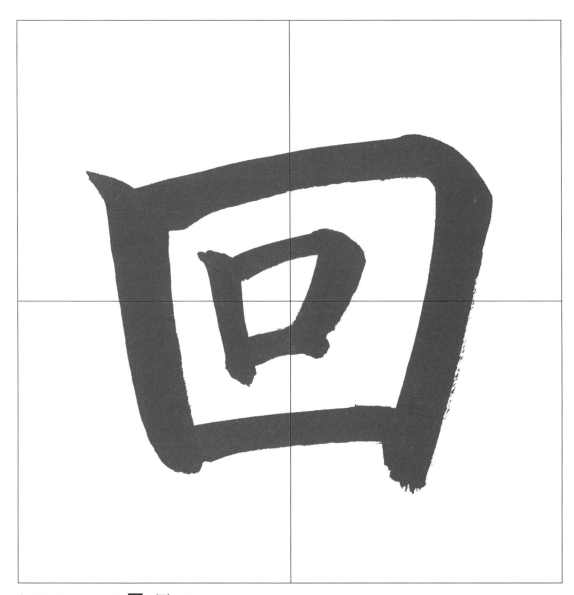

SKIP Pattern 3 □ 回 3-3-3

6 STROKES	-times, around, revolve	回
	Based on radical #31 (口), this character is normally used independently, but does occur inside of a few other characters.	

Onyomi: kai, e

何回	nankai	how many times
回数	kaisuu	number of times, frequency
回答	kaitou	answer, response
回向	ekou	Buddhist memorial service

Kunyomi: mawa-

回る	mawaru	go around, to revolve
走り回る	hashiri mawaru	to run about

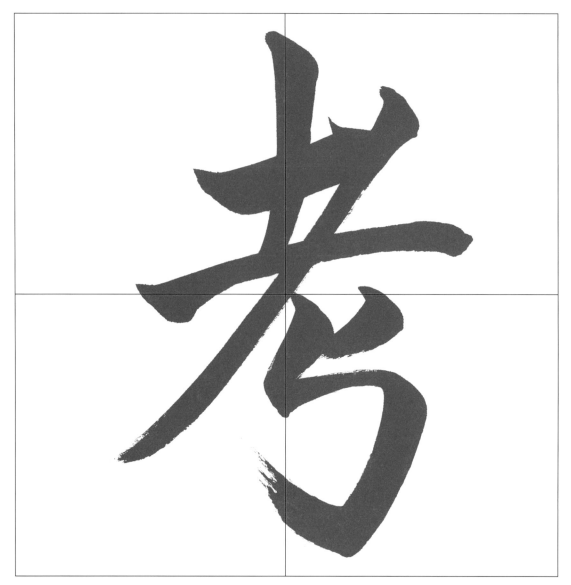

SKIP Pattern 3 □ 考 3-4-2

6 STROKES	consider, think over	考
	Used independently or as a radical (#125) in a few characters. Occurs most often in many other characters as "oigashira" 耂 crown.	

Onyomi: kou

再考	saikou	reconsideration
参考	sankou	reference
考慮	kouryo	take into account
思考	shikou	thought, thinking

Kunyomi: kanga(e)-

考える	kangaeru	to think, to consider
考え方	kangaekata	way of thinking
考えもの	kangaemono	questionable

一 十 土 耂 耂 考

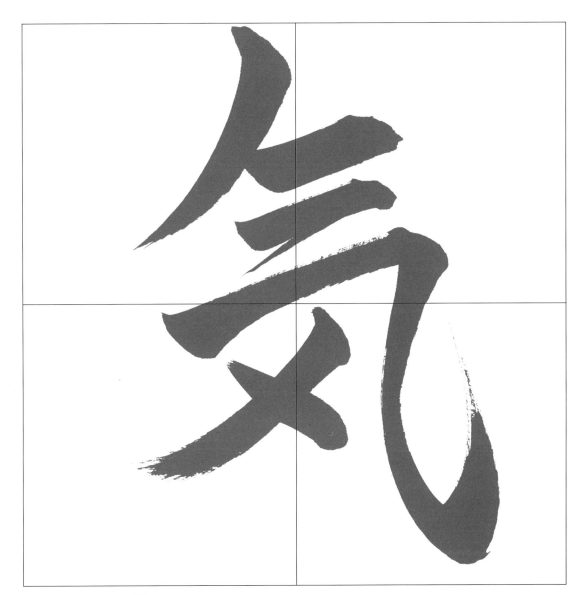

SKIP Pattern 3 ☐ 気 3-4-2

6 STROKES

spirit, mind, essence

Based on radical #84 (气), this character is used independently and does not occur inside of other characters.

気

Onyomi: ki, ke

元気	genki	vigor, cheerful, healthy
気持	kimochi	mood, feeling, sensation
気象	kishou	weather, climate
気付く	kizuku	to notice, to be aware of
脚気	kakke	beriberi

Kunyomi: *<none>*

 ノ ヒ 仁 气 気 気

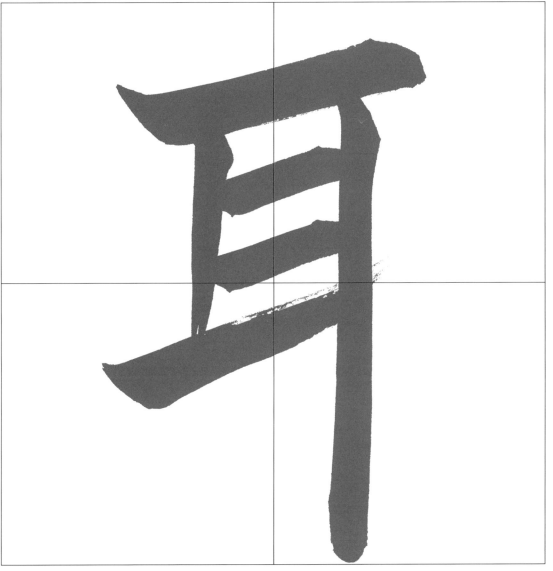

SKIP Pattern 4 ■ 耳 4-6-1

6 STROKES

ear

Used independently or as a radical (#128) in many other characters. In the hen position, changes appearance to 耳.

耳

Onyomi: ji

耳鼻科	jibika	otolaryngology (ENT)
内耳	naiji	inner ear
牛耳る	gyuujiru	to dominate, to control

Kunyomi: mimi

耳たぶ	mimitabu	ear lobe
聞き耳	kikimimi	keep one's ears open
空耳	soramimi	mishear
耳鳴り	miminari	buzzing in the ears

 一 丁 下 F 耳 耳

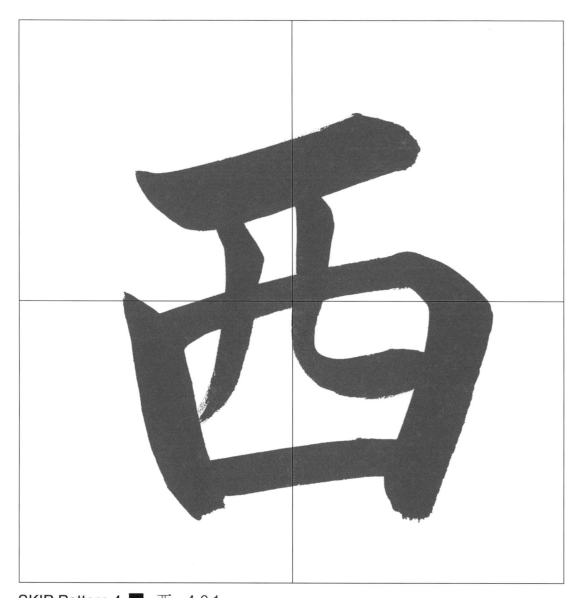

SKIP Pattern 4 ■ 西 4-6-1

west

This radical (#146) is used independently and also occurs in other forms when used as a component in complex kanji.

西

Onyomi: sei, sai

北西	hokusei	northwest
西欧	sei'ou	Western Europe
大西洋	taiseiyou	Atlantic Ocean
関西	kansai	Kansai district

Kunyomi: nishi

西日	nishibi	sun in the west
西向き	nishimuki	facing west
真西	manishi	due west
西口	nishiguchi	west exit

INDEPENDENT FORM:

OTHER RADICAL FORMS:

Alternate form	Tsukuri	Centered	Kanmuri position forms	
西	価	簞	要	覇

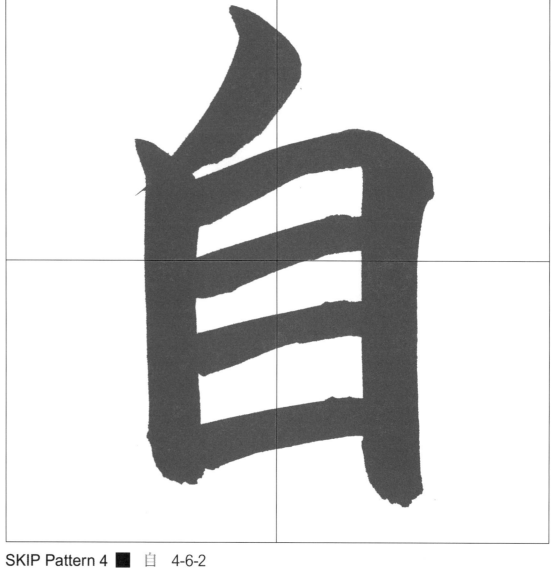

SKIP Pattern 4 ■ 自 4-6-2

oneself, nature

This radical (#132) is used independently and also occurs as a component in many other complex characters.

自

Onyomi: ji, shi

自立	jiritsu	independent
自己	jiko	self-
自筆	jihitsu	handwriting
自然	shizen	natural, spontaneous

Kunyomi: mizuka(ra)

自ら	mizukara	for yourself, personally

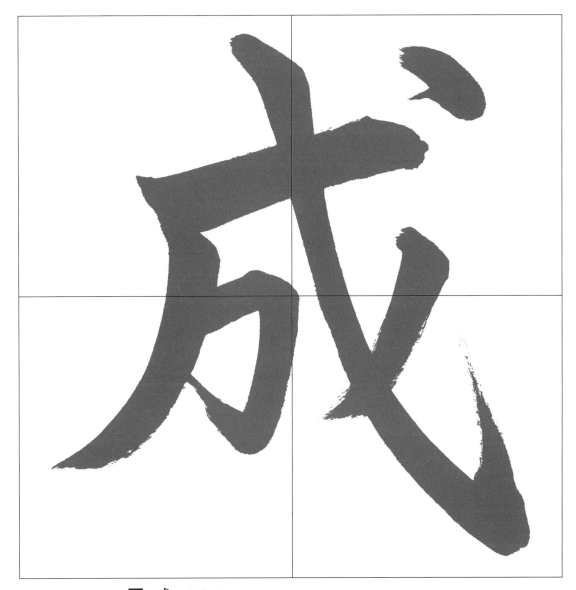

SKIP Pattern 4 ■ 成 4-6-4

| 6 STROKES | **become, turn into** 成 | Based on radical # 62 (戈), this character is used independently and occurs as a component in only one other complex character.(箴) |

Onyomi: sei, jou

成立	seiritsu	establish, come to be
作成する	sakusei suru	to make, to draw up
成人	seijin	adult
成長	seichou	mature, grow up
成仏する	joubutsu suru	to become Buddha

Kunyomi: na-, nari

ノ 厂 厈 成 成 成

成す	nasu	to perform, to accomplish
成る	naru	to become
成り立ち	naritachi	origin, history
成田空港	naritakuukou	Narita (airport)

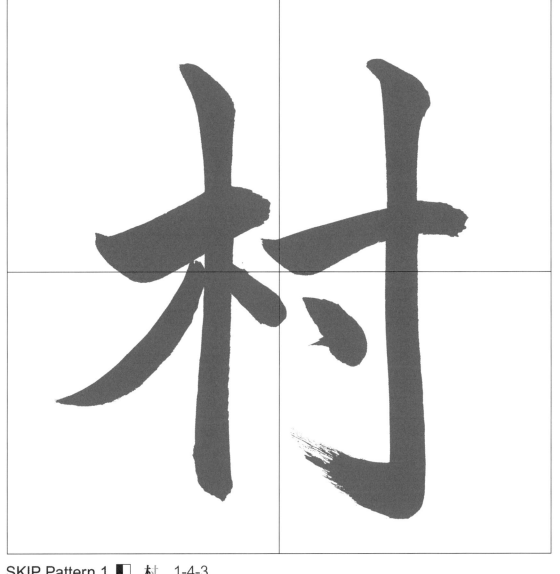

SKIP Pattern 1 ▌ 村 1-4-3

| 7 STROKES | **village** 村 | Based on radical # 75 (木),this character is used independently and does not occur inside of other characters. |

Onyomi: son

村長	sonchou	village leader
村民	sonmin	village people
漁村	gyoson	fishing village
農村	nouson	farming village

Kunyomi: mura

一 十 オ 木 木 村 村

| 村役場 | murayakuba | village office |
| 村祭り | muramatsuri | village festival |

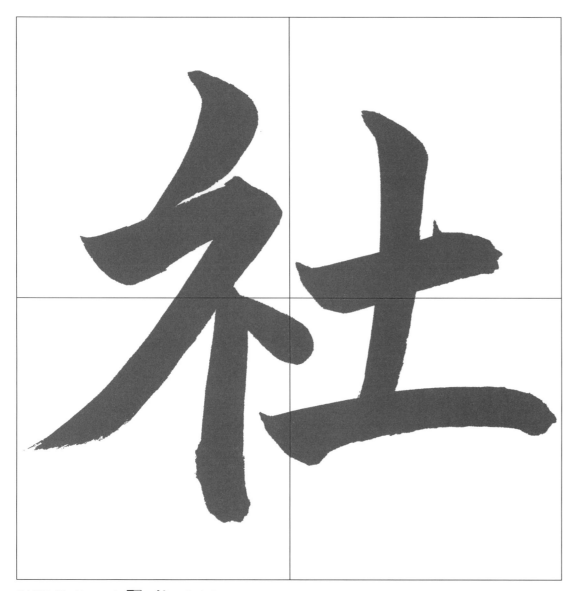

SKIP Pattern 1 ▮ 社 1-4-3

7 STROKES	**company, association**	社

Based on radical #113(示),this character is used independently and does not occur inside of other characters.

Onyomi: sha

会社	kaisha	company
社会	shakai	society
社名	shamei	company name
社則	shasoku	company regulations

Kunyomi: yashiro

社	yashiro	shrine

丶 ウ オ ネ ネ 社 社

SKIP Pattern 1 ▮ 町 1-5-2

7 STROKES	**town, block, street**	町

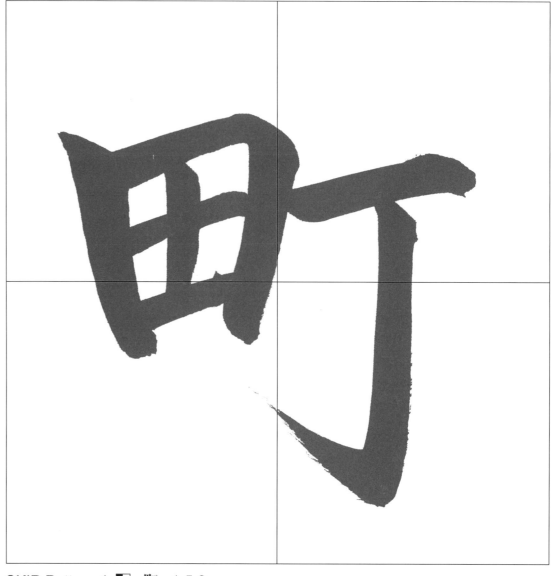

Based on radical #102(田),this character is used independently and does not occur inside of other characters.

Onyomi: chou

町民	choumin	town's folk
町長	chouchou	town's leader
町内	chounai	in the town

Kunyomi: machi

町	machi	town
町へ行く	machi e iku	to go to town
町外れ	machihazure	outskirts
町角	machikado	at the corner of the street

丨 冂 冂 田 田 町 町

76

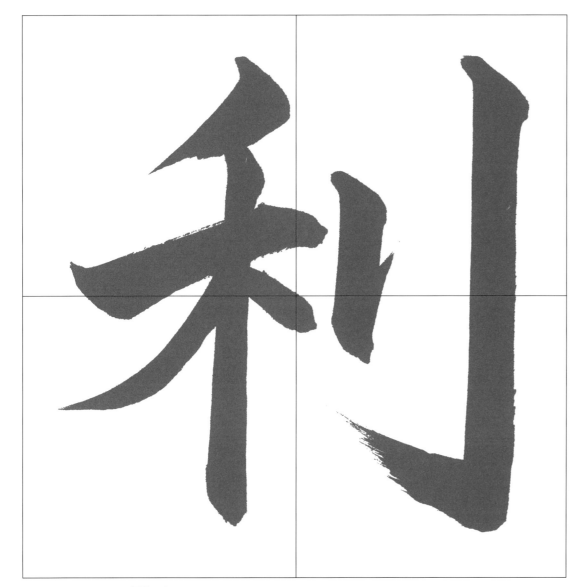

SKIP Pattern 1 ▮▯ 利 1-5-2

7 STROKES

benefit, advantage

 利

Based on radical #18 (刀), this character is used independently and occurs in many complex characters.

Onyomi: ri

利口	rikou	clever, smart
有利	yuuri	advantage
利用	riyou	use
金利	kinri	interest rate

Kunyomi: ki-

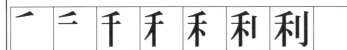

利く	kiku	to be effective
利き酒	kikizake	sake tasting
利き手	kikite	dominant hand

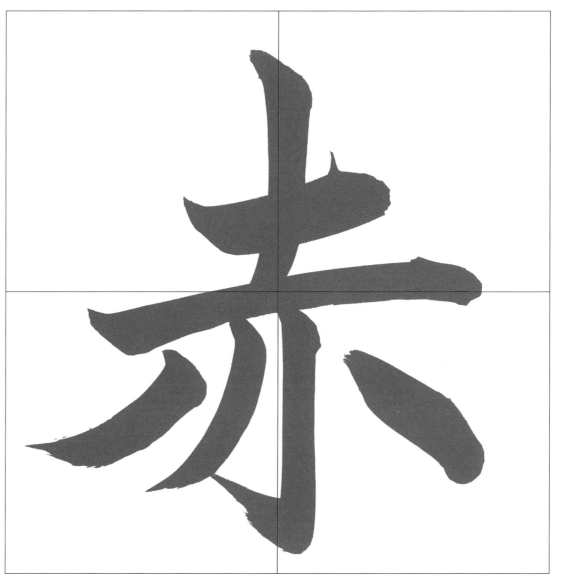

SKIP Pattern 2 ▬ 赤 2-3-4

7 STROKES

red

 赤

This radical (#155) is used independently and occurs as a component in only a few other complex characters.

Onyomi: seki, se*-, shaku

赤道	sekidou	equator
赤外線	sekigaisen	infrared rays
赤面	sekimen	blush
赤血球	sekkekkyuu	red blood cell
赤銅色	shakudou'iro	copper

Kunyomi: aka

一 十 土 牛 赤 赤 赤

赤い	akai	red
赤信号	akashingou	red (traffic) light
赤ちゃん	akachan	baby, infant

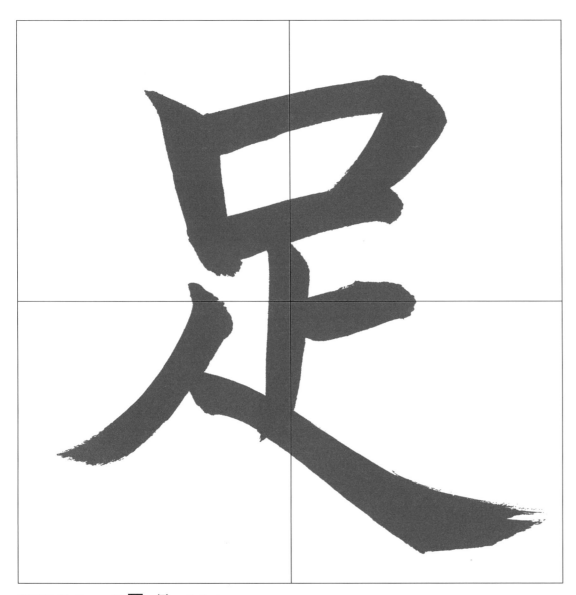

SKIP Pattern 2 ▬ 足 2-3-4

7 STROKES **foot, suffice**
Used independently or as a radical (#157) in many other characters. In the hen position, changes appearance to .

足

Onyomi: soku, -zoku

充足	jyuusoku	sufficiency
不足	fusoku	shortage
足跡	sokuseki	footprints
満足	manzoku	satisfaction

Kunyomi: ashi, ta-

一足	hitoashi	one leg, one foot
足首	ashikubi	ankle
足音	ashi'oto	sound of footsteps
足りる	tariru	to suffice, to be enough

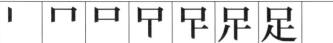

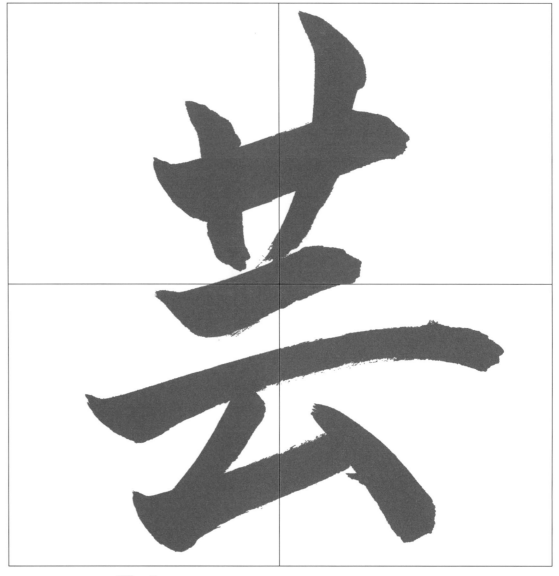

SKIP Pattern 2 ▬ 芸 2-3-4

7 STROKES **art**
Based on radical #140(艸),this character is used independently and does not occur inside of other characters.

芸

Onyomi: gei

芸術	geijutsu	art, the arts
芸能	geinou	entertainment
芸人	geinin	entertainer
芸者	geisha	geisha girl

Kunyomi: <none>

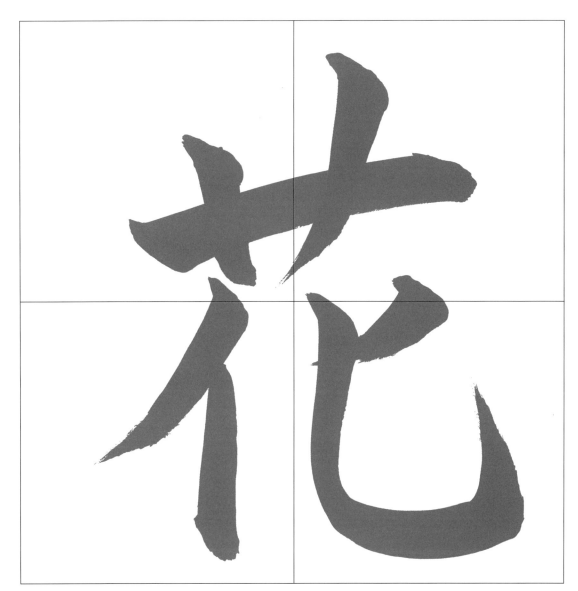

SKIP Pattern 2 � 花 2-3-4

 7 STROKES

flower

Based on radical #140 (艸), this character is used independently and occurs as a component in only a few other complex characters.

花

Onyomi: **ka**		
花鳥風月	kachoufuugetsu	beauty of nature
花瓶	kabin	flower pot
花粉	kafun	pollen
国花	kokka	national flower

Kunyomi: **hana**		
花びら	hanabira	flower petal
花火	hanabi	fireworks
花束	hanataba	bouquet of flowers
生花	ikebana	flower arrangement

 一 十 艹 芢 艿 花 花

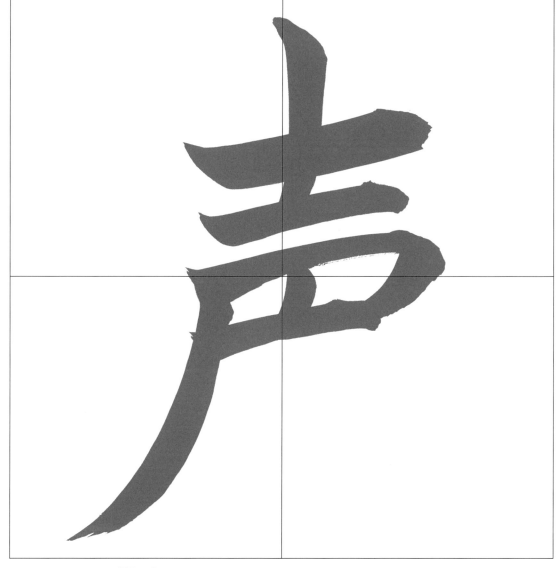

SKIP Pattern 2 ▭ 声 2-3-4

 7 STROKES

voice

Based on radical #33 (士), this character is used independently and does not occur inside of other characters.

声

Onyomi: **sei, shou**		
音声	onsei	voice, sound
声帯	seitai	vocal chords
声明	seimei	declaration
名声	meisei	fame, honor

Kunyomi: **koe, -goe, kowa-**		
優しい声	yasashii koe	soft voice
声を上げる	koe o ageru	to raise one's voice
鼻声	hanagoe	nasal voice
声高	kowadaka	in a loud voice

 一 十 壴 寺 寺 声 声

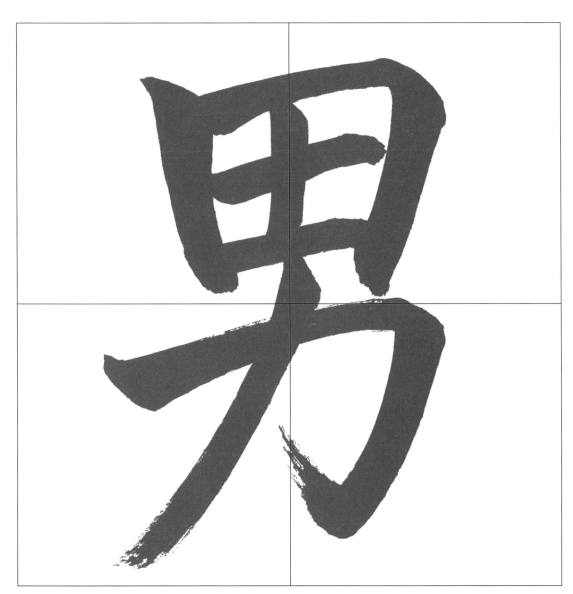

SKIP Pattern 2 ⬓ 男 2-5-2

7 STROKES

man, male 男

Based on radical #102(田), this character is used independently and occurs in many complex characters.

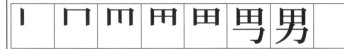

Onyomi: dan, nan

男性	dansei	man, male
男優	danyuu	male actor
男系	dankei	male lineage
次男	jinan	second born son

Kunyomi: otoko

男の子	otoko no ko	boy
男達	otokotachi	men
男っぽい	otokoppoi	manly, masculine
男前	otokomae	handsome

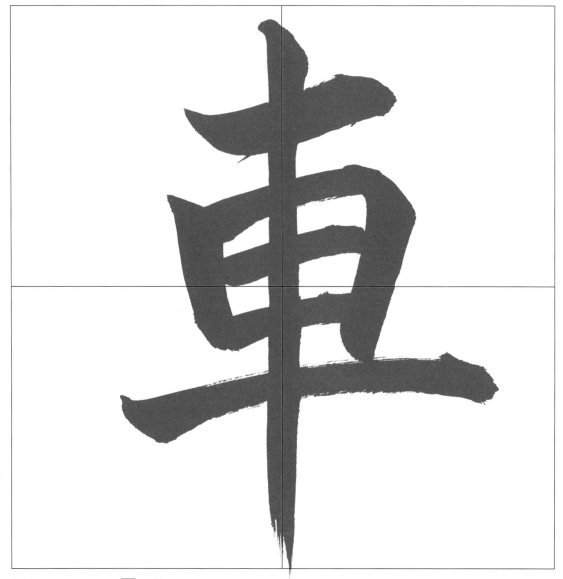

SKIP Pattern 4 ◼ 車 4-7-3

7 STROKES

car, vehicle, wheel 車

This radical (#159) is used independently and also occurs as a component in a few other complex characters.

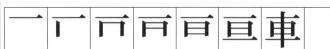

Onyomi: sha

外車	gaisha	foreign car
電車	densha	(electric) train
軽自動車	keijidousha	light weight vehicle
人力車	jinrikisha	rickshaw

Kunyomi: kuruma, -guruma

車椅子	kuruma'isu	wheelchair
車座	kurumaza	sitting in a circle
車えび	kuruma'ebi	prawn, scampi
歯車	haguruma	gear, cog

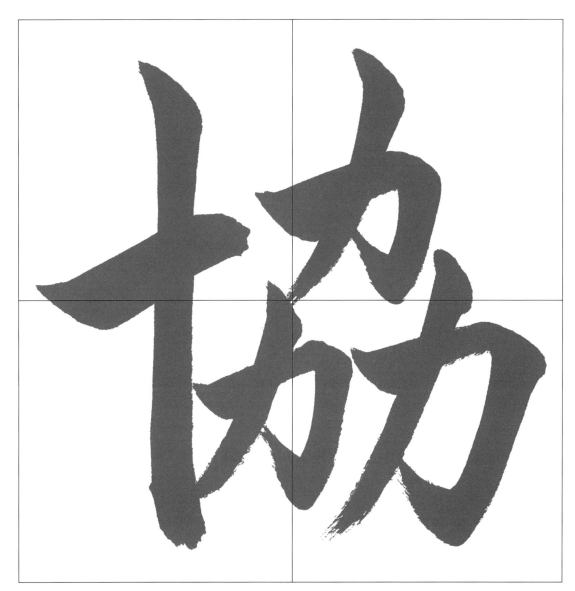

SKIP Pattern 1 ▮▯ 協 1-2-6

8
STROKES

cooperation

Based on radical #24 (十), this character is used independently and does not occur inside of other characters.

Onyomi: kyou

協力	kyouryoku	cooperation, collaboration
協和	kyouwa	harmony, concord
妥協	dakyou	compromise
協会	kyoukai	conference, convention

Kunyomi: *<none>*

一　十　ヤ　ヤ　ヤ　ヤ　協　協

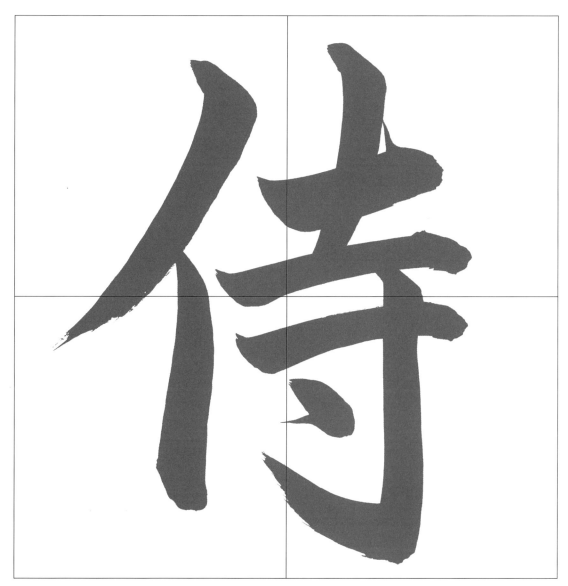

SKIP Pattern 1 ▮▯ 侍 1-2-6

8
STROKES

samurai

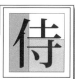

Based on radical #9 (人), this character is used independently and does not occur inside of other characters.

Onyomi: ji

侍者	jisha	attendant, valet
侍女	jijyo	lady attendant, maid.
侍する	jisuru	to wait upon, to serve

Kunyomi: samurai, -zamurai, habe-

侍	samurai	samurai
若侍	wakazamurai	young samurai
芋侍	imozamurai	rustic (boorish) samurai
侍る	haberu	to serve

ノ　イ　イ　イ　伴　侍　侍

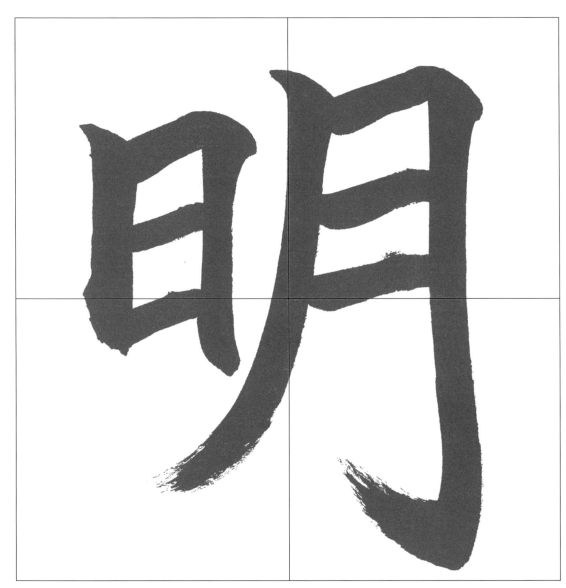

SKIP Pattern 1 ▮ 明 1-4-4

8 STROKES **bright, light, clear**

Based on radical # 72 (日), this character is used independently and occurs as a component in only a few other complex characters.

Onyomi: mei, myou

明確	meikaku	clarify, define
自明	jimei	self-evident, obvious
説明	setsumei	explanation
明朝	myouchou	tomorrow morning

Kunyomi: aka-, aki-, a-

明るい	akarui	bright
明ける	akeru	to become daylight
明らか	akiraka	plainly, clearly
明日	ashita	tomorrow

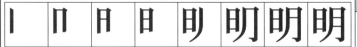

SKIP Pattern 1 ▮ 門 1-4-4

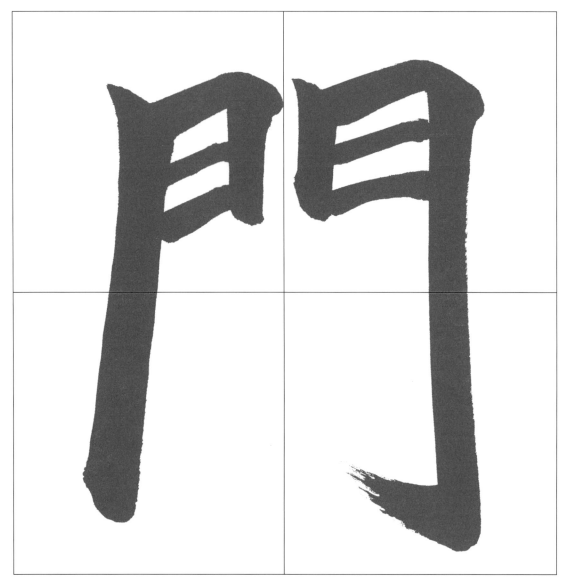

8 STROKES **gate**

This radical (#169) is used independently and also occurs as a component in many other complex characters.

Onyomi: mon

門限	mongen	lockup, closing time
入門書	nyuumonsho	handbook primer
正門	seimon	main gate, front gate
裏門	uramon	back gate

Kunyomi: kado

門出	kadode	embarkation, departure
お門違い	okadochigai	bark up the wrong tree
門松	kadomatsu	decorative pine branches

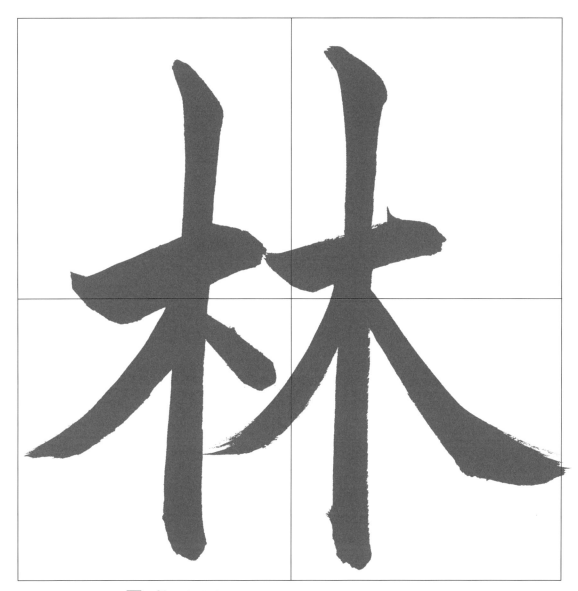

SKIP Pattern 1 ■□ 林 1-4-4

 8 STROKES **forest**

Based on radical # 75 (木), this character is used independently and occurs in some complex characters.

Onyomi: rin

森林	shinrin	woods, forest
林道	rindou	path through the forest
農林	nourin	agriculture and forestry
密林	mitsurin	jungle

Kunyomi: hayashi, -bayashi

一 十 才 木 杧 村 材 林

| 林の中 | hayashi no naka | in the forest |
| 松林 | matsubayashi | pine forest |

SKIP Pattern 1 ■□ 和 1-5-3

 8 STROKES **peace, Japan**

Based on radical #115 (禾), this character is used independently and occurs as a component in only a few other complex characters.

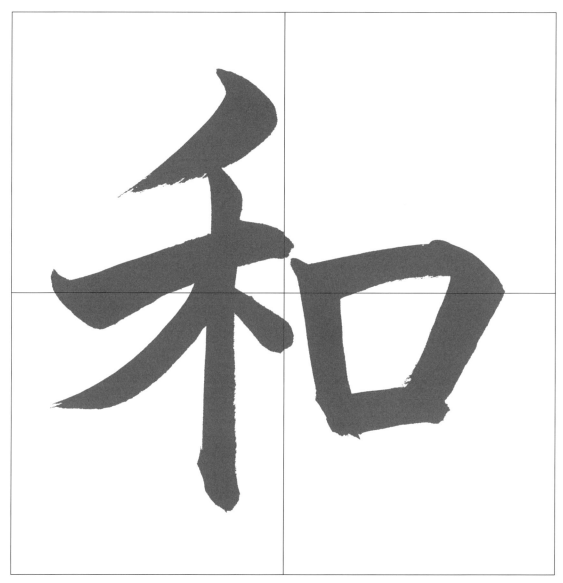

Onyomi: wa

平和	heiwa	peace
和食	washoku	Japanese food
和解	wakai	reconcilliation
調和	chouwa	harmony

Kunyomi: yawa-, nago-

一 二 千 千 禾 利 和 和

| 和らぐ | yawaragu | to soften, to calm down |
| 和む | nagomu | to be comforted |

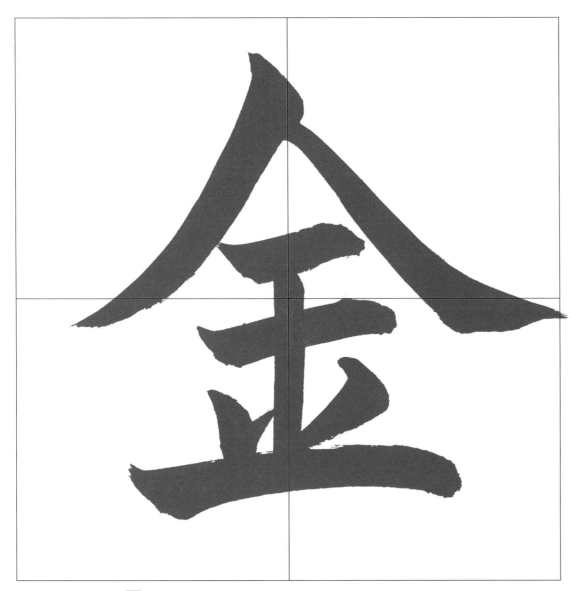

SKIP Pattern 2 ▬ 金 2-2-6

 8 STROKES

gold, metal, money

金

Used independently or as a radical (#167) in many other characters. In the hen position, changes appearance to 釒.

Onyomi: kin, kon, gon

金曜日	kinyoubi	Friday
金庫	kinko	a safe
金堂	kondou	temple sanctuary
黄金	ougon	gold

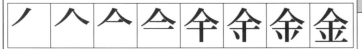

Kunyomi: kane, -gane, kana

お金	okane	money
金持ち	kanemochi	rich, wealthy
針金	harigane	wire, line
金物	kanamono	hardware

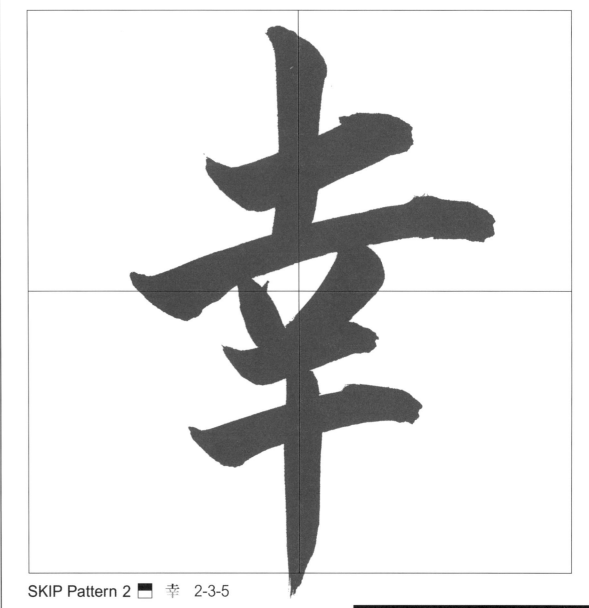

SKIP Pattern 2 ▬ 幸 2-3-5

 8 STROKES

fortune

幸

Based on radical #51 (干), this character is used independently and occurs in many complex characters.

Onyomi: kou

幸福	koufuku	happiness
幸運	kou'un	good luck
多幸	takou	every happiness
不幸	fukou	misfortune

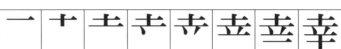

Kunyomi: shiawa(se), saiwa(i), sachi

幸せ	shiawase	happiness, good fortune
不幸せ	fushiawase	unhappiness, bad luck
幸い	saiwai	fortunately, happiness, blessing

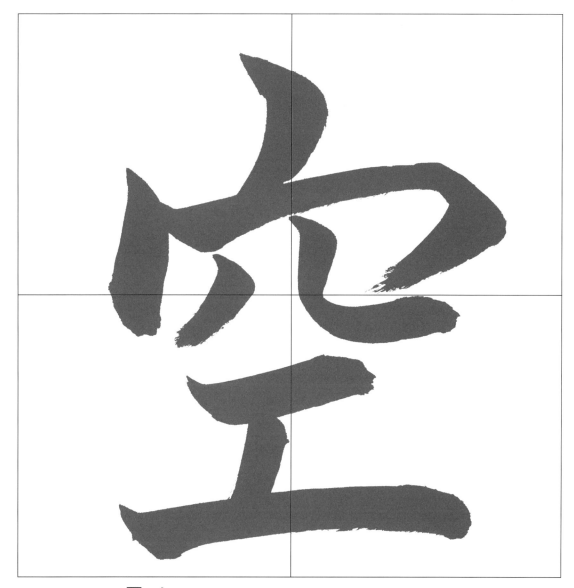

SKIP Pattern 2 � 空 2-3-5

 8 STROKES **sky, air, empty**
Based on radical #116 (穴), this character is used independently and occurs as a component in only a few other complex characters.

空

Onyomi: kuu

空港	kuukou	airport
空気	kuuki	air
空間	kuukan	space, room
空白	kuuhaku	blank

` ゛ 宀 宀 究 空 空 空

Kunyomi: sora, kara, a-, su-

空色	sora'iro	sky blue
空手	karate	karate, empty hand
空ける	akeru	to emply, to become vacant
空いた	suita	hungry, empty

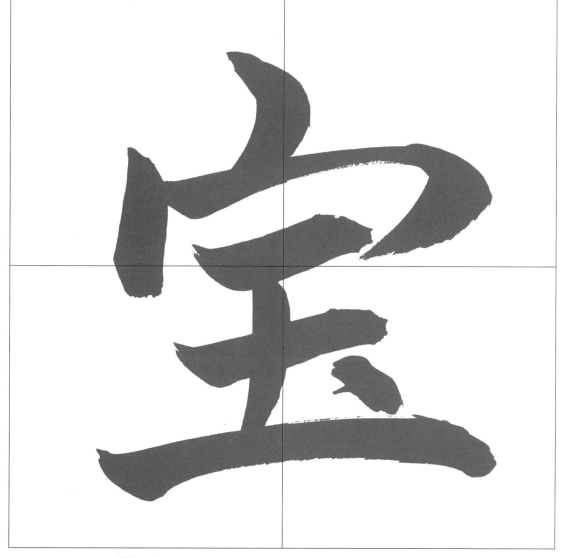

SKIP Pattern 2 ▯ 宝 2-3-5

 8 STROKES **treasure, wealth**
Based on radical # 40 (宀), this character is used independently and does not occur inside of other characters.

宝

Onyomi: hou, .-*pou

宝石	houseki	jewel
秘宝	hihou	secret treasure
国宝	kokuhou	national treasure
七宝焼	shippouyaki	cloisonne ware

` ゛ 宀 宀 宁 宇 宝 宝

Kunyomi: takara

宝物	takaramono	treasure, riches
宝島	takarajima	treasure island
宝探し	takarasagashi	treasure hunting
宝くじ	takarakuji	lottery

85

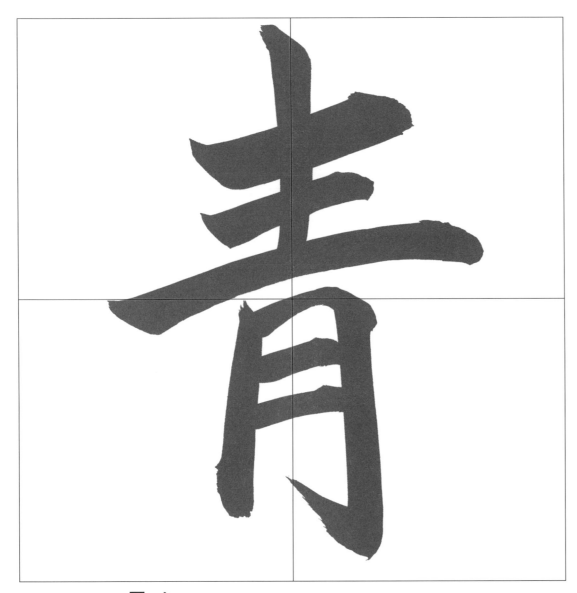

SKIP Pattern 2 ▬ 青 2-4-4

 8 STROKES

blue, green

This radical (#174) is used independently and occurs as a component in only a few other complex characters.

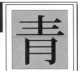 青

Onyomi: **sei, shou, jyou**

青春	seishun	youth, adolescent
青雲	seiun	blue sky
緑青	rokushou	green (copper) rust
群青	gunjyou	ultramarine

Kunyomi: **ao**

青梅	ao'ume	unripe plum
青物	aomono	vegetables
青竹	aodake	green bamboo
青菜	aona	greens, leafy vegetables

SKIP Pattern 2 ▬ 学 2-5-3

 8 STROKES

study, learn, science

Based on radical # 39 (子),this character is used independently and does not occur inside of other characters.

 学

Onyomi: **gaku, ga*-**

学者	gakusha	scholar
学問	gakumon	learning, scholarship
学校	gakkou	school
学会	gakkai	academic society

Kunyomi: **mana-**

| 学ぶ | manabu | to study, to learn |
| 学び | manabi | learning |

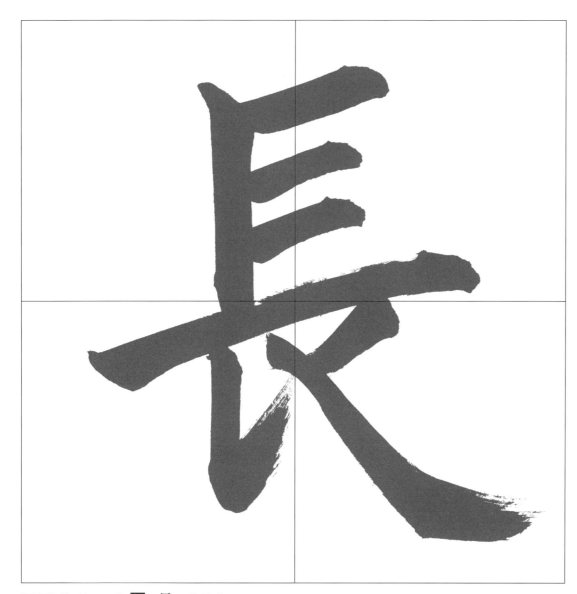

SKIP Pattern 2 ▬ 長 2-5-3

8 STROKES

long, leader

This radical (#168) is used independently and also occurs as a component in a few other complex characters.

長

Onyomi: chou

長身	choushin	tall
長短	choutan	long and short, length
校長	kouchou	principal
社長	shachou	company president

Kunyomi: naga-

長い	nagai	long
長い間	nagai aida	a long time
長靴	nagagutsu	boots
長持ち	nagamochi	lasting, durable

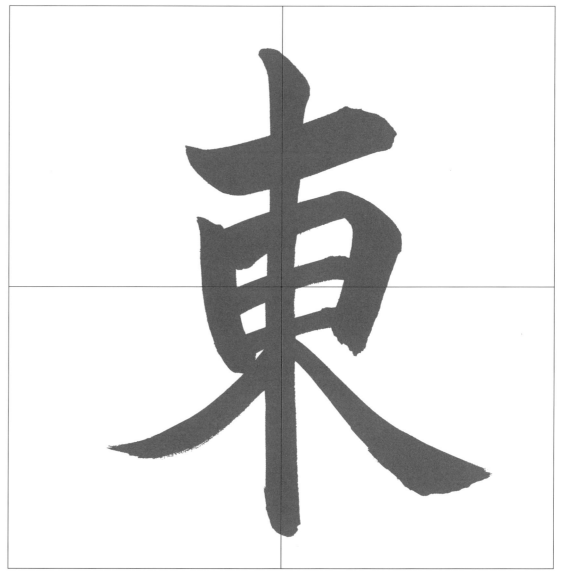

SKIP Pattern 4 ■ 東 4-8-3

8 STROKES

east

Based on radical # 75 (木), this character is used independently and occurs as a component in only a few other complex characters.

東

Onyomi: tou

極東	kyokutou	Far East
東欧	touou	Eastern Europe
東京	toukyou	Tokyo
東南アジア	tounan ajia	Southeast Asia

Kunyomi: higashi

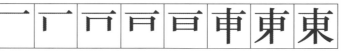

東海岸	higashi kaigan	east coast
東寄り	higashi yori	from the east, easterly

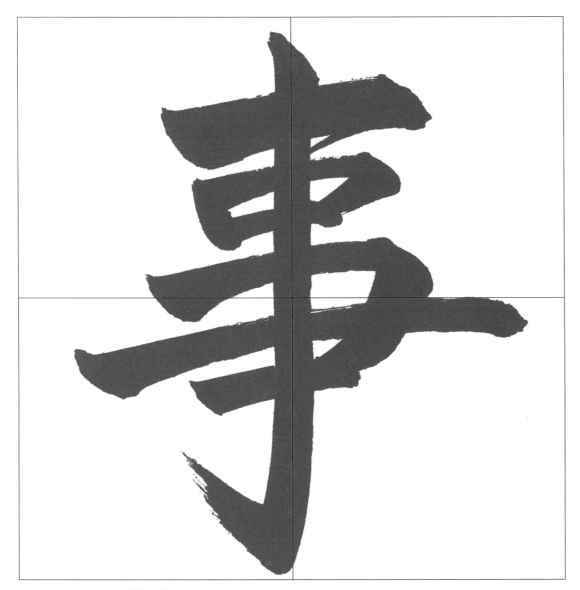

SKIP Pattern 4 ■ 事 4-8-3

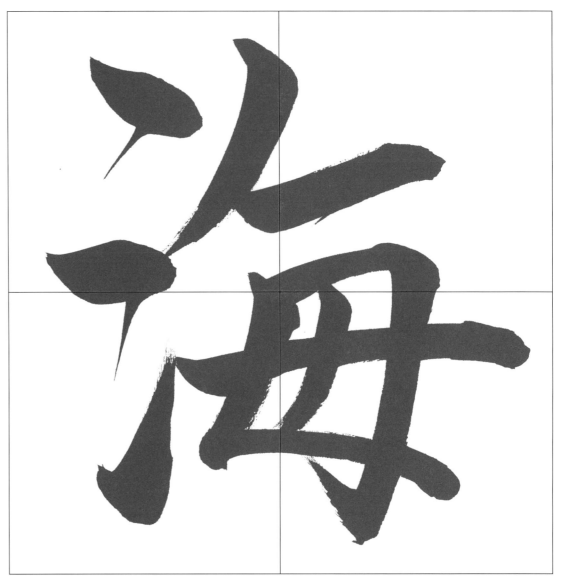

SKIP Pattern 1 ▮ 海 1-3-6

8 STROKES matter, affair, business
Based on radical # 6 (亅), this character is used independently and does not occur inside of other characters.

事

Onyomi: ji

事実	jijitsu	fact, reality
事故	jiko	accident, trouble
工事	kouji	construction work
事務	jimu	business, office work

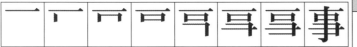

Kunyomi: koto, -goto

事なく	kotonaku	uneventfully
考える事	kangaeru koto	what one thinks
仕事	shigoto	work, job

9 STROKES sea, ocean
Based on radical #85 (水), this character is used independently and does not occur inside of other characters.

海

Onyomi: kai

深海	shinkai	deep-sea
海抜	kaibatsu	height above sea level
海水	kaisui	sea water
海外	kaigai	overseas

` ｀ 氵 氵 汇 汇 洹 海
海

Kunyomi: umi

海鳥	umidori	sea bird
波立つ海	namidatsu umi	choppy seas
海辺	umibe	beach, seashore
海鳴り	uminari	roaring of the sea

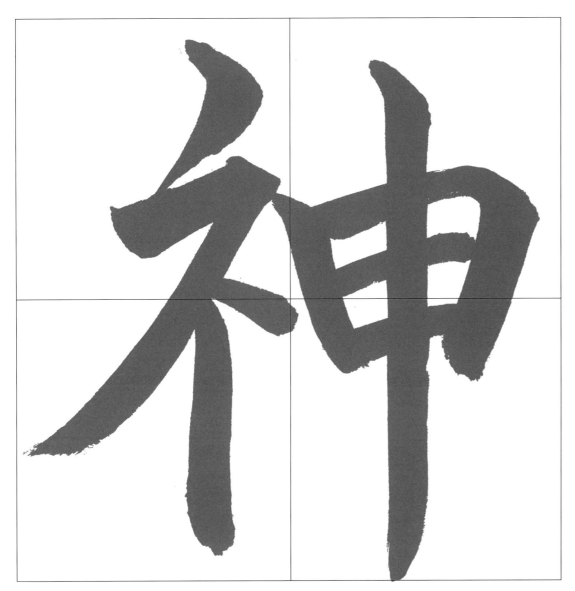

SKIP Pattern 1 ▌☐ 神 1-4-5

9 STROKES	**gods, soul, nerves**	神
	Based on radical #113(示), this character is used independently and occurs as a component in only one other complex character.(榊)	

`ʾ ク ネ ネ ネ 初 祀 神`

神

Onyomi: **shin, jin, kan, kou**

神経	shinkei	nerves, sensitivity
神社	jinja	Shinto shrine
神主	kannushi	Shinto priest
神戸	koube	Kobe (city)

Kunyomi: **kami, -gami**

神様	kamisama	a god
神神	kamigami	the gods
神隠し	kamikakushi	strange disappearance
神風	kamikaze	divine wind, kamikaze

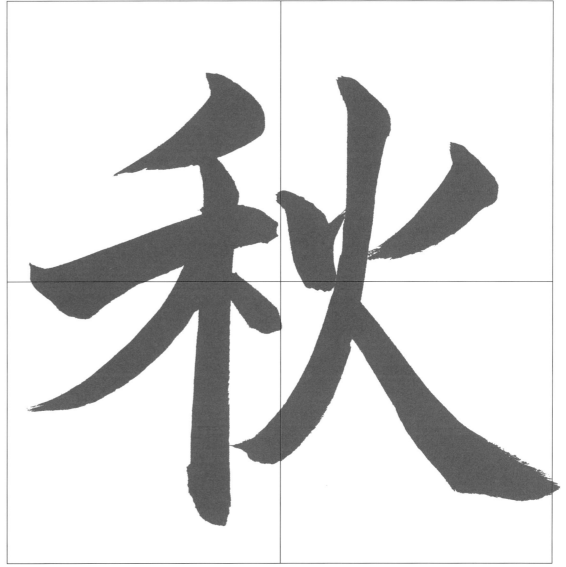

SKIP Pattern 1 ▌☐ 秋 1-5-4

9 STROKES	**autumn**	秋
	Based on radical #115(禾), this character is used independently and occurs as a component in only a few other complex characters.	

`一 二 千 禾 禾 禾 秋ʾ 秋`

秋

Onyomi: **shuu**

秋季	shuuki	autumn season
秋月	shuugetsu	autumn moon
秋分の日	shuubun no hi	autumn equinox

Kunyomi: **aki**

秋の色	aki no iro	the colors of autumn
秋風	akikaze	autumn breeze

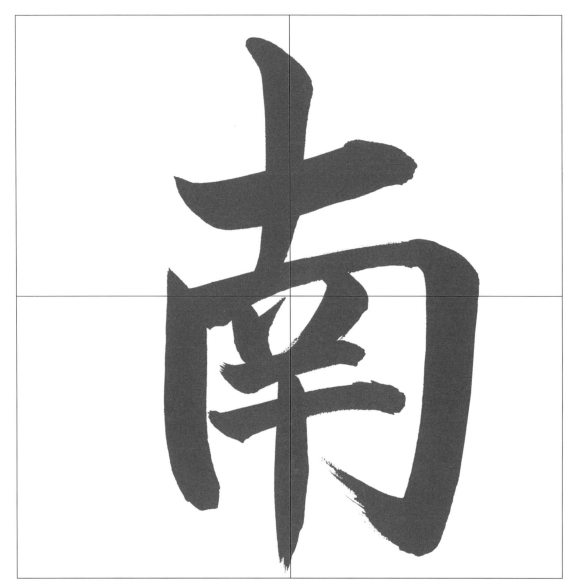

SKIP Pattern 2 ▬ 南 2-2-7

 south

Based on radical #24 (十), this character is used independently and occurs as a component in only a few other complex characters.

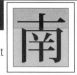 南

Onyomi: **nan**

南国	nangoku	southern countries
南極	nankyoku	South Pole
南米	nanbei	South America
西南	seinan	southwest

Kunyomi: **minami**

南風	minami kaze	south wind
南口	minamiguchi	south entrance
南側	minamigawa	south side
南太平洋	minami taiheiyou	South Pacific

一 十 十 市 市 南 南 南
南

SKIP Pattern 2 ▬ 食 2-2-7

 food, eat

This radical (#184) is used independently and also occurs as a component in many other complex characters in various forms.

 食

Onyomi: **shoku, jiki**

食堂	shokudou	cafeteria
食事	shokuji	a meal
試食	shishoku	sampling food
断食	danjiki	fast

Kunyomi: **ta(be)-, ku-**

食べる	taberu	to eat
食べ物	tabemono	food, something to eat
食べ過ぎ	tabesugi	to eat too much
食いしん坊	kuishinbou	glutton, big eater

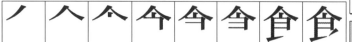 ノ 人 今 今 今 今 食 食
食

COMPONENT FORMS

NORMAL SIMPLIFIED ALTERNATE

 喰 餌 舗

SKIP Pattern 2 �â– â– â–¡ æ˜¥ 2-5-4

9 STROKES

springtime

Based on radical #72 (æ—¥), this character is used independently and occurs as a component in only a few other complex characters.

 æ˜¥

Onyomi: shun

æ˜¥åˆ†ã®æ—¥	shunbun no hi	Vernal Equinox Day
æ€æ˜¥æœŸ	shishunki	adolescence, puberty
æ—©æ˜¥	soushun	early spring
æ–°æ˜¥	shinshun	New Year

Kunyomi: haru

æ˜¥é¢¨	harukaze	spring breeze
æ˜¥ä¸€ç•ª	haru'ichiban	the first gale of spring
æ˜¥é›¨	harusame	a spring rain
æ˜¥ä¼‘ã¿	haruyasumi	spring vacation

ä¸€	äºŒ	ä¸‰	å‰	å¤«	æˆ‰	æ˜¥	æ˜¥
æ˜¥							

SKIP Pattern 2 ▢▢▢ 界 2-5-4

9 STROKES

realm

Based on radical #102 (ç”°), this character is used independently and occurs as a component in only one other complex character.(å †)

 ç•Œ

Onyomi: kai

å¢ƒç•Œç·š	kyoukaisen	bountry line
å¤©ç•Œ	tenkai	the heavens
å¤–ç•Œ	gaikai	the outside world
éœŠç•Œ	reikai	spiritual world

Kunyomi: *<none>*

ï½œ	å£	ï¼	ç”²	ç”°	ç•Œ	ç•Œ	ç•Œ
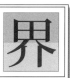 ç•Œ							

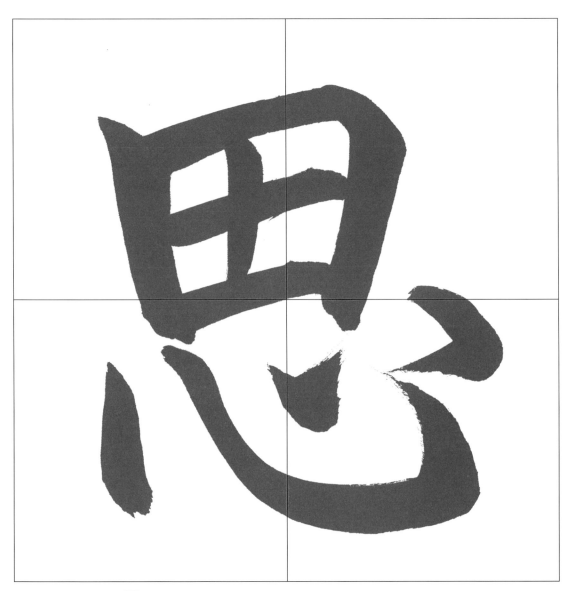

SKIP Pattern 2 ▆ 思 2-5-4

9 STROKES	think, recall	思
	Based on radical #61 (心), this character is used independently and occurs in some complex characters.	

Onyomi: shi

意思	ishi	intention, purpose
思考	shikou	thought
思慮	shiryo	prudence
不思議	fushigi	wonder, mystery, strange

 丨 冂 冊 用 田 甲 思 思

思

Kunyomi: omo-

思う	omou	to think
思い出	omoide	recollection, memory
片思い	kataomoi	unrequited love
思いやり	omoiyari	consideration, sympathy

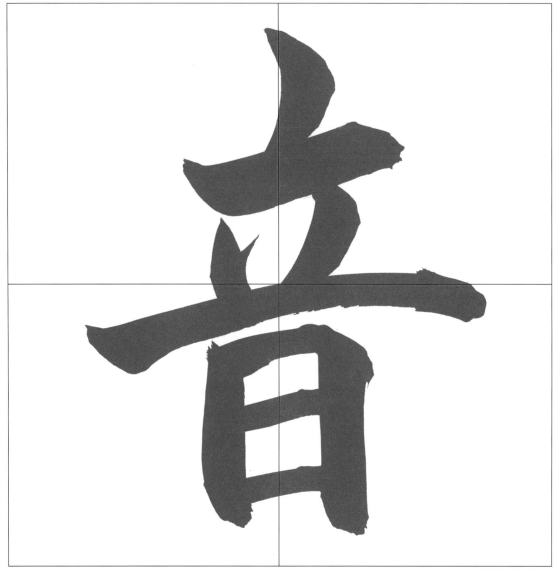

SKIP Pattern 2 ▆ 音 2-5-4

9 STROKES	sound	音
	Used independently or as a radical (#180) in many other characters.	

Onyomi: on, in, ne

音楽	ongaku	music
音量	onryou	volume
子音	shi'in	consonant sound
音色	ne'iro	tone (sound)

 丶 亠 立 立 产 咅 音 音

音

Kunyomi: oto

羽音	ha'oto	buzz, hum
物音	mono'oto	sound, noise
音合わせ	oto'awase	tuning
波の音	nami no oto	sound of waves

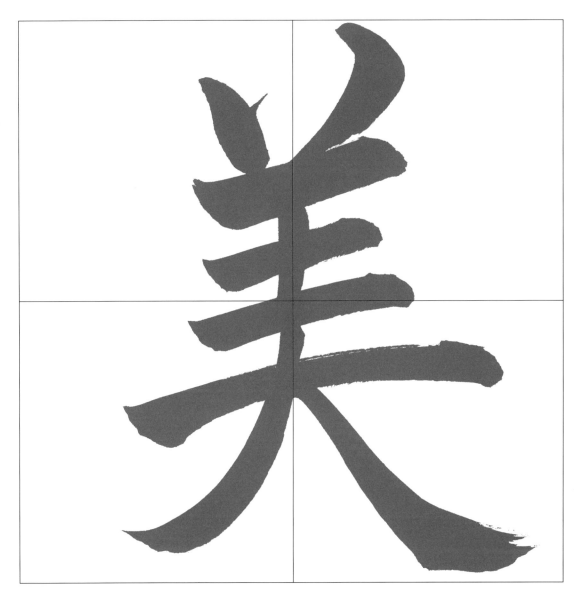

SKIP Pattern 2 ▭ 美 2-6-3

 9 STROKES
beautiful
Based on radical #123(羊),this character is used independently and does not occur inside of other characters.

美

Onyomi: bi

美術	bijyutsu	fine arts
美化	bika	beautification
美女	bijyo	beautiful woman
美徳	bitoku	virtue

Kunyomi: utsuku-

| 美しい | utsukushii | beautiful |
| 美しく | utsukushiku | beautifully |

丶	丷	䒑	羊	羊	羊	美	美
 美 | | | | | | | |

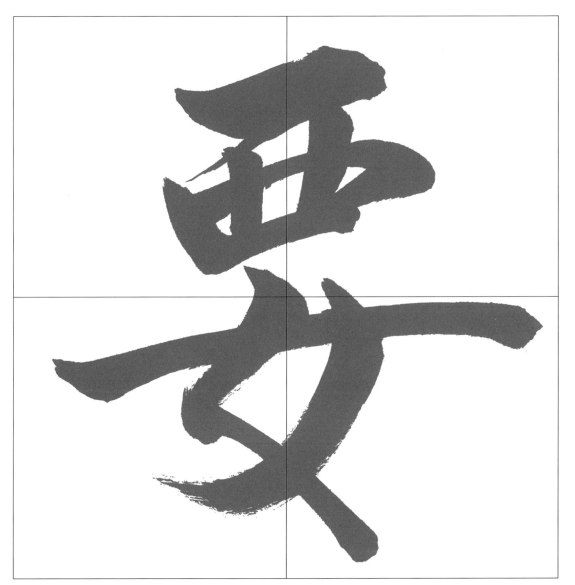

SKIP Pattern 2 ▭ 要 2-6-3

 9 STROKES
necessity, essence
Based on radical #146(西), this character is used independently and occurs as a component in only one other complex character.(腰)

要

Onyomi: you

主要な	shuyou na	main, principle
重要な	jyuuyou na	necessary, important
要求	youkyuu	demand, request
要領	youryou	point, gist, essentials

Kunyomi: i-

| 要る | iru | to need |
| 要らない | iranai | unnecessary |

一	一	一	币	西	西	要	要
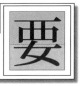 要 | | | | | | | |

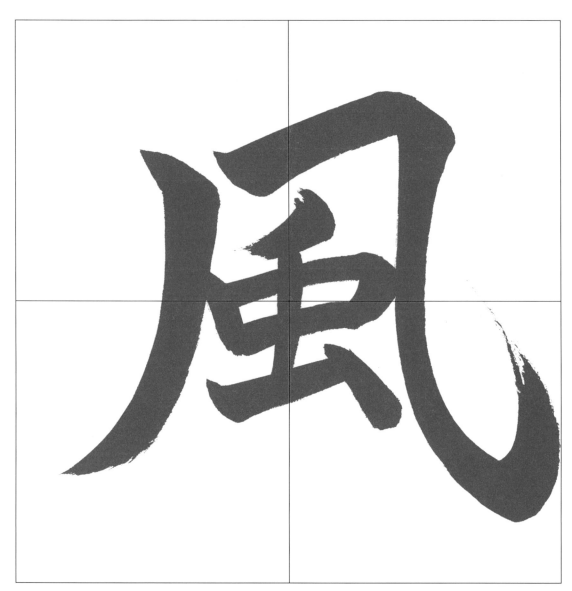

SKIP Pattern 3 ☐ 風 3-2-7

9 STROKES	**wind, air, style, manner** 風
This radical (#182) is used independently and also occurs as a component in a few other complex characters.

Onyomi: fuu, fu

風車	fuusha	windmill
和風	wafuu	Japanese style
昔風	mukashifuu	old style
風景	fuukei	scenery
風情	fuzei	appearance

丿 几 几 凡 同 同 風 風 風

Kunyomi: kaze, kaza, ka-

強い風	tsuyoi kaze	strong wind
追い風	oikaze	a tail wind
風通し	kazetooshi	ventilation
風下	kazashimo	leeward
風邪	kaze	a cold, flu

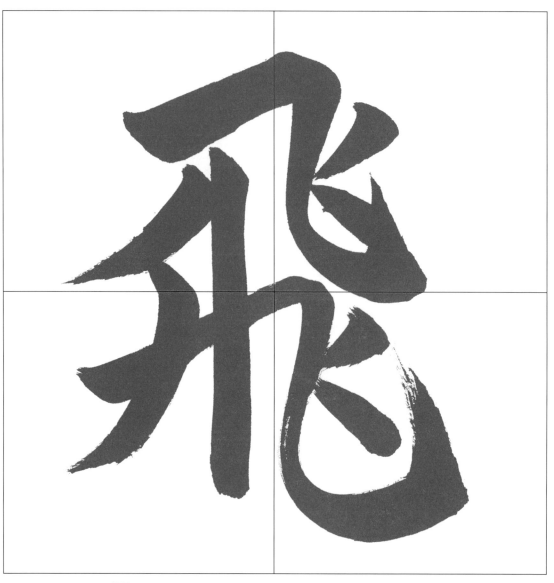

SKIP Pattern 4 ■ 飛 4-9-1

9 STROKES	**fly, skip, scatter** 飛
This radical (#183) is used independently, but also occurs as a component in one or two other complex characters.

Onyomi: hi, -*pi

飛行機	hikouki	airplane
飛龍	hiryuu	flying dragon
飛球	hikyuu	a fly (ball)
突飛	toppi	erratic, wild

乁 飞 飞 飞 飞 飛 飛 飛

飛

Kunyomi: to-

飛ぶ	tobu	to fly
飛び下りる	tobioriru	to jump off of
飛魚	tobiuo	flying fish
飛び込む	tobikomu	to dive into

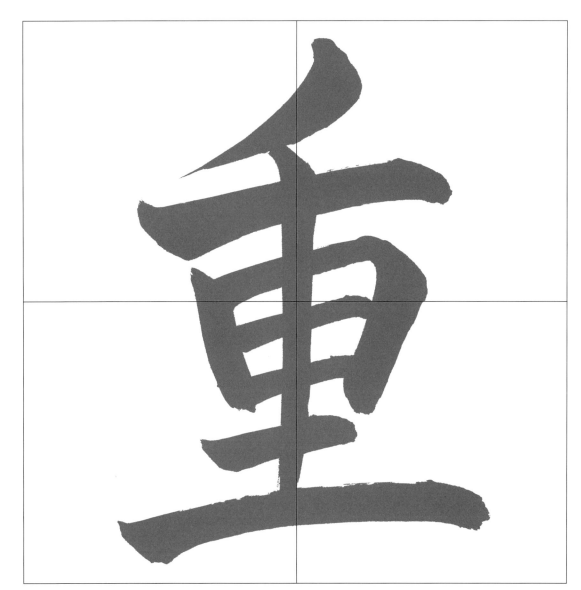

SKIP Pattern 4 ■ 重 4-9-2

<table>
<tr><td>**9** STROKES</td><td>**heavy, piled up, layered**
Based on radical #166 (里), this character is used independently, and also occurs as a component in many other complex kanji.</td><td>重</td></tr>
</table>

一 二 一 一 一 一 重 重

重

Onyomi: jyuu, chou, e

重役	jyuuyaku	excective, director, heavy responsibility
重量	jyuuryou	weight
尊重	sonchou	respect, esteem
一重	hitoe	one fold, single ~

Kunyomi: omo-, kasa-

重い	omoi	heavy
重り	omori	balance, weight
重荷	omoni	burden, load
重ねる	kasaneru	pile up, to stack

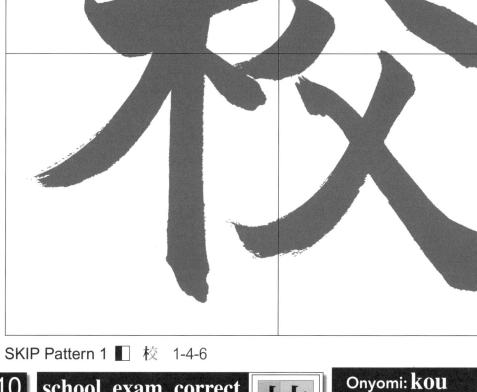

SKIP Pattern 1 ■ 校 1-4-6

<table>
<tr><td>**10** STROKES</td><td>**school, exam, correct**
Based on radical #75 (木), this character is used independently and does not occur inside of other characters.</td><td>校</td></tr>
</table>

一 十 才 木 术 杧 杧 校

校

Onyomi: kou

高校	koukou	high school
校舎	kousha	school building
校外	kougai	off-campus, out of school
校正	kousei	proofreading

Kunyomi: <none>

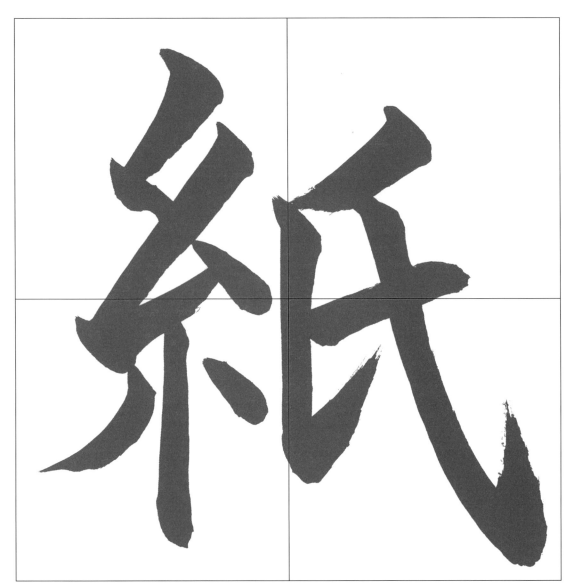

SKIP Pattern 1 ■ 紙 1-6-4

 10 STROKES **paper**

Based on radical #120(糸), this character is used independently and does not occur inside of other characters.

 紙

Onyomi: shi

表紙	hyoushi	front cover
色紙	shikishi	thick paper for writing
紙幣	shihei	paper money, bill
和紙	washi	Japanese paper

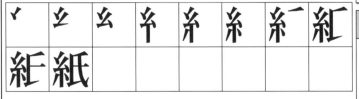

Kunyomi: kami, -gami

紙芝居	kamishibai	story with picture card
紙袋	kamibukuro	paper bag
手紙	tegami	letter
折紙	origami	origami, folding paper

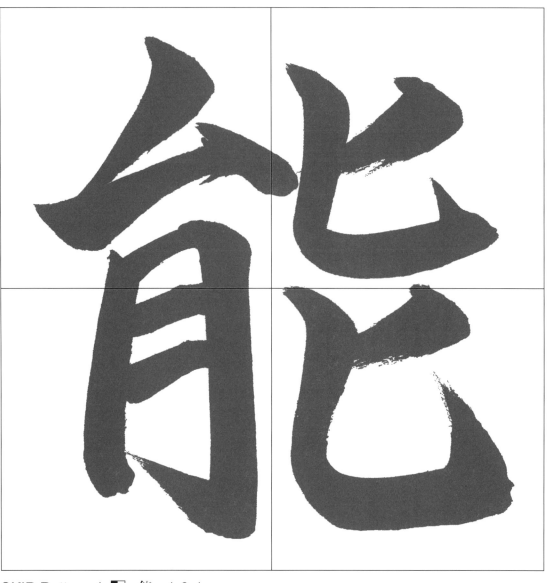

SKIP Pattern 1 ■ 能 1-6-4

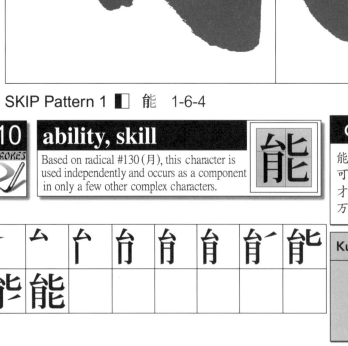 **10 STROKES** **ability, skill**

Based on radical #130(月), this character is used independently and occurs as a component in only a few other complex characters.

 能

Onyomi: nou

能力	nouryoku	ability, skill
可能	kanou	possible, feasible
才能	sainou	talent
万能	bannou	omnipotent, almighty

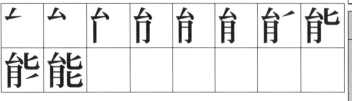

Kunyomi: *<none>*

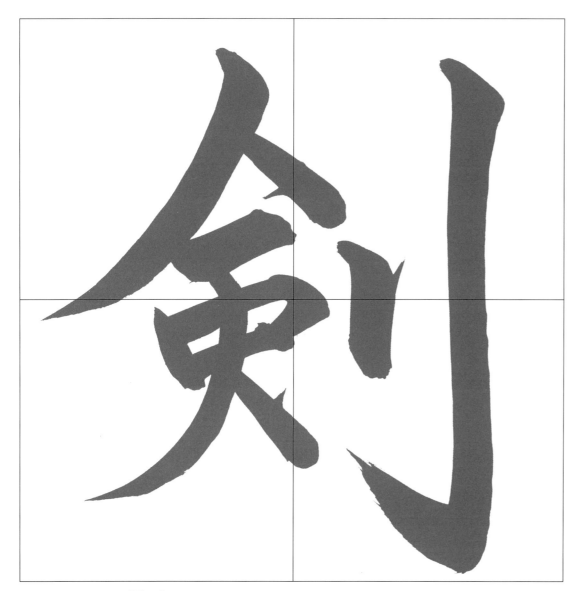

SKIP Pattern 1 ■☐ 剣 1-8-2

10 STROKES	**sword, blade**	剣

Based on radical #18 (刀),this character is used independently and does not occur inside of other characters.

Onyomi: ken

剣士	kenshi	swordsman
剣道	kendou	Kendo (fencing)
剣先	kensaki	tip of a sword
真剣	shinken	seriousness

ノ	入	�	产	合	合	争	余

剣 剣

Kunyomi: tsurugi

剣の舞	tsurugi no mai	
		sword dance
両刃の剣	moroha no tsurugi	
		double-edged sword

SKIP Pattern 2 ▬ 夏 2-2-8

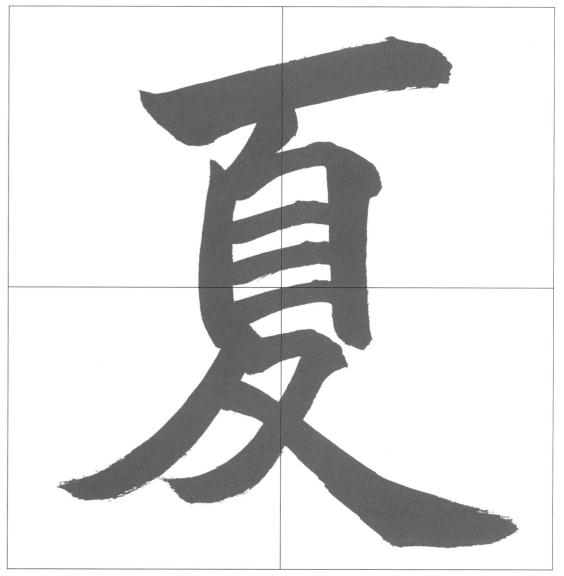

10 STROKES	**summer**	夏

Based on radical #35 (夊), this character is used independently and occurs as a component in only a few other complex characters.

Onyomi: ka, ge

夏季	kaki	summer season
初夏	shoka	early summer
冷夏	reika	cool summer
夏至	geshi	summer solstice

一	一	厂	百	百	百	百	頁

頁 夏

Kunyomi: natsu

夏休み	natsu yasumi	summer vacation
夏時間	natsujikan	summer time
真夏	manatsu	midsummer
常夏	tokonatsu	everlasting summer

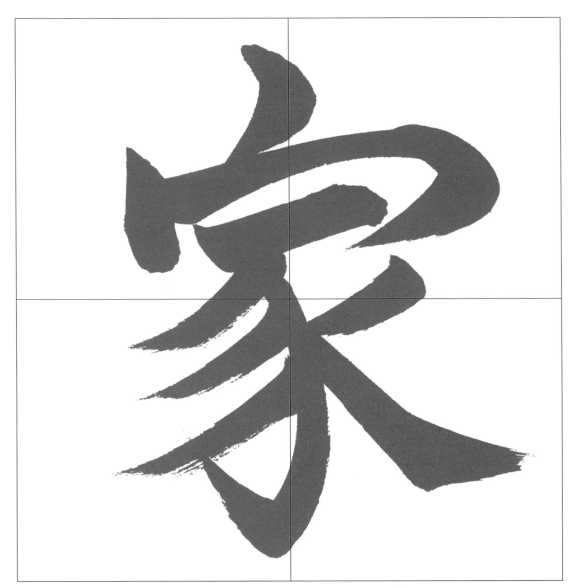

SKIP Pattern 2 ▬ 家 2-3-7

10 STROKES	**house, home, expert**

Based on radical #40 (宀), this character is used independently and occurs as a component in only a few other complex characters.

家

Onyomi: **ka, ke**

家族	kazoku	family
家具	kagu	furniture
歴史家	rekishika	historian
良家	ryouke	good family

Kunyomi: **ie, ya**

家に帰る	ie ni kaeru	to go home
売り家	uri ya	house for sale
貸家	kashiya	house for rent
家賃	yachin	rent

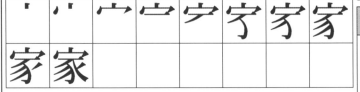

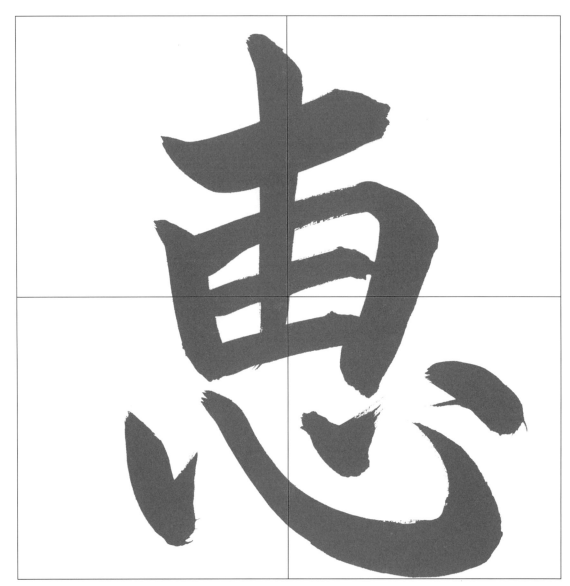

SKIP Pattern 2 ▬ 恵 2-6-4

10 STROKES	**blessing, kindness**

Based on radical #61 (心), this character is used independently and occurs as a component in only a few other complex characters.

恵

Onyomi: **kei, e**

仁恵	jinkei	mercy, graciousness
恩恵	onkei	blessing, favor
智恵	chie	wisdom
猿知恵	sarujie	instinctive cleverness

Kunyomi: **megu-**

恵む	megumu	to be bless
恵み	megumi	blessing
恵まれる	megumareru	to be blessed

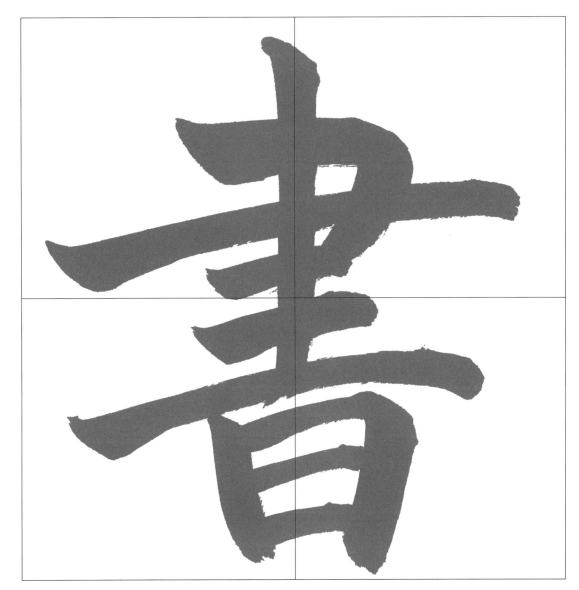

SKIP Pattern 2 ☐ 書 2-6-4

10 STROKES	**write, book** Based on radical # 73 (日), this character is used independently and occurs as a component in only one other complex character.(畫)	書

Onyomi: sho

書類	shorui	documents, papers
教科書	kyoukasho	text book
草書	sousho	cursive style text
原書	gensho	original document

 一 ㇆ ㇅ 主 ㇕ 聿 書 書 書 書

Kunyomi: ka-, ga-

書く	kaku	to write
落書き	rakugaki	graffiti, scribble
縦書き	tategaki	vertical writing
横書き	yokogaki	horizontal writing

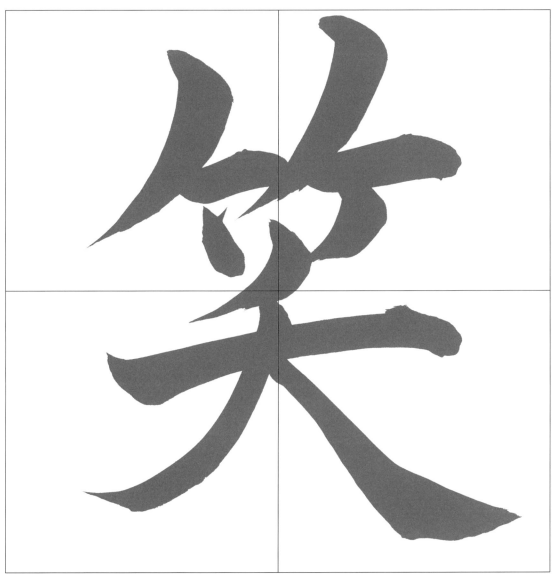

SKIP Pattern 2 ☐ 笑 2-6-4

10 STROKES	**laugh** Based on radical #118(竹),this character is used independently and does not occur inside of other characters.	笑

Onyomi: shou

一笑	isshou	a laugh, a smile
苦笑	kushou	a bitter smile
爆笑	bakushou	outburst of laughter
冷笑	reishou	scornful laugh

 ノ ㇒ ㇓ ㇗ 竹 竹 竺 竺 竿 笑

Kunyomi: wara-, e-

笑う	warau	to laugh, to smile
笑い声	waraigoe	laughter
高笑い	takawarai	loud laugh
ほほ笑む	hohoemu	to smile at

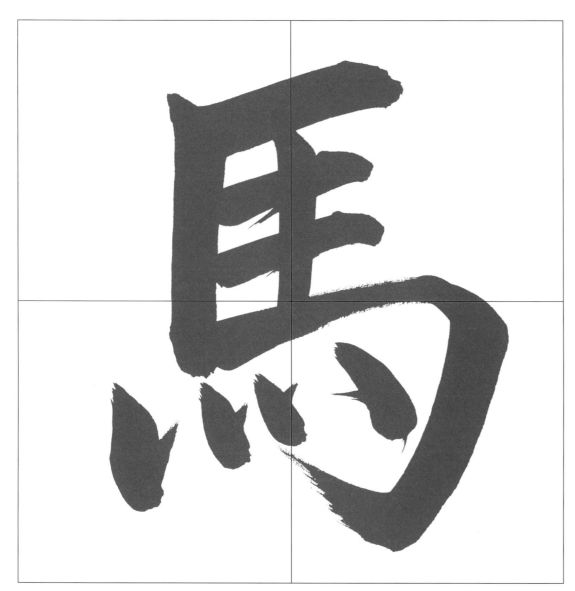

SKIP Pattern 3 □ 馬 3-6-4

10 STROKES	**horse**
	This radical (#187) is used independently and also occurs as a component in many other complex characters.

馬

Onyomi: ba, ma

競馬	keiba	horse racing
乗馬	jouba	horse riding
馬鹿	baka	stupid
絵馬	ema	*ema*, a votive picture tablet of horse

 一 厂 厂 厈 厈 馬 馬 馬

 馬 馬

Kunyomi: uma, ma

馬小屋	umagoya	barn, stable
竹馬	takeuma	stilt
子馬	kouma	pony
頓馬	tonma	odopt, fool

SKIP Pattern 3 □ 勉 3-8-2

10 STROKES	**diligence, exertion**
	Based on radical #19 (力),this character is used independently and does not occur inside of other characters.

勉

Onyomi: ben

勉強	benkyou	study, diligence
不勉強	fubenkyou	lack of study
試験勉強	shikenbenkyou	cramming for a test
勤勉	kinben	diligence

 丿 勹 夕 夕 兽 兔 免 免

 勉 勉

Kunyomi: tsuto(meru)

勉める	tsutomeru	to do one's best

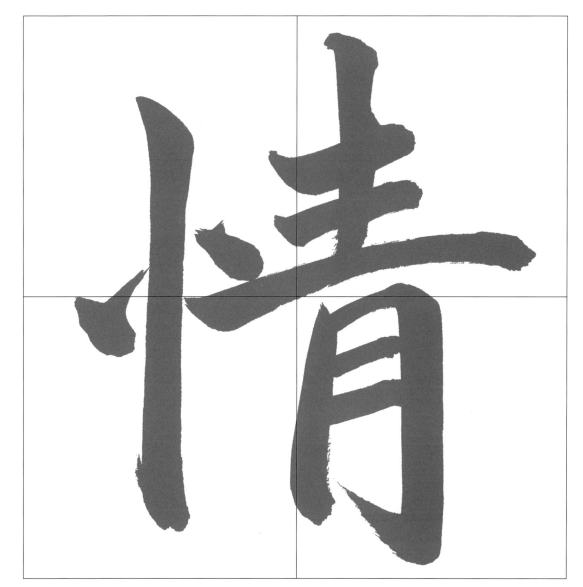

SKIP Pattern 1 ▮▯ 情 1-3-8

11 STROKES

feelings, situation, compassion 情

Based on radical # 61 (心), this character is used independently and does not occur inside of other characters.

Onyomi: **jyou**

人情	ninjyou	humanity, kindness
情熱	jyounetsu	passion, zeal
事情	jijyou	situation, conditions
情報	jyouhou	information

 ′ ′′ 忄 忄 忄 忄 忄 情

情 情 情

Kunyomi: **nasa(ke)**

情け	nasake	compassion
情け深い	nasakebukai	tender-hearted
情け知らず	nasakeshirazu	cold-hearted
情けない	nasakenai	miserable

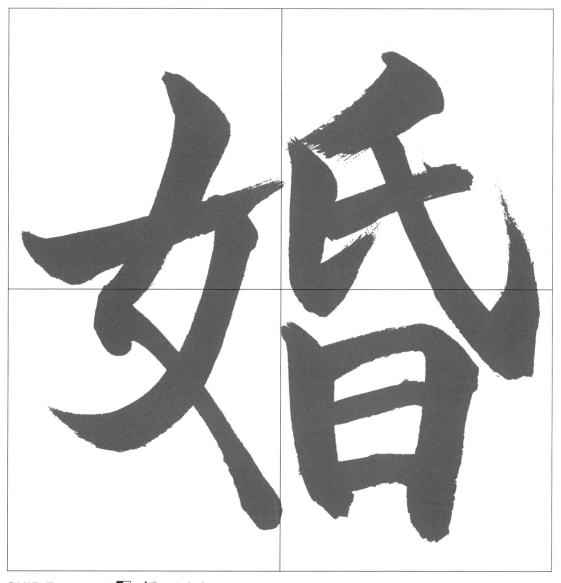

SKIP Pattern 1 ▮▯ 婚 1-3-8

11 STROKES

marriage 婚

Based on radical #38 (女), this character is used independently and does not occur inside of other characters.

Onyomi: **kon**

結婚	kekkon	marriage
新婚	shinkon	newly-wed
再婚	saikon	second marriage
婚約者	konyakusha	fiancee

 乚 女 女 妤 妖 妖 娇 娇

婚 婚 婚

Kunyomi: *<none>*

SKIP Pattern 1 ▯▮ 猫 1-3-8

 cat 11 STROKES

Based on radical #94 (犬), this character is used independently and does not occur inside of other characters.

猫

Onyomi: byou

| 愛猫 | aibyou | pet cat |
| 愛猫家 | aibyouka | cat lover |

Kunyomi: neko

子猫	koneko	kitten
山猫	yamaneko	wildcat, lynx
黒猫	kuroneko	black cat
虎猫	toraneko	tabby cat

| ノ | 犭 | 犭 | 犷 | 犷 | 犷 | 犷 | 猫 |
| 猫 | 猫 | 猫 | | | | | |

SKIP Pattern 1 ▯▮ 強 1-3-8

 strong 11 STROKES

Based on radical #57 (弓), this character is used independently and occurs as a component in only one other complex character.(彊)

強

Onyomi: kyou, gou

強化	kyouka	enlightenment
強大	kyoudai	mighty
強力な	kyouryoku na	powerful
強情	goujyou	stubbornness

Kunyomi: tsuyo-, shi(i)-

強い	tsuyoi	strong
強さ	tsuyosa	strength
強がり	tsuyogari	bluff
強いる	shiiru	to force

| フ | フ | 弓 | 弓 | 弓 | 弓 | 強 |
| 弱 | 強 | 強 | | | | |

102

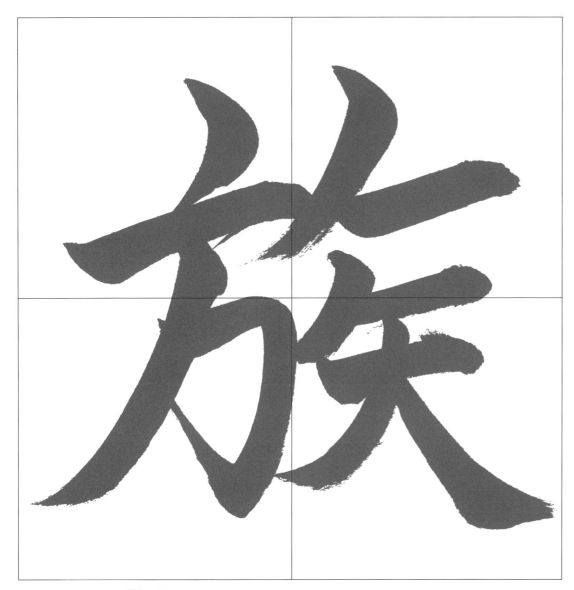

SKIP Pattern 1 ■ 族 1-4-7

11 STROKES 	**belong** Based on radical # 70 (方), this character is used independently and occurs as a component in only a few other complex characters.	族

Onyomi: zoku

一族	ichizoku	family, dependents
氏族	shizoku	clan, family
民族	minzoku	people, race, nation
王族	ouzoku	royality

Kunyomi: yakara

族	yakara	company, bunch, gang

` ' 亠 方 方 方 扩 扩 挤 `
` 旌 族 族 `

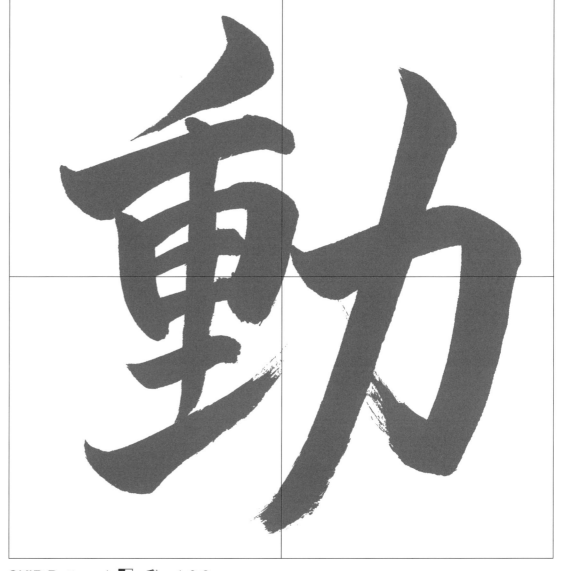

SKIP Pattern 1 ■ 動 1-9-2

11 STROKES 	**active, move** Based on radical # 19 (力), this character is used independently and occurs as a component in only a few other complex characters.	動

Onyomi: dou

行動	koudou	action, behavior
自動の	jidou no	automatic
動物園	doubutsuen	zoo
動作	dousa	movement, work

Kunyomi: ugo-

動く	ugoku	to move
動かす	ugokasu	to set into motion
動き	ugoki	movement, trend
動き回る	ugokimawaru	to move around

` 一 二 午 乕 旨 重 重 重 `
` 重 動 動 `

SKIP Pattern 2 ▭ 魚 2-2-9

11 STROKES	**fish** 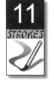 This radical (#195) is used independently and also occurs as a component in many other complex characters.	魚

Onyomi: gyo

海水魚	kaisuigyo	saltwater fish
人魚	ningyo	mermaid
金魚	kingyo	goldfish
漁介	gyokai	seafood
魚雷	gyorai	torpedo

ノ 𠂊 𠂢 𠂢 角 角 角 角

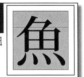 魚 魚 魚

Kunyomi: sakana, -zakana, uo

魚屋	sakana ya	fish shop
焼き魚	yakizakana	grilled fish
川魚	kawa'uo	freshwater fish
魚市場	uo'ichiba	fish market

SKIP Pattern 2 ▭ 黄 2-4-7

11 STROKES	**yellow** 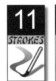 This radical (#201) is used independently and occurs as a component in only a few other complex characters.	黄

Onyomi: kou, ou

黄土	koudo	yellow soil
黄道帯	koudoutai	the zodiaic
黄金	ougon	gold, yellow metal
硫黄	iou	sulphur

一 十 廿 共 芦 苦 带 苗

 苗 黄 黄

Kunyomi: ki

黄色	kiiro	yellow color
黄身	kimi	egg yolk
黄鯉	kigoi	yellow carp
黄ばむ	kibamu	to yellow

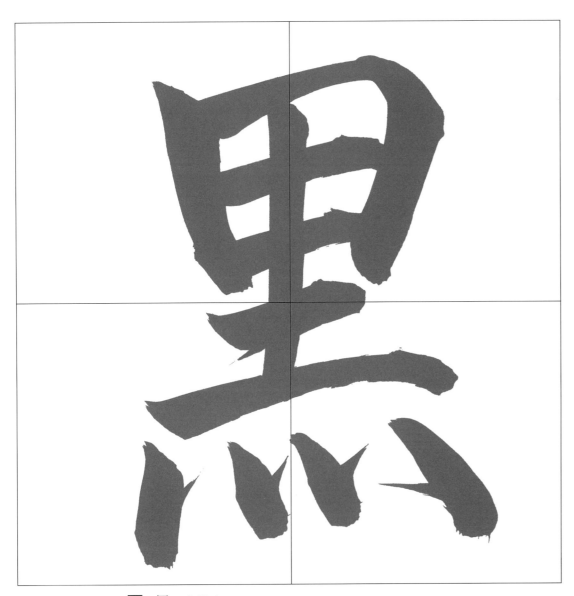

SKIP Pattern 2 ■ 黒 2-7-4

 11 STROKES | **black**
This radical (#203) is used independently and occurs as a component in only a few other complex characters.

黒

Onyomi: koku, ko*-

黒点	kokuten	black spot, sunspot
暗黒	ankoku	darkness
黒海	kokkai	the Black Sea
漆黒	shikkoku	super-black

Kunyomi: kuro, -guro

黒髪	korokami	black hair
黒幕	kuromaku	black curtain, wirepuller
白黒	shirokuro	black and white
腹黒い	haraguroi	black-hearted

丨	冂	冃	曰	甲	甲	里	黒

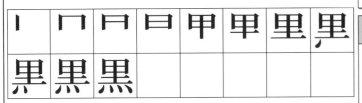

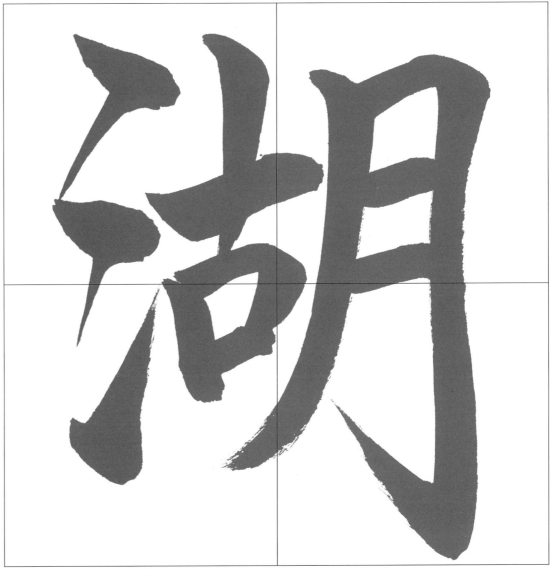

SKIP Pattern 1 ■ 湖 1-3-9

 12 STROKES | **lake**
Based on radical #85(水), this character is used independently and does not occur inside of other characters.

湖

Onyomi: ko

湖水	kosui	lake water
湖上	kojou	surface of a lake
湖底	kotei	bottom of a lake
塩湖	enko	salt lake

Kunyomi: mizuumi

| 深い湖 | fukai mizuumi | deep lake |

丶	氵	氵	汀	汁	沽	沽

油 湖 湖 湖

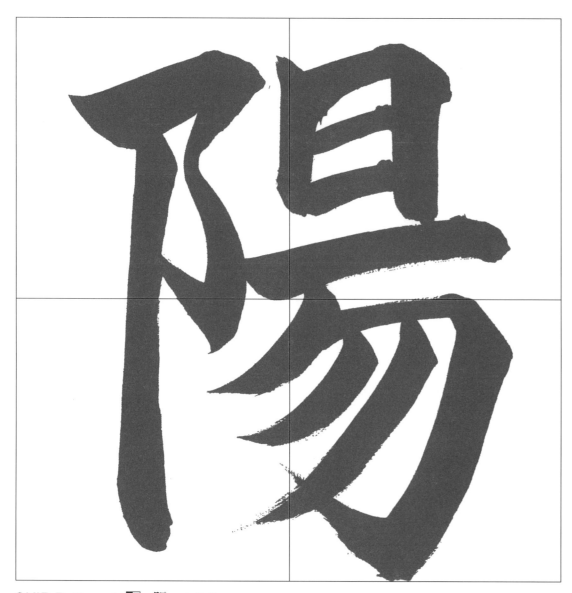

SKIP Pattern 1 ■□ 陽 1-3-9

<table>
<tr><td>12
STROKES</td><td>**sunshine, positive**
Based on radical #170 (阝), this character is used independently and does not occur inside of other characters.</td><td>陽</td></tr>
</table>

Onyomi: you

太陽	taiyou	the sun, solar
陽光	youkou	sunshine
陰陽	inyou	Yin and Yang
陽性	yousei	postive polarity
落陽	rakuyou	sunset

Kunyomi: hi, bi

夕陽	yuuhi	the setting sun
陽射し	hizashi	sunshine
薄陽	usubi	soft light

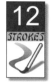 了 阝 阝 阝 阝 阝 阝 阝
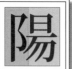 阝 陽 陽 陽

SKIP Pattern 1 ■□ 勝 1-4-8

<table>
<tr><td>12
STROKES</td><td>**victory, excel**
Based on radical #19 (力), this character is used independently and does not occur inside of other characters.</td><td>勝</td></tr>
</table>

Onyomi: shou

優勝	yuushou	victory
勝負	shoubu	win or loose, match
勝者	shousha	winner
必勝	hisshou	certain victory

Kunyomi: ka-, masa-

勝つ	katsu	to win
打ち勝つ	uchikatsu	to overcome
勝ち気	kachiki	winning spirit
勝る	masaru	to surpass, to excel

 丿 月 月 月 月 月 胖 胖
 胖 胖 勝 勝

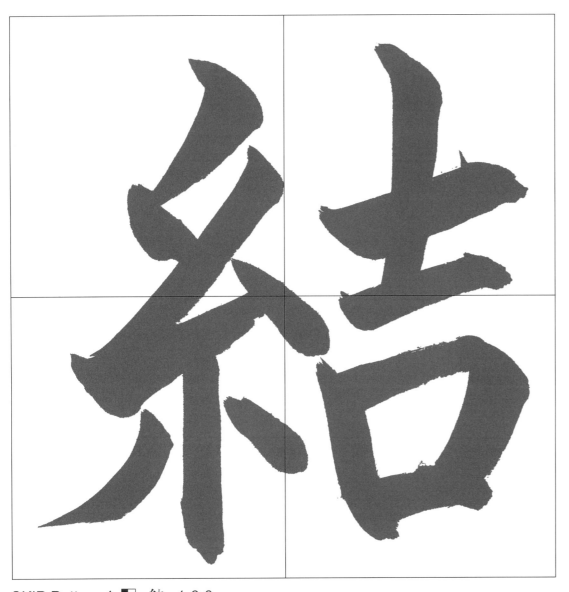

SKIP Pattern 1 ▮▯ 結 1-6-6

12 STROKES	**tie, bind, contract** Based on radical #120 (糸), this character is used independently and occurs as a component in only one other character. (纈)	

Onyomi: ketsu, ke*-

団結	danketsu	union
結婚	kekkon	marriage
結果	kekka	conslusion, result
結社	kessha	association, society

Kunyomi: musu-, yu-

結ぶ	musubu	to join, to tie
手を結ぶ	te wo musubu	form an alliance
結び目	musubime	knot
髪結い	kamiyui	hair decorating

⺯	幺	幺	糸	糸	糸	糸	糾
絉	結	結	結				

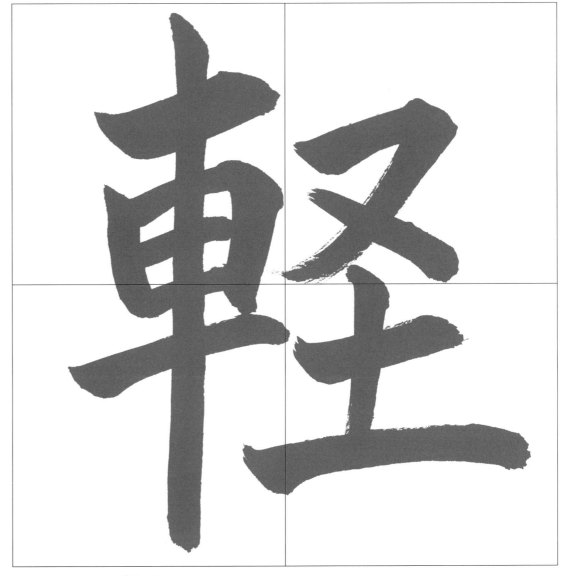

SKIP Pattern 1 ▮▯ 軽 1-7-5

12 STROKES	**light, unimportant** Based on radical #159 (車), this character is used independently and does not occur inside of other characters.	

Onyomi: kei

軽食	keishoku	light meal, snack
軽快	keikai	nimble, light
軽妙	keimyou	light and clever, witty
軽度	keido	slight degree

Kunyomi: karu-, -garu, karo(yaka)

軽い	karui	light, minor
軽はずみ	karuhazumi	rashness, imprudence
足軽	ashigaru	foot soldier
軽やか	karoyaka	light

一	厂	厅	戸	亘	亘	車	軯
軯	軽	軽	軽				

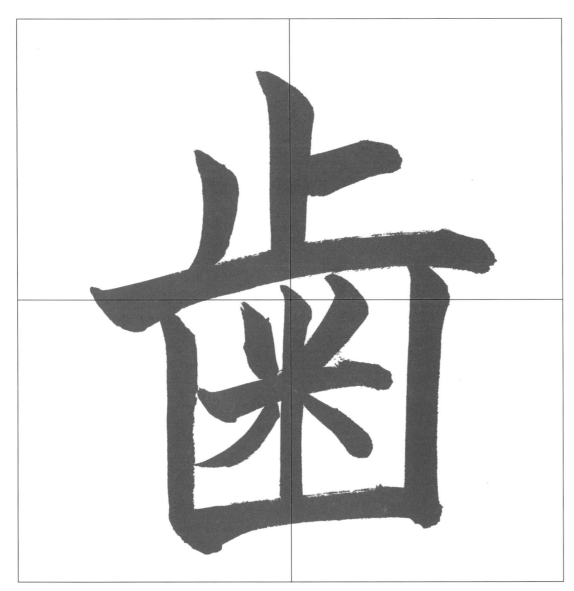

SKIP Pattern 2 ▬ 歯 2-4-8

 12 STROKES

tooth, cog

This radical (#211) is used independently, but also occurs as a component in one or two other complex characters.

歯

Note: This character is described in the section titled "The Structure of Kanji".

丨	卜	止	止	贵	歩	歩	牮
崇	崇	歯	歯				

Onyomi: shi

歯学	shigaku	dentistry
犬歯	kenshi	fang, cuspid
乳歯	nyuushi	milk tooth
永久歯	eikyuushi	permanent tooth

Kunyomi: ha, -ba

歯医者	haisha	dentist
歯車	haguruma	gear
虫歯	mushiba	cavity
入れ歯	ireba	false teeth

SKIP Pattern 2 ▬ 筆 2-6-6

 12 STROKES

brush, writing

Based on radical #118(竹), this character is used independently and does not occur inside of other characters.

筆

丿	丆	仸	竹	竹	竺	竿	笋
筞	筜	筆	筆				

Onyomi: hitsu, -*pitsu, hi

筆順	hitsujun	the stroke order
鉛筆	enpitsu	pencil
執筆	shippitsu	writing
筆者	hissha	author, writer

Kunyomi: fude

筆先	fudesaki	brush tip
筆箱	fudebako	brush/pencil case
絵筆	efude	artist's brush
筆遣い	fudezukai	brushwork

108

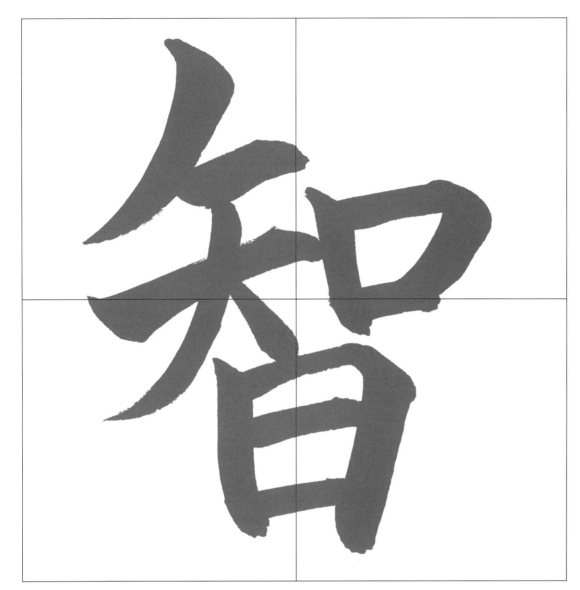

SKIP Pattern 2 ▭ 智 2-8-4

12 STROKES

wisdom, intellect

A combination of radical #72 (日), #111 (矢), #30 (口), this character is not used within any other characters.

智

Onyomi: chi

智恵	chi'e	wisdom, wit
智慮	chiryo	wisdom and thought
智勇	chiyuu	wisdom and courage
霊智	reichi	mystic wisdom

Kunyomi: *<none>*

SKIP Pattern 2 ▭ 善 2-9-3

12 STROKES

virtuous, goodness

Based on radical #30 (口), this character is used independently and occurs as a component in only a few other complex characters.

善

Onyomi: zen

善行	zenkou	benevolence
善意	zen'i	goodwill
改善	kaizen	improvement
最善	saizen	the best

Kunyomi: yo(i)

| 善い | yoi | good, pleasant |

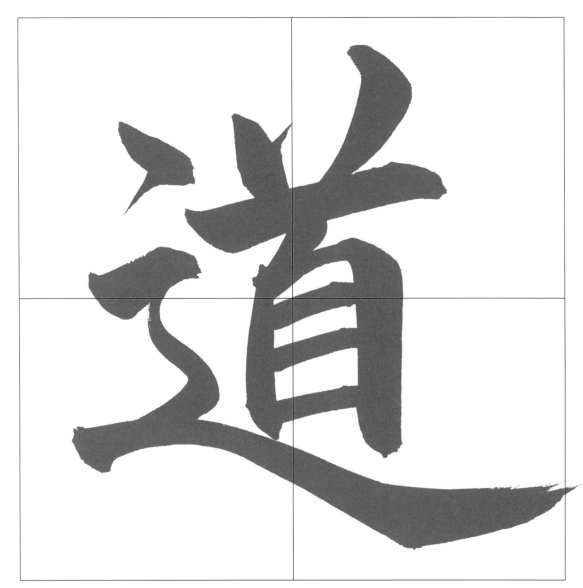

SKIP Pattern 3 ◻ 道 3-3-9

12 STROKES	**street, way, moral** Based on radical #162 (辶), this character is used in only one other character (導).	道

Onyomi: dou, tou

道路	douro	road
書道	shodou	Japanese calligraphy
柔道	jyuudou	judo
神道	shintou	Shinto (religion)

 丶 丷 丷 丷 首 首 首 首

首 首 道 道

Kunyomi: michi

近道	chikamichi	shortcut
道端	michibata	roadside, wayside
抜け道	nukemichi	loophole
道草	michikusa	loiter on the way

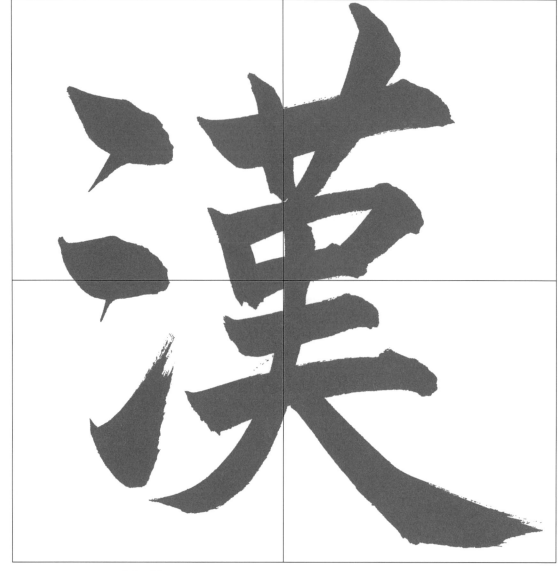

SKIP Pattern 1 ◼ 漢 1-3-10

13 STROKES	**Chinese, fellow** Based on radical #85 (水), this character is used independently and does not occur inside of other characters.	漢

Onyomi: kan

漢字	kanji	kanji characters
漢文	kanbun	Chinese literature
漢方	kanpou	Chinese medicine
漢代	kandai	Han Dynasty

 丶 丶 氵 汀 汗 沢 沢 沢

沢 漢 漢 漢 漢

Kunyomi: <none>

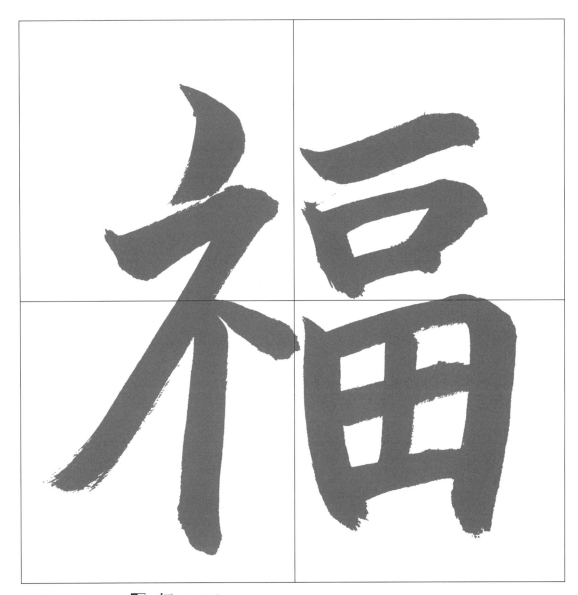

SKIP Pattern 1 ■☐ 福 1-4-9

 fortune, luck
13 STROKES

Based on radical #113 (示), this character is used independently and does not occur inside of other characters.

福

Onyomi: fuku

幸福	koufuku	happiness
福音	fukuin	good news
祝福	shukufuku	blessing
裕福	yuufuku	wealth, rich

Kunyomi: *<none>*

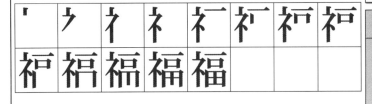

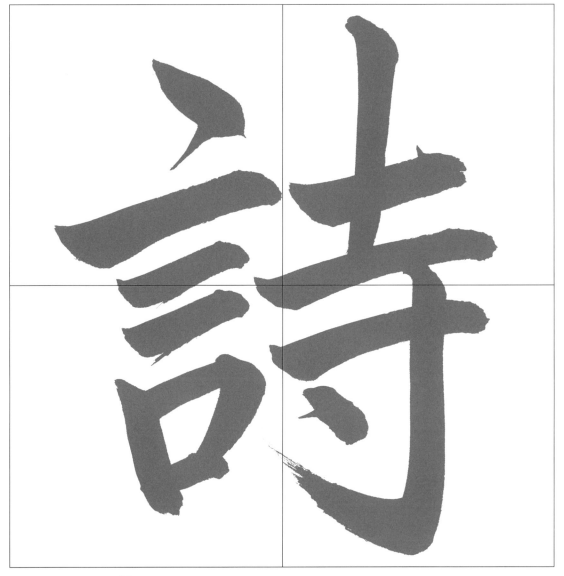

SKIP Pattern 1 ▮☐ 詩 1-7-6

 poem, poetry
13 STROKES

Based on radical #149 (言), this character is used independently and does not occur inside of other characters.

詩

Onyomi: shi

詩人	shijin	poet
詩集	shishuu	collection of poems
詩情	shijou	poetic sentiment
漢詩	kanshi	Chinese poetry

Kunyomi: *<none>*

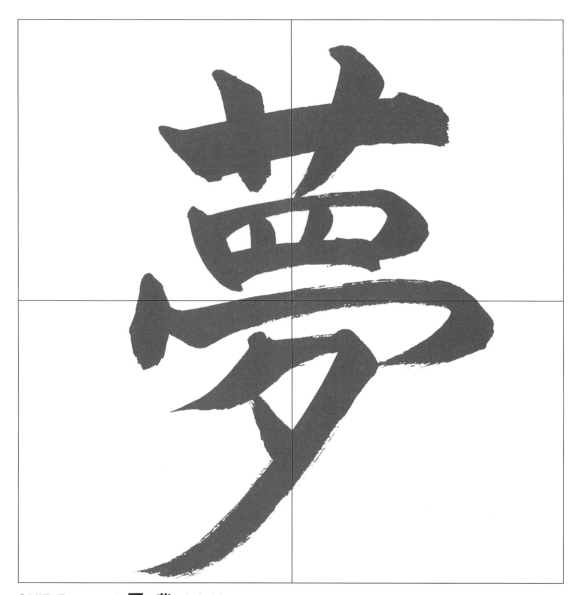

13 STROKES	dream	夢
	A combination of radical #140 (艹), #122 (罒), #14 (冖), and #36 (夕), it is used in few other characters.	

一 十 艹 艹 芦 苎 苎 苗

 苗 芇 夢 夢 夢

Onyomi: mu, bou

悪夢	akumu	nightmare
白日夢	hakujitsumu	daydream
夢中	muchuu	in a daze, a trance

Kunyomi: yume

夢見る	yumemiru	to dream
正夢	masayume	dream comes true
夢占い	yume uranai	dream interpretation
夢物語	yumemonogatari	fantastic story

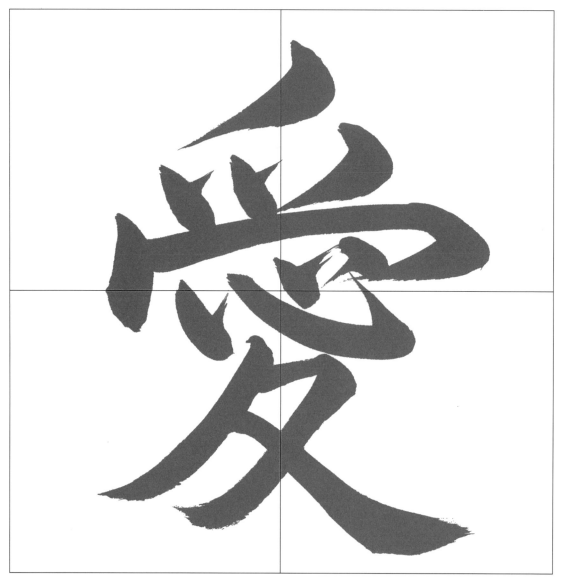

13 STROKES	love, affection, favorite	愛
	Based on radical #61 (心), this character is normally used independently, but does occur inside of a few other characters.	

一 厂 厂 ⺢ ⺤ 爫 爫 愛

 愛 愛 愛 愛 愛

Onyomi: ai

愛国心	aikokushin	patriotism
敬愛	kei'ai	love and respect
愛情	aijyou	affection
愛人	aijin	lover

Kunyomi: ito(shii)

愛しい	itoshii	lovely, dear, beloved
愛しい子	itoshiiko	a beloved child

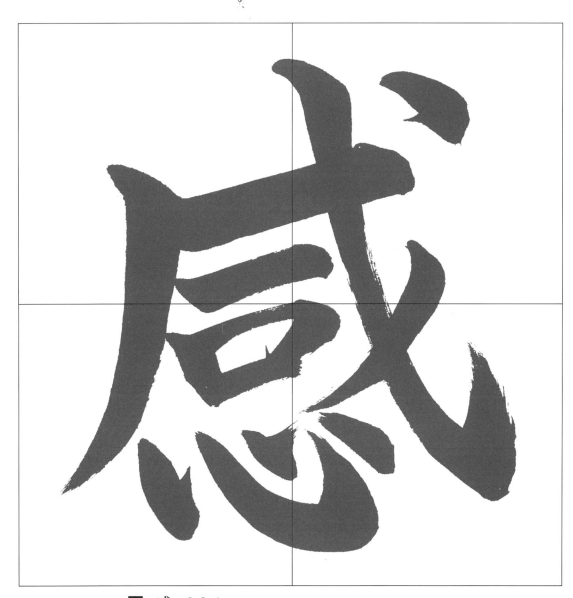

SKIP Pattern 2 ■ 感 2-9-4

13 STROKES **feeling, emotion**
Based on radical # 61 (心), this character is used independently and occurs as a component in only a few other complex characters.

感

Onyomi: kan

五感	gokan	the five senses
感情	kanjyou	emotions, feelings
同感	doukan	sympathy
予感	yokan	hunch

Kunyomi: <none>

 厂 厂 斤 后 后 咸 咸
咸 咸 感 感 感

SKIP Pattern 2 □ 楽 2-9-4

13 STROKES **music, comfort**
Based on radical #75 (木), this character is used independently and occurs as a component in only a few other complex characters.

楽

Onyomi: gaku, raku, ra*-

音楽	ongaku	music
気楽	kiraku	at ease, comfortable
楽園	raku'en	paradise
楽観	rakkan	optimism

Kunyomi: tano(shi)-

楽しい	tanoshii	happy
楽しむ	tanoshimu	to enjoy oneself
楽しみ	tanoshimi	enjoyment

 厂 冇 白 白 白 泊 泊
泊 泊 楽 楽 楽

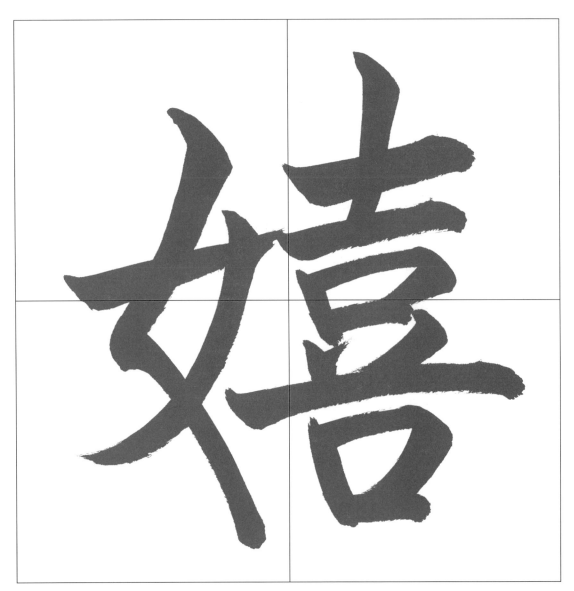

SKIP Pattern 1 ■ 嬉 1-3-12

 14 STROKES **glad, pleased**

Based on radical #38 (女), this character is used independently and does not occur inside of other characters.

嬉

Onyomi: ki

嬉嬉として	kikitoshite	gleeful
嬉遊	kisyuu	to play

Kunyomi: ure(shi)-

嬉しい	ureshii	happy, glad
嬉しく	ureshiku	delightful
嬉し涙	ureshinamida	tears of joy
嬉し泣き	ureshinaki	weep with joy

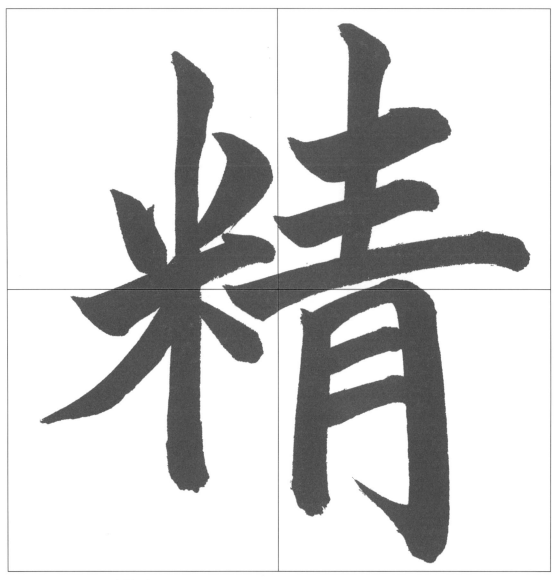

SKIP Pattern 1 ■ 精 1-6-8

 14 STROKES **purity, refined**

Based on radical #119 (米), this character is used independently and does not occur inside of other characters.

精

Onyomi: sei, shou

精神	seishin	soul, spirit, mind
精密	seimitsu	accurate, precise
精力	seiryoku	vitality, energy
精進	shoujin	religious purification

Kunyomi: *<none>*

`	`	⺍	⺌	半	米	籵	籵
籵	精	精	精	精	精		

SKIP Pattern 2 ▬ 髪 2-10-4

14 STROKES	**hair (on the head)** Based on radical #190 (髟), this character is used independently and does not occur inside of other characters.	髪

Onyomi: hatsu, -patsu

白髪	hakuhatsu	grey hair
散髪	sampatsu	hair dressing
金髪	kimpatsu	blond hair
間一髪	kan'ippatsu	by a hair's breadth

Kunyomi: kami, -gami

黒髪	kurokami	black hair
髪飾り	kamikazari	hair decorations
乱れ髪	midaregami	untidy hair
日本髪	nihongami	Japanese style hair

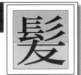

丨	厂	斤	斤	镸	镸	镸	镸
髟	髟	髟	髣	髪	髪		

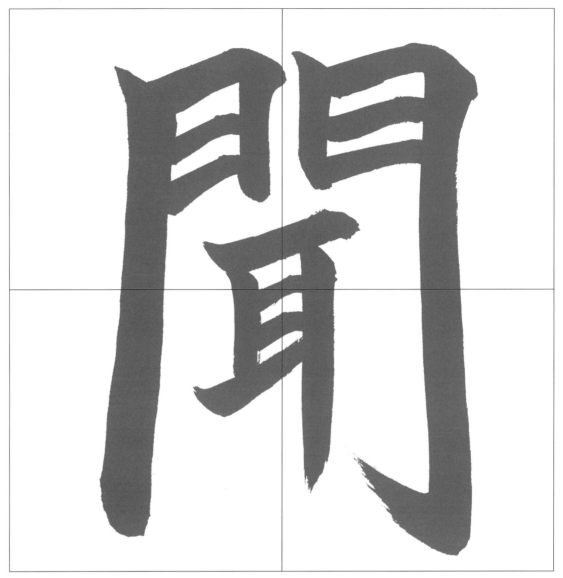

SKIP Pattern 3 ☐ 聞 3-8-6

14 STROKES	**hear, ask, listen** Based on radical #169 (門), this character is used independently and does not occur inside of other characters.	聞

Onyomi: bun, mon

新聞	shinbun	newspaper
見聞	kenbun	observation
醜聞	shuubun	scandal
聴聞	choumon	listening

Kunyomi: ki-, -gi

聞く	kiku	to listen, to hear
聞こえる	kikoeru	to be audible
又聞き	matagiki	hearsay
盗み聞き	nusumigiki	eavesdropping

丨	冂	冂	冃	冃	門	門	門
門	門	門	閂	閏	聞		

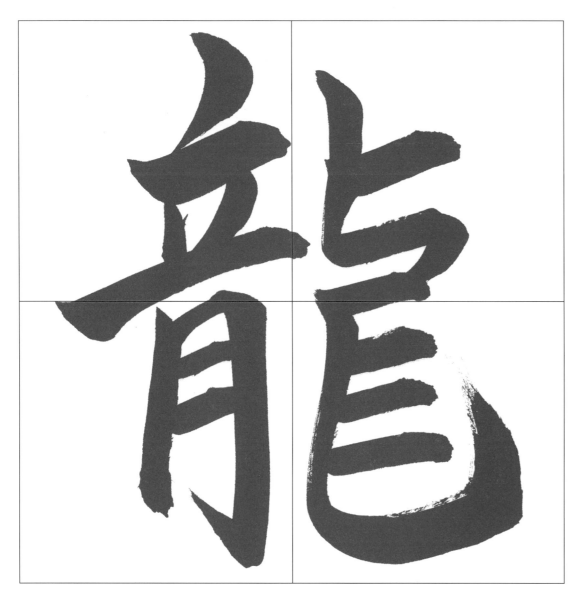

SKIP Pattern 1 ■□ 龍 1-9-7

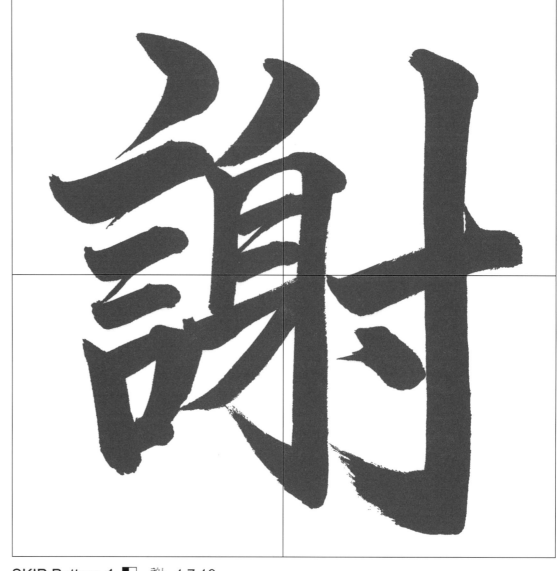

SKIP Pattern 1 ■□ 謝 1-7-10

DOUBLE CHARACTERS

In this section, I've selected compound character words using characters from the first section.

CHARACTER SPACING

When writing grouped characters, aligning them together correctly can be difficult and takes practice. The two important points to consider are 1) the spacing between the two characters and 2) the proper centering of the second character under the first.

Keep in mind that the positioning of each character is determined by where you put the first stroke, so think carefully before you begin to write.

After finishing the first character, carefully consider the alignment of where the first stroke should be under the first character. Trying to envision the entire character on the paper before writing is helpful.

PRONUNCIATION

As stated in the pronunciation section, words comprised of two of more kanji characters grouped together generally use the onyomi pronunciation. All of the words on the next few pages use the onyomi pronunciation. Two of them, school, *"gakkou"*, and marriage, *"kekkon"* use the small *"tsu"* (っ) to make the characteristic soku'on double consonant.

Touching

Too far

Off Center

Good

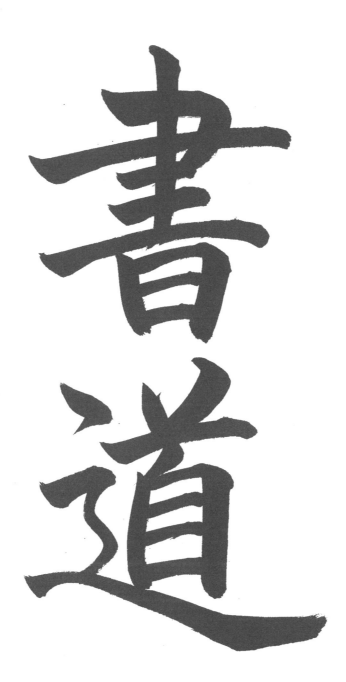

calligraphy
しょどう
shodou

sun
たいよう
taiyou

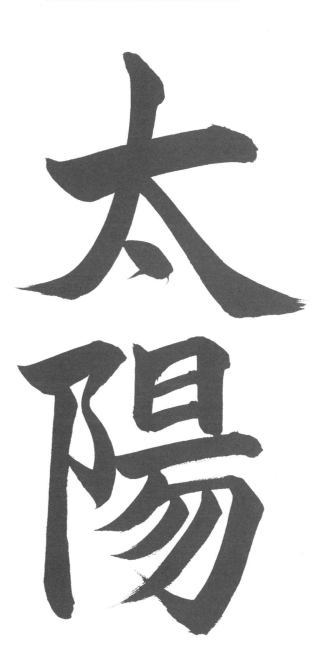

117

study

べんきょう

benkyou

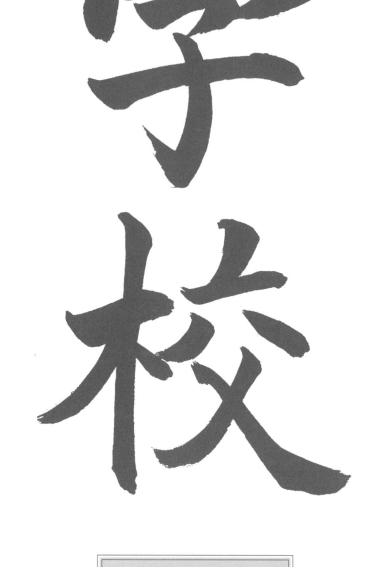

school

がっこう

gakkou

talent
げいのう
geinou

夕日

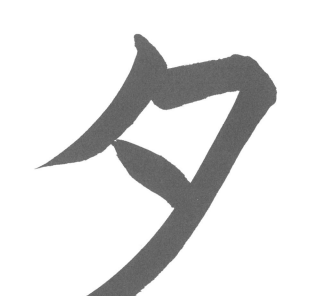

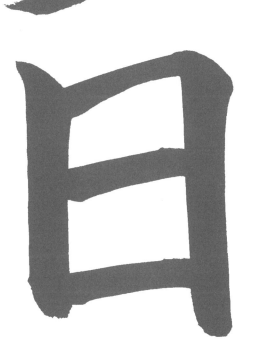

sunset
ゆうひ
yuuhi

freedom
じゆう
jiyuu

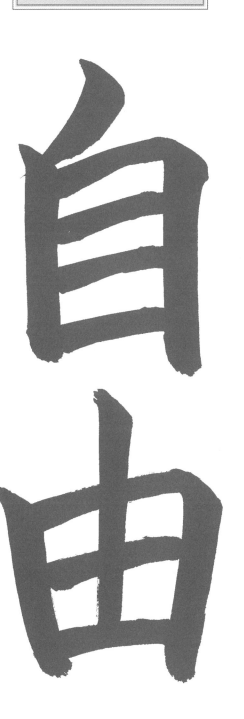

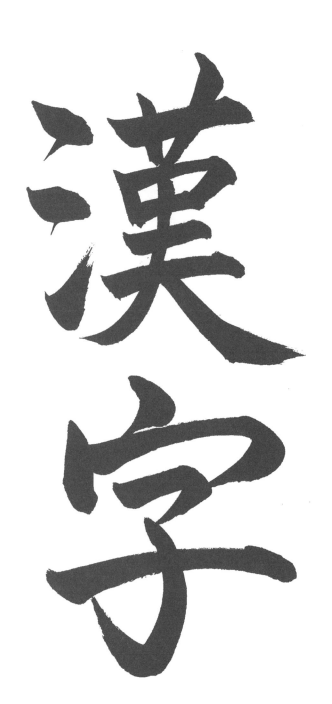

kanji

かんじ

kanji

appreciation

かんしゃ

kansha

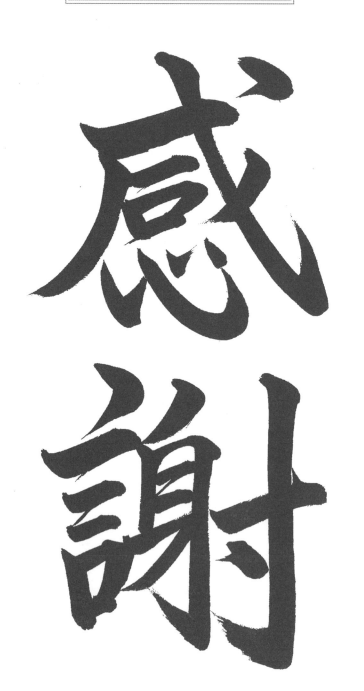

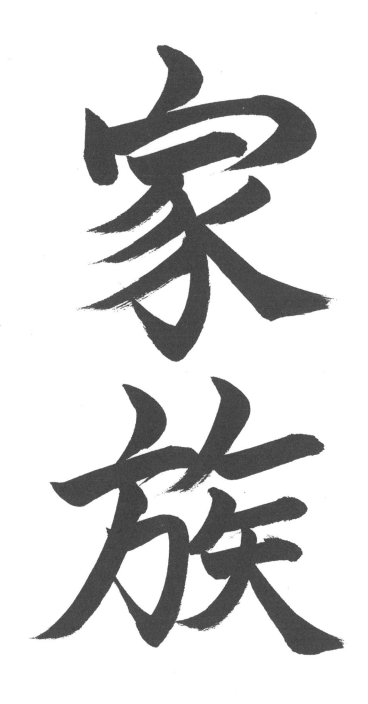

family

かぞく

kazoku

marriage

けっこん

kekkon

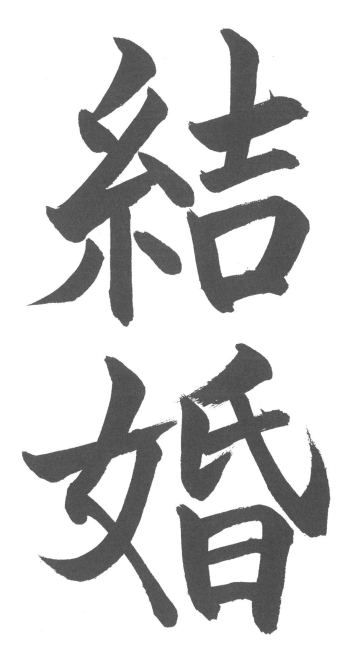

fortune

こうふく

koufuku

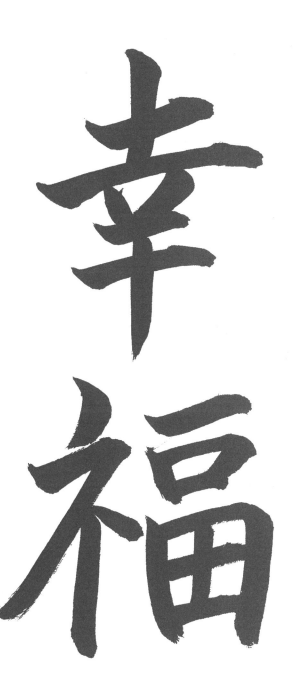

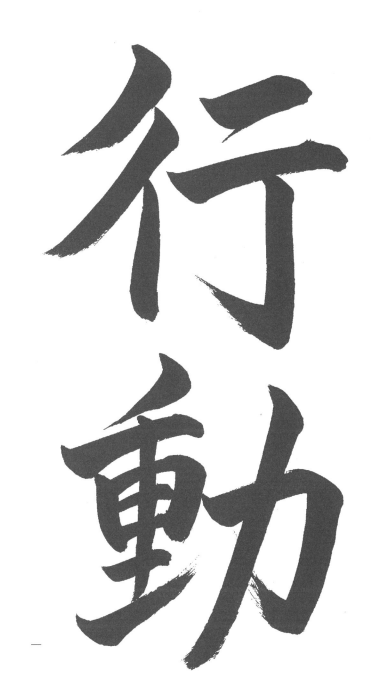

behavior

こうどう

koudou

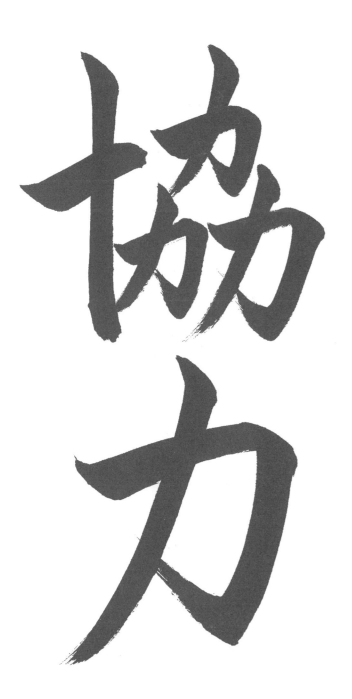

cooperation

きょうりょく

kyouryoku

compassion

にんじょう

ninjyou

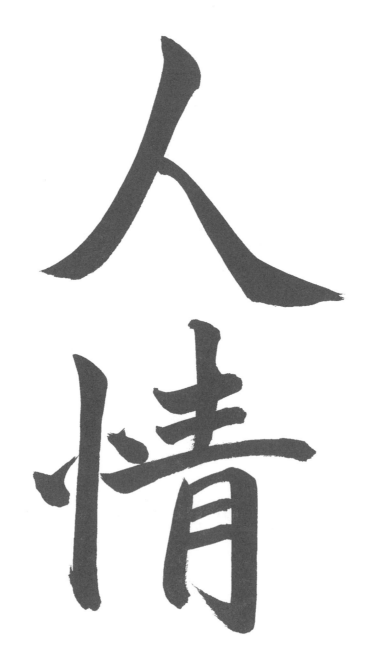

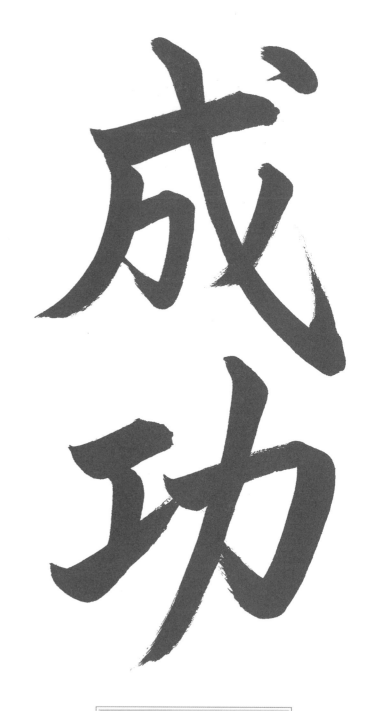

success

せいこう

seikou

mind

せいしん

seishin

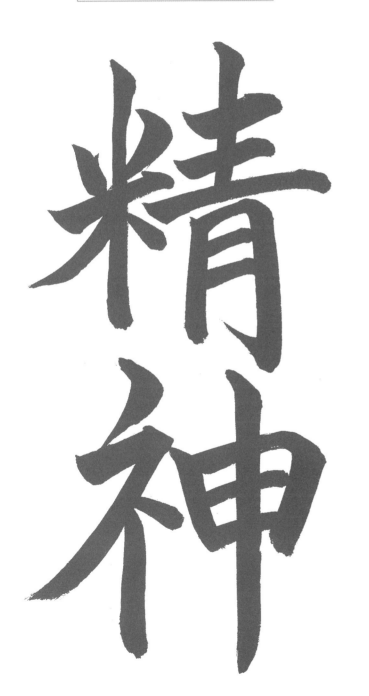

世界

world

せかい

sekai

society

しゃかい

shakai

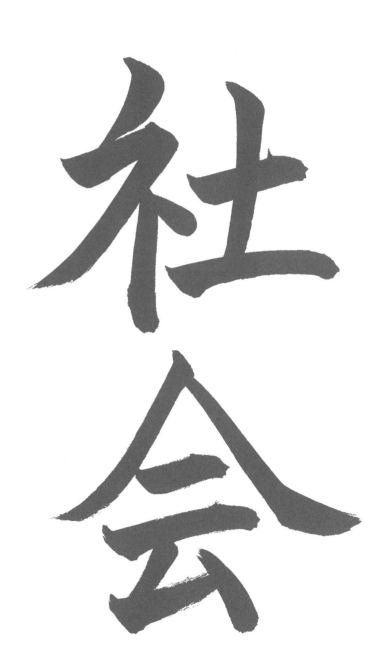

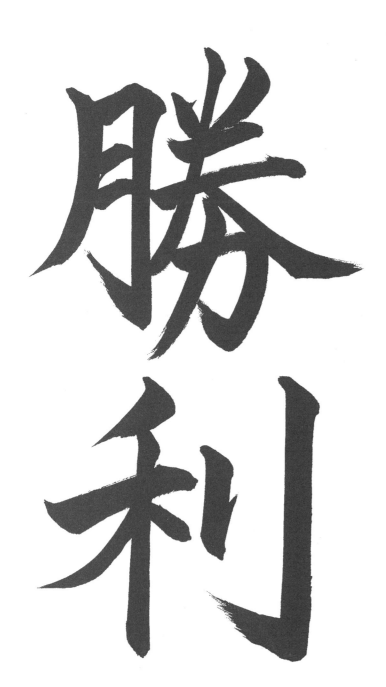

success

しょうり

shouri

meal

しょくじ

shokuji

carriage

ばしゃ

basha

wisdom

ちえ

chie

music

おんがく

ongaku

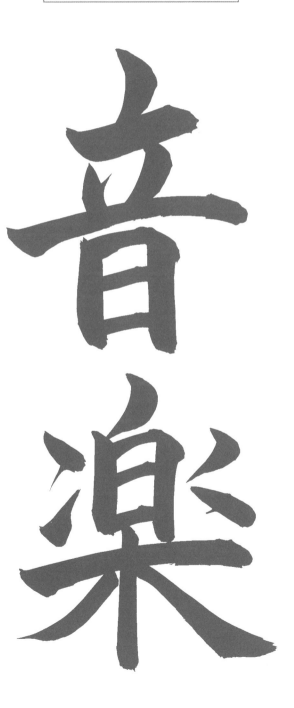

earth

だいち

daichi

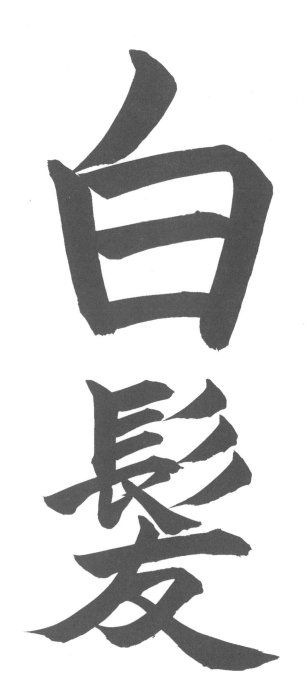

white hair

しらが

shiraga

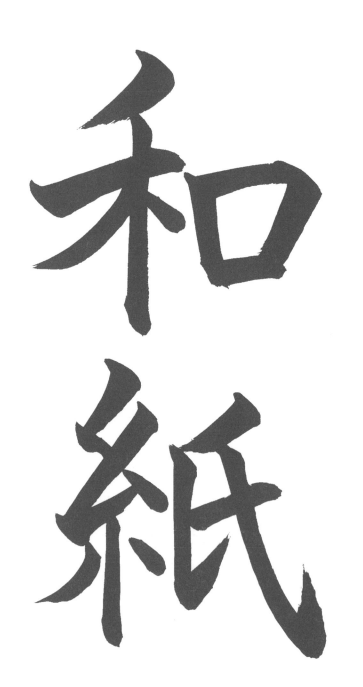

Japanese paper

わし

washi

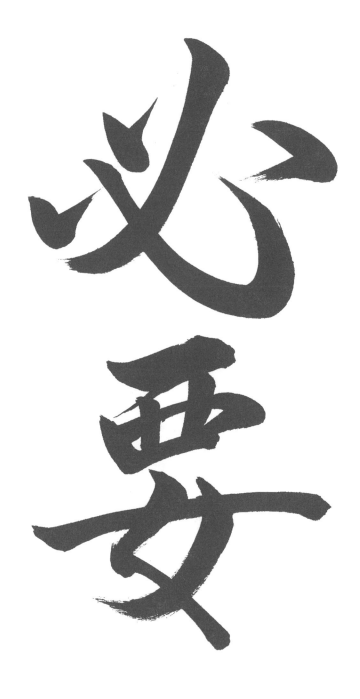

necessary

ひつよう

hitsuyou

126

CHARACTERS INDEXED BY MEANING

Index